Turkish Style

The Turkish house manifests itself less through

some clever play of symmetry on the façade than through its

integration with surrounding nature, as here in the

yalı of Count Ostrorog on the shores of the Bosphorous (PAGES 6-7),

or in the houses on the banks of the river Yeşihrmak at

Amasya, a city in northwest Anatolia (PAGES 8-9). The interior space,

other than its most intimate aspects, extends quite

naturally into water or vegetation.

Design
Louise Brody

Translation
Daniel Wheeler

Editorial coordination
Emmanuelle Laudon

Copyright © Editions Didier Millet, 23 Avenue Villemain, 75014 Paris, France

Published in the United States of America in 1992 by

The Vendome Press, 515 Madison Avenue, New York, NY 10022

Distributed in the USA and Canada by Rizzoli International Publications

300 Park Avenue South, New York, NY 10010

Library of Congress Cataloging-in-Publication Data

Yerasimos, Stéphane

Turkish Style / by Stéphane Yerasimos; foreword by Mica Ertegun.

p. cm.

ISBN 0-86565-137-X

1. Interior decoration—Turkey—Themes, motives. 2. Turkey—

Social life and customs. 1. Title.

NK2065.A1B44 1992

728'.09561—dc20 92-15027 CIP

Printed and bound in Italy

Turkish Style

◆

PHOTOGRAPHS BY
ARA GÜLER AND
SAMIH RIFAT

◆

TEXT BY
STEPHANE YERASIMOS

◆

ILLUSTRATIONS BY
KAYA DINÇER

THE VENDOME PRESS ◆ NEW YORK

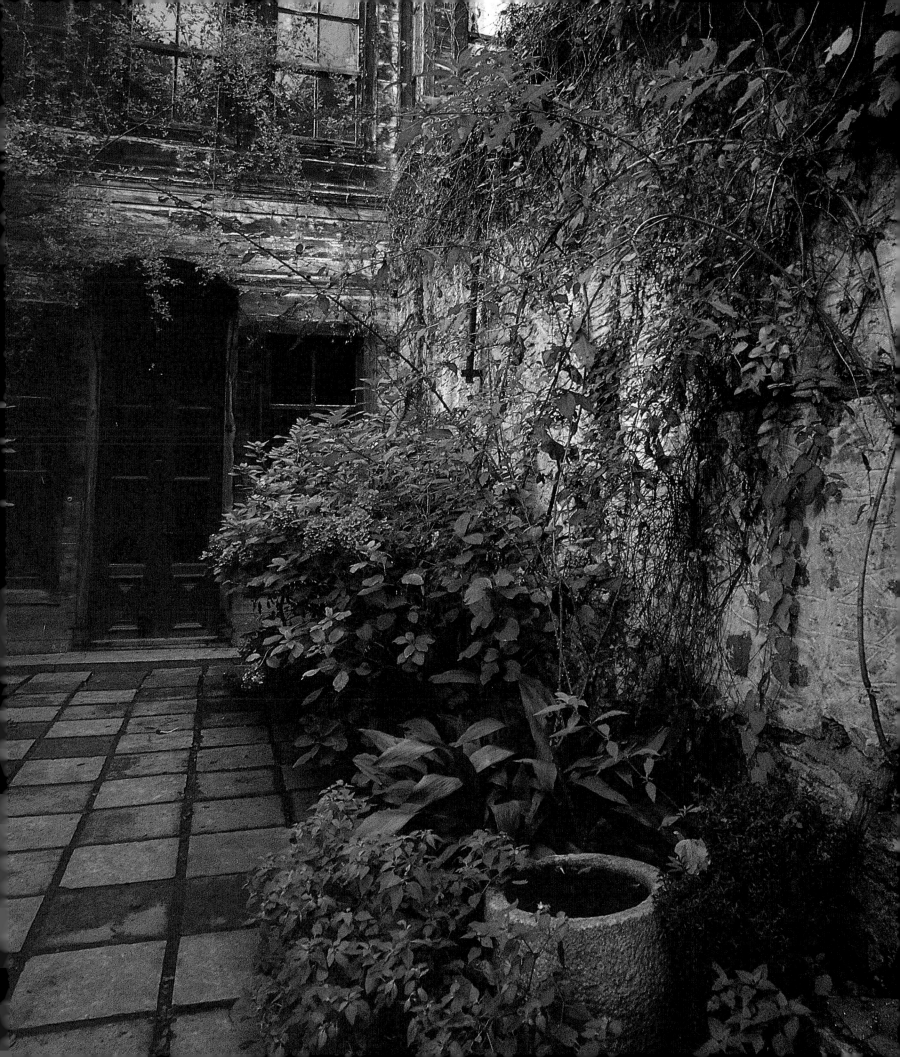

CONTENTS

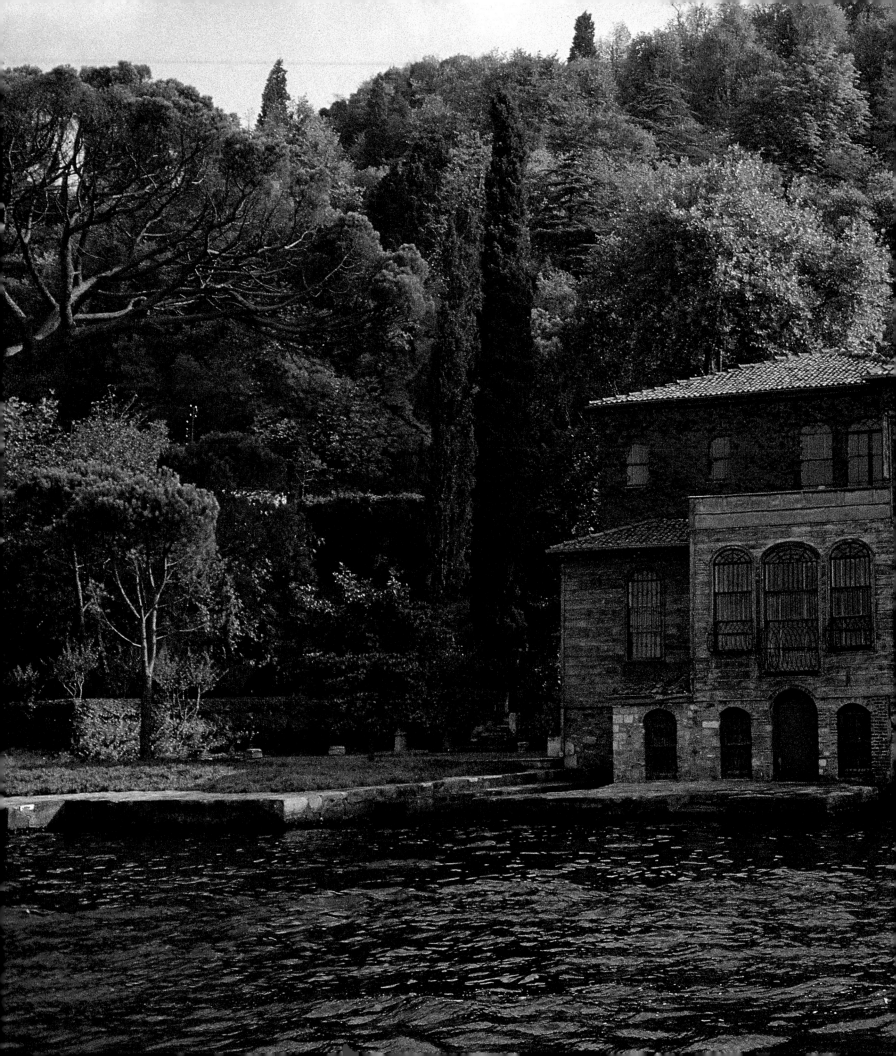

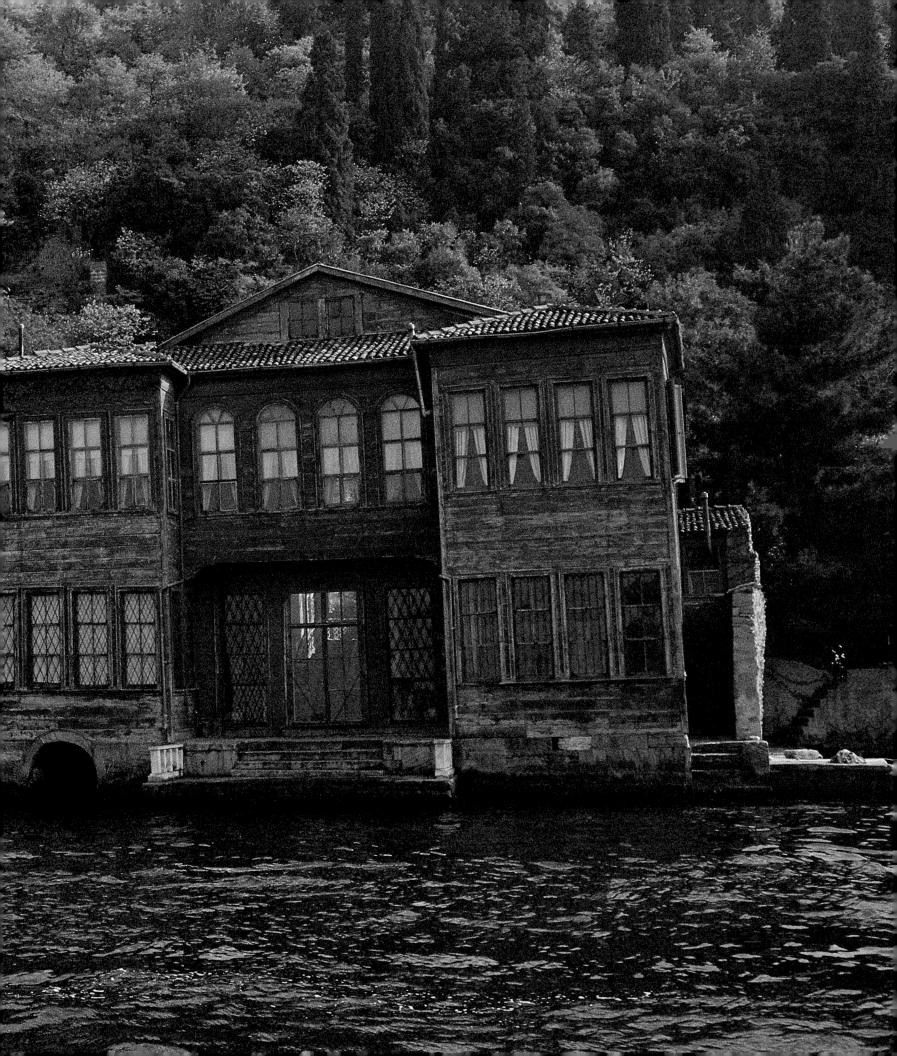

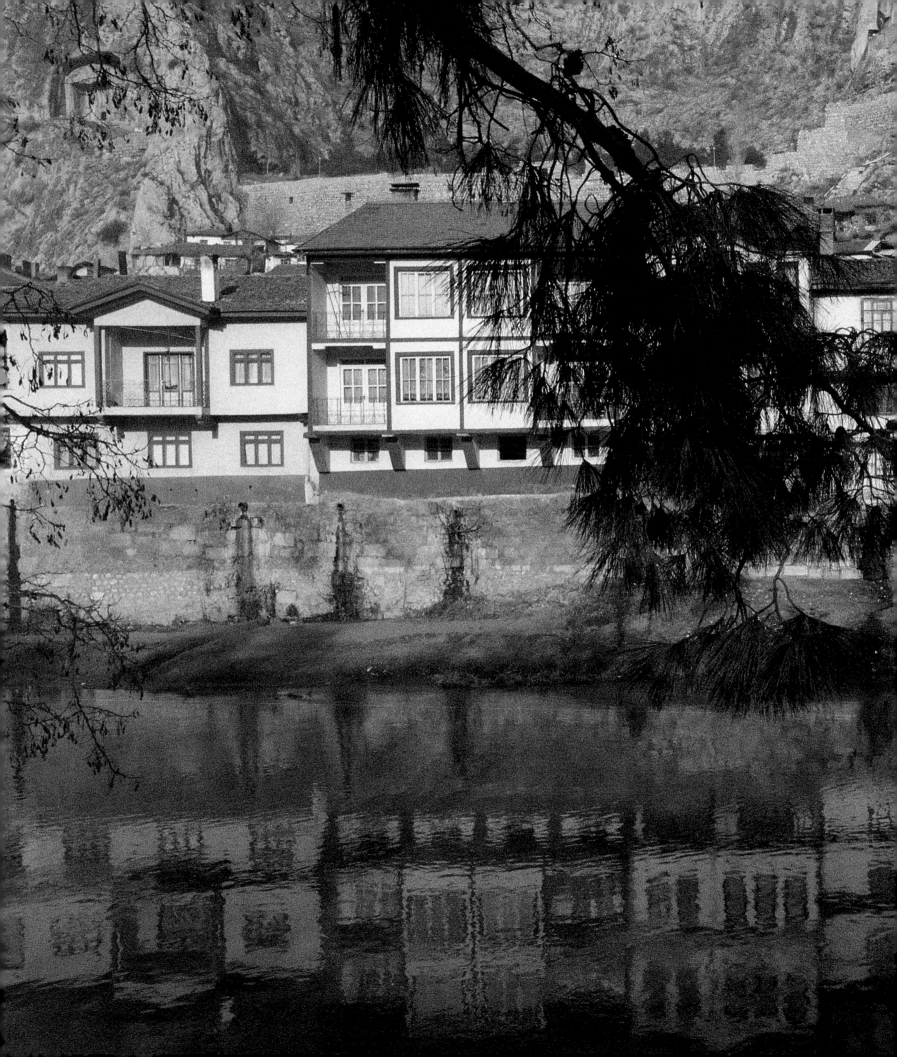

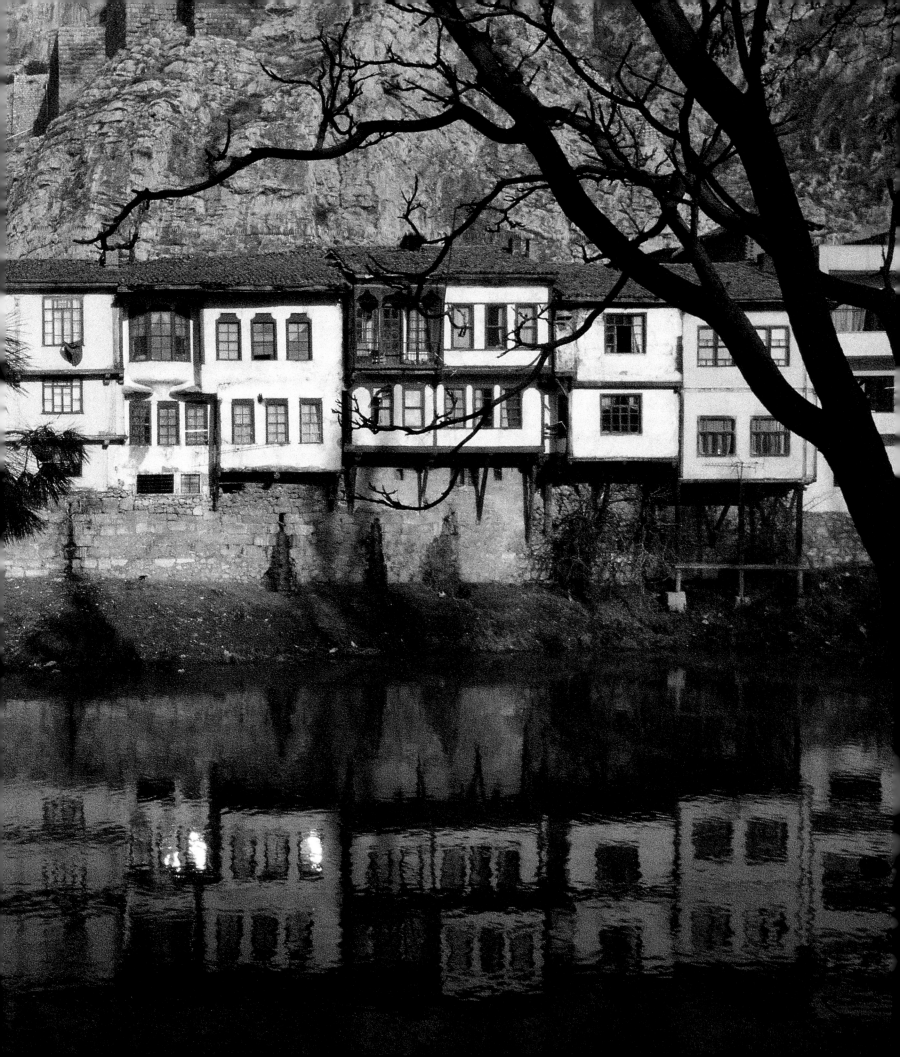

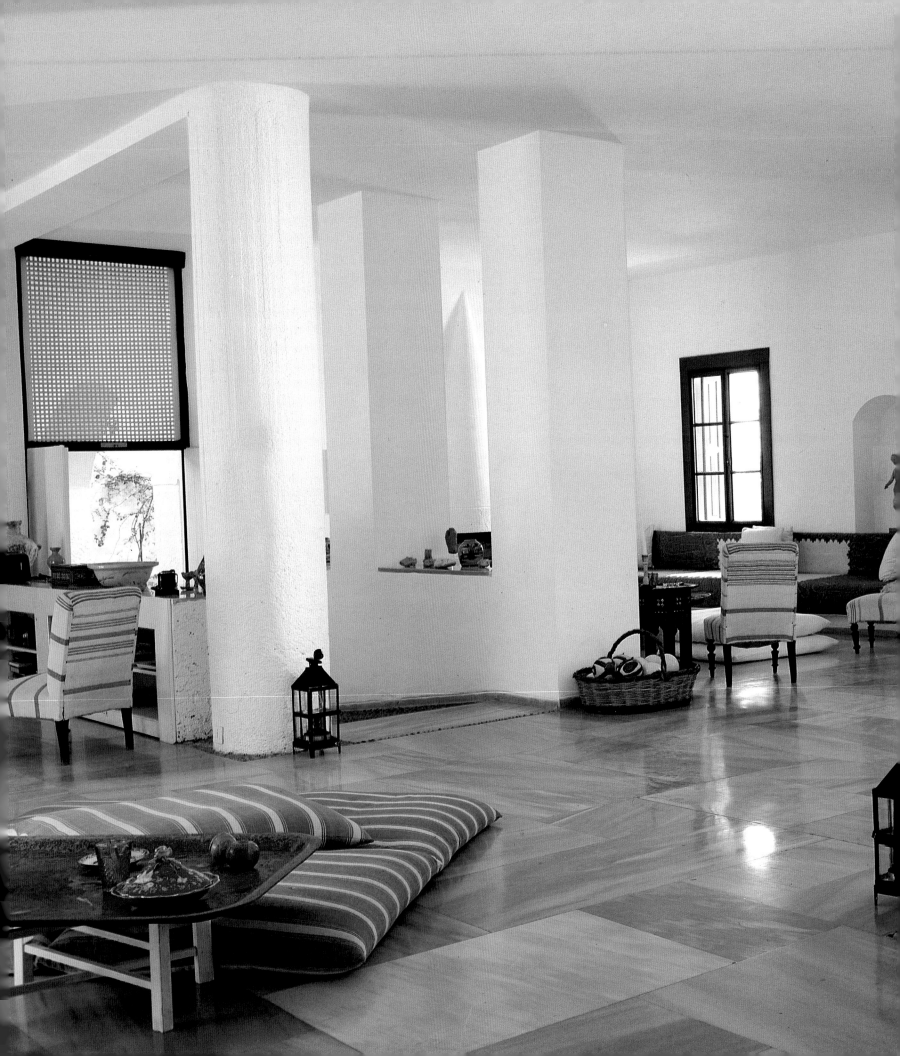

FOREWORD

After numerous visits to Istanbul, my husband and I found ourselves drawn into the Turkish countryside, eager to explore first hand some of the fascinating places we had read and heard about – Ankara, Cappadocia, Konya, Antalya, Alanya, and Maramaris up to Izmir. It was south of the latter, in the year 1970, that we were destined to come upon a series of houses in ruins on the shore of the Aegean Sea. We fell in love with the place – a village called Bodrum – and soon thereafter bought our home. The excitement of restoring an old, characterful house set fire to my imagination, filling me with a great desire to re-create so many of the things I had admired in the special order of Ottoman architecture. Most particularly, I wanted to recover, as much as possible, the unique refinement that the Ottomans had captured throughout hundreds of years of designing and building. The simplicity and purity of their domestic structures, the grandeur and proportion that prevailed even on a private scale, the romantic light filtering through shuttered windows, the sound of water – from fountains, basins, wells, and, of course, the ever-present sea – accompanying the hush of quiet voices, the scented, beautifully overgrown gardens. All this filled my dreams! While my house may be finished, it will never be complete, as was ever the state of the classic Ottoman residence. It is a living object that changes as the lives about it change. Still, with all the new influences that have inevitably come into the house, I ardently hope to have preserved some of the old traditions that attracted me here in the first place. Fortunately, many others are attempting the same in modern Turkey, as the wonderful images in this book so abundantly affirm, together with the beautifully informed text prepared by Professor Yerasimos. I also hope that the present volume will be received as both a witness and a tribute to their efforts, as well as to the traditions that inspired them, and a shared, enlarging, pleasurable experience for all who encounter it.

MICA ERTEGÜN, Bodrum, Turkey, 1992

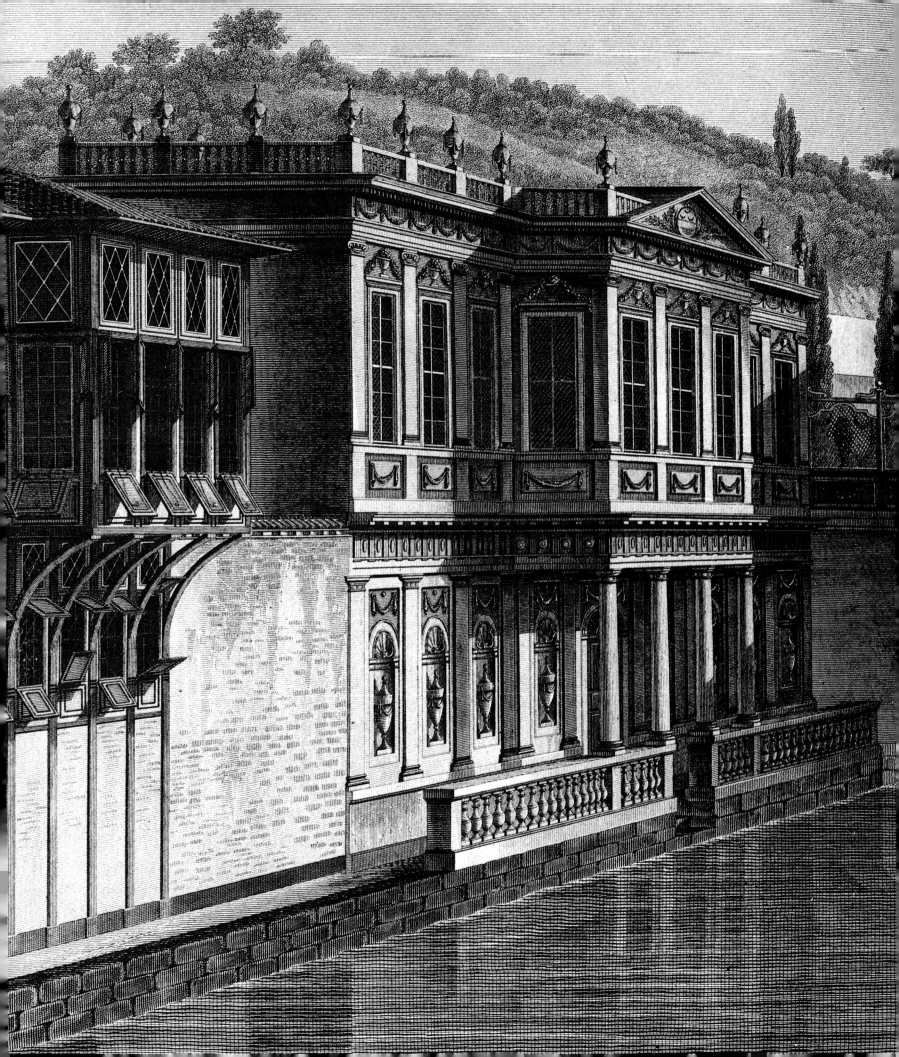

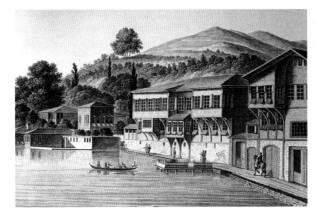

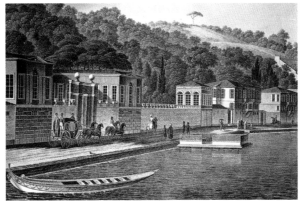

The Lorraine painter

Antoine-Ignace Melling

arrived in the Ottoman

capital at the end of

the 18th century and

spent a dozen years there.

He built Neoclassical

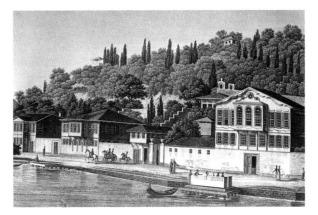

palaces for Hatice Sultan,

(OPPOSITE) the monarch's

sister, but, most notably,

he also engraved a series

of plates representing

Istanbul and the

Bosphorus. They

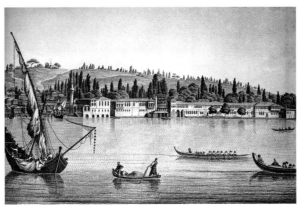

give splendid witness to

a way of life now long

disappeared.

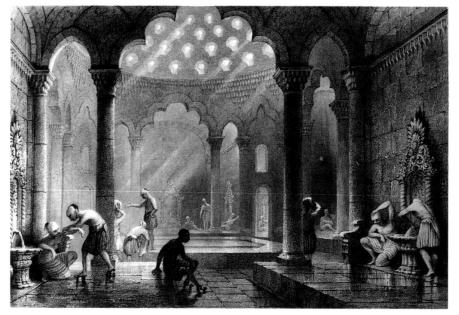

The 19th century's Orientalism – the exotic side of the Romantic age – took great delight in both the public and the private life of the Ottomans, evincing a real predilection for the hamam, or Turkish bath. Sublimated images of the most realistic detail combine – as here, in the monumental fountain placed at the center of a vaulted hall – to create an idealized vision of Oriental languor.

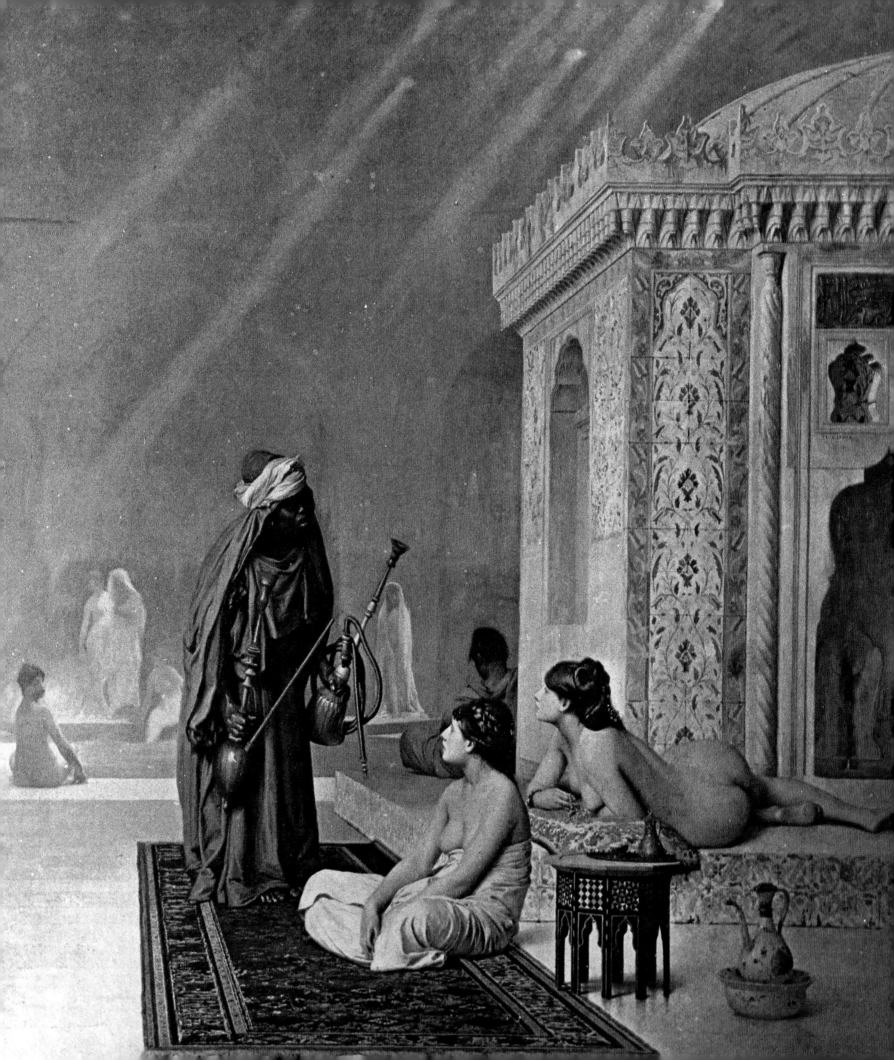

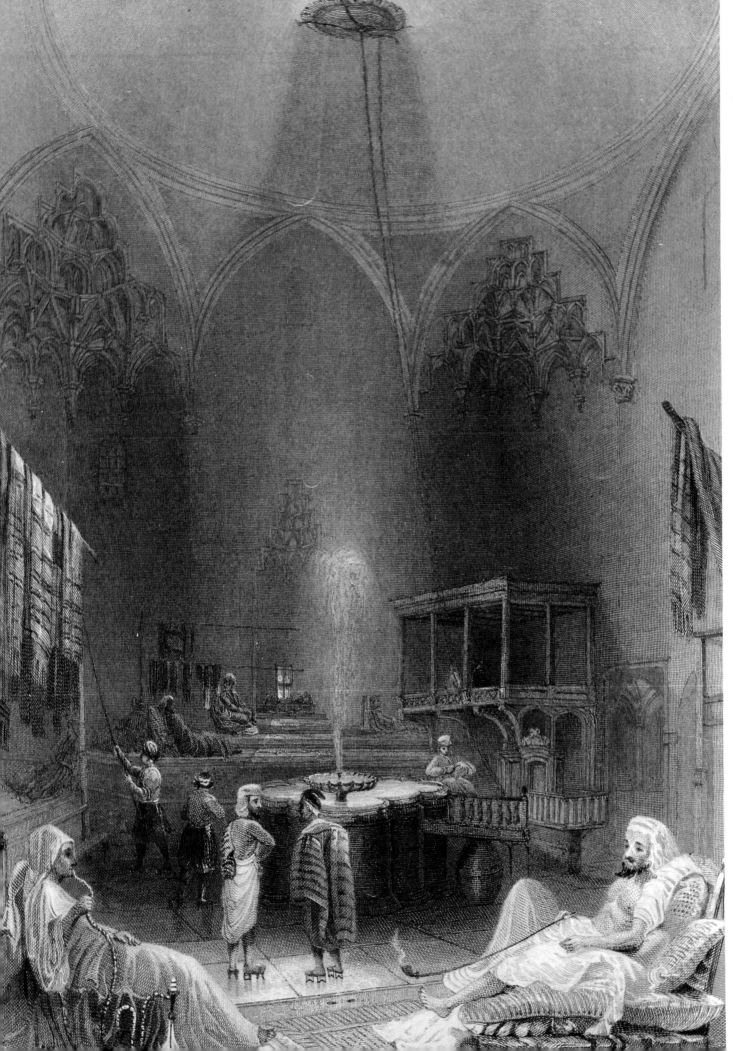

*A*nother cult site was the coffeehouse, where the beverage, which spread to the world from the Ottoman Empire, joined with tobacco, an early addiction in Turkey, consumed through countless pipes or through distillations from the tube of a nargile, to yield an ambience celebrated by generations of painters and writers. Scarcely less fascinating was the teeming life of the caravanserais, with their sparkling colors and the enveloping aromas of their exotic products.

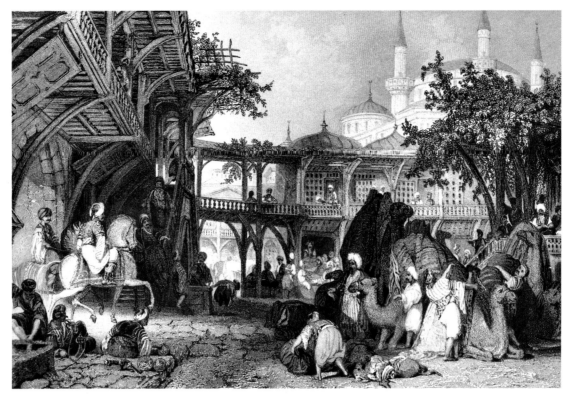

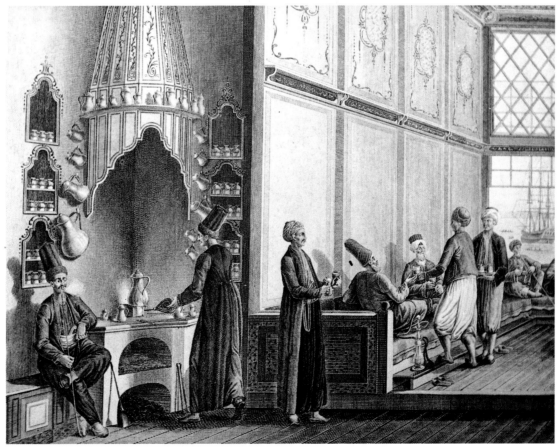

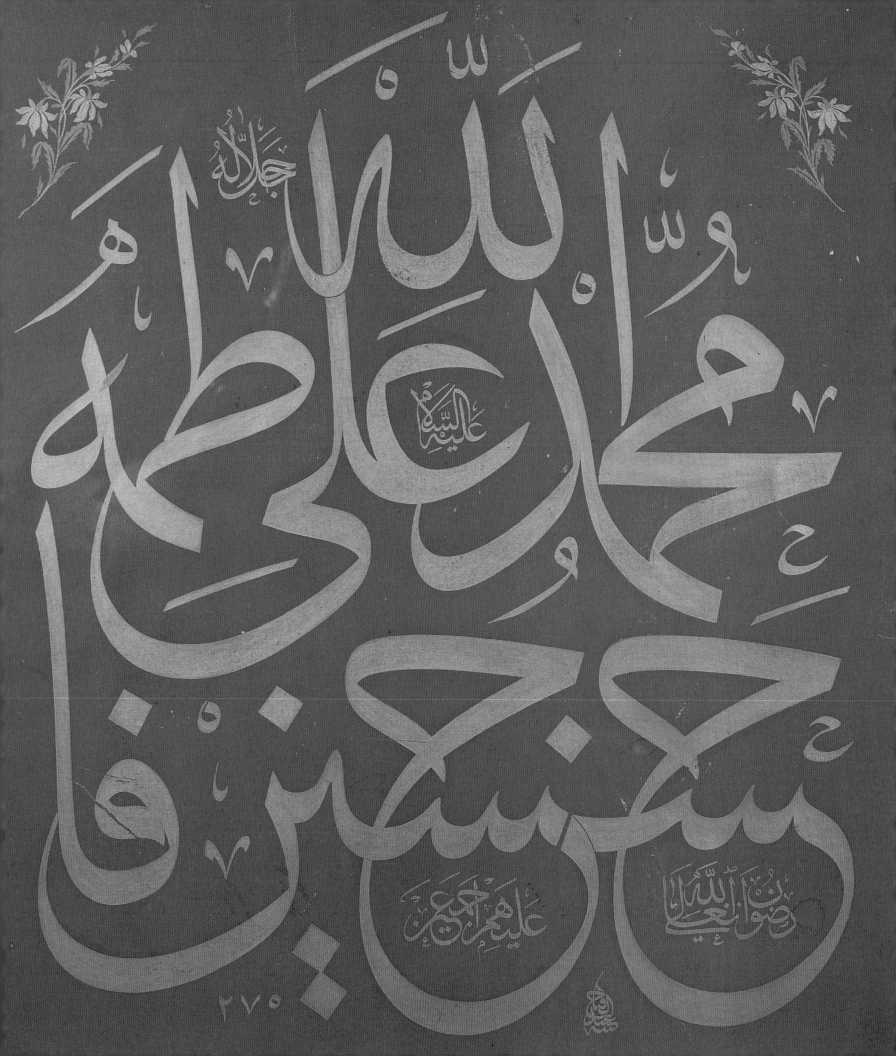

HISTORY AND TRADITION

They always travel with tents, but I chose to lie in houses all the way. . . . I had the curiosity to view all the apartments destined for the ladies of his court. They were in the midst of a thick grove of trees, made fresh by fountains, but I was surprised to see the walls almost covered with little distiches of Turkish verse writ with pencils. I made my interpreter explain them to me and I found several of them very well turned, though I easily believed him that they lost much of their beauty in the translation. One runs literally thus in English: "We come into this world, we lodge, and we depart; He never goes that's lodged within my heart."

LADY MARY WORTLEY MONTAGU, Constantinople, May 1717.

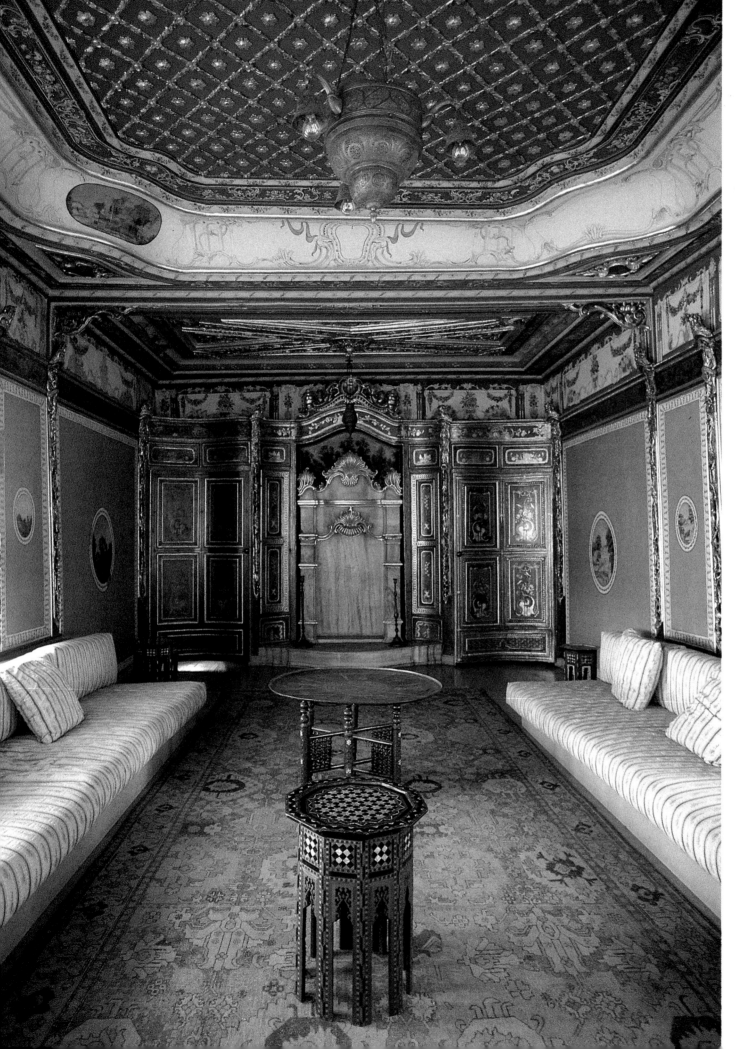

In Ottoman art,
architecture would reign
unchallenged were it not
for calligraphy, where
strokes are reduced
to their essentials, to the
mere trace of a word,
which in turn is itself
limited to the expression
of the elemental and the
primary. Here, the names
of Allah, his prophet
Mohammed, the latter's
only daughter, Fatima,
her husband, Ali,
and their children,
Hassan and Hussein.
And it is the same
aesthetic of scrolling
strokes that prevails in the
decoration of interiors.

or three hundred years, from the 16th century to the 19th, the Ottoman Empire extended over three continents, territory now occupied by some thirty different countries. Peoples of extraordinarily diverse languages, religions, and customs lived under Ottoman rule, in climates as varied as the heat of Yemen and the rigors of the Russian steppe, the sun of the Sahara and the mists of Transylvania, each of them fashioning from these givens its own way of life. Still, the Empire possessed a center – the crucible of civilization, a place of cultural syncretism – as well as peripheries, where the shadow of political power stretched long and wide, leaving every land it fell upon both garrisoned and taxed.

Simultaneously, the center – dominated by Istanbul, the capital and mother of Empires – nourished the whole vast realm with men, goods, and ideas. Yet, the very interaction defining it left the center circumscribed within a radius of some 500 kilometers (300 miles) from the shores of the Bosphorus, running south of the Balkans to the middle of the Anatolian plateau, and from the banks of the Black Sea to the Aegean coast. Here, of course, one found Turks, the builders of the Empire, but also Greeks, the former masters of Byzantium conquered by the Turks, Armenians from the Eastern provinces, and Jews expelled from Spain, as well as Serbs, Bulgarians, and Albanians whose own countries had been absorbed by the Empire. While an ethnic element often prevailed in the countryside, cities and towns were a mosaic of culturally diverse quarters, each of them coalesced about a mosque, a church, or a synagogue. Still, they all formed part of the same ramified network of lanes, alleys, and impasses, and their inhabitants converged and mingled in the same bazaars and shops at the center of the metropolis. It was this urban space that would produce a mode of living and dwelling, a mode whose house – which can only be qualified as Ottoman – was the happy synthesis.

When the Turks arrived in Anatolia and spread into the Balkans, they carried with them three civilizations: that of the Central Asian steppes, where they originated; the ancient one of the recently traversed Persia; and that of Arab Islam, henceforth their religion. In Anatolia, of course, they discover-

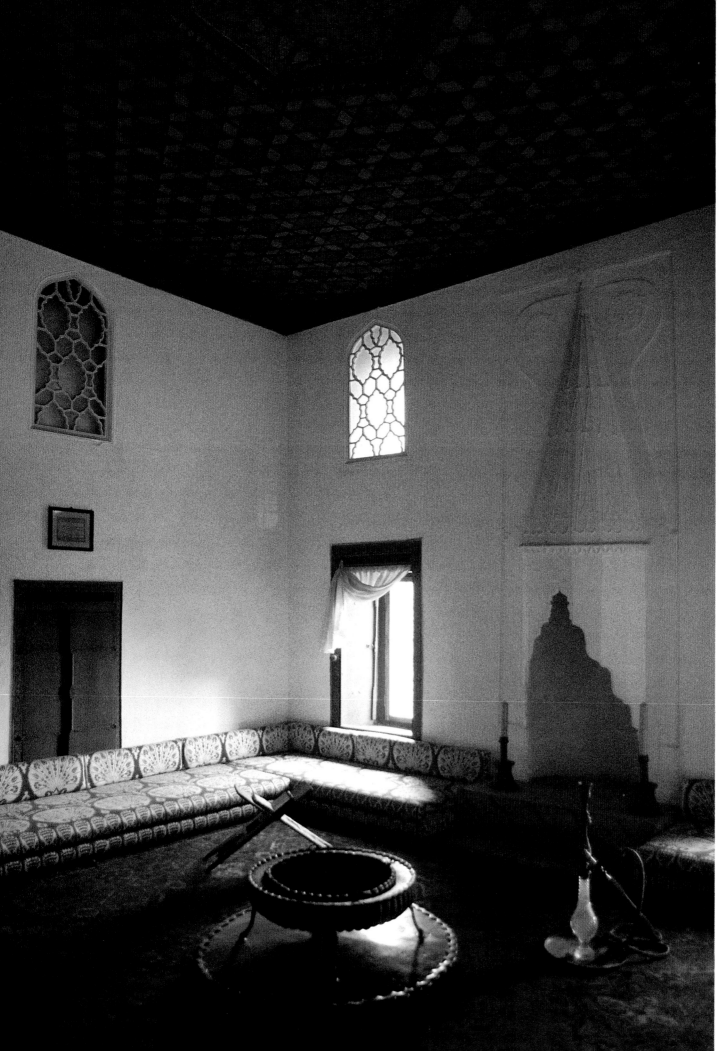

*B*efore the arrival
of large-pane glass in the
early 19th century,
a pair of superposed
windows shared the dual
functions of aerating
and lighting the interiors.
The lower opening is
equipped only with a pair
of shutters, vertical or
horizontal (SEE PAGE 12),
which remain closed
during bad weather or
heat waves, while light
filters through the
opening above, where
small fixed panes,
often multicolored,
are fitted like stained-
glass windows.

ed the civilization of Byzantium, itself the heir to Greece and Rome, together with the contributions of their subject peoples. Almost nothing is known about the local human habitat or its forms before this collision of cultures, nor anything of those which came in the immediate aftermath of the great encounter. At best, studies undertaken with texts – since almost nothing remains in the way of buildings, and even images are cruelly lacking – tell us that the habitat of the 16th-century Empire – in Istanbul and the provinces alike – must have been quite different from what we now define by the term "Ottoman house," the earliest surviving examples of which date from the 18th century.

Thus, we also have no way of determining what ingredients came from each culture in the process of gestation – no doubt lasting two or three centuries – which yielded an Ottoman mode of living and dwelling. Even if it seems plausible that Istanbul constituted the generative center for the diffusion of a model habitat, we can measure neither the contributions very likely made by the provinces, nor – *a fortiori* – the part played by the Balkans and Anatolia. We merely observe that, gradually, the sphere of influence grew, notably in the 19th century, towards the northern Balkans, on the one hand, and, on the other, towards central and northeastern Anatolia.

At the same time, we know as well that during the period of its expansion, this type of habitat involved all the many ethnic and socioeconomic groups within the area under consideration, a reality that now makes it impossible to establish whether the original owners of a given house were Turks, Greeks, Armenians, Bulgarians, or whatever, unless there are written documents on the subject. Moreover, while we know that itinerant Macedonian, Greek, or Bulgarian masons roamed through the Balkans, and that Armenian master stone-cutters and carpenters worked in Anatolia, we may also be sure that the repertoire of construction materials and techniques remained more or less exclusively Turkish. Thus, what we find ourselves examining is a product of Ottoman culture, collectively fashioned through the practical expertise of the entire, mixed community at the center of the Empire, in a space where, from the house to the city, the pulse of life throbbed at the same rhythm for everyone.

◆

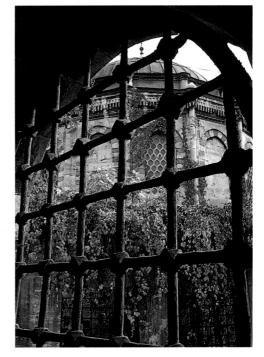

The whole ensemble appears to arise from a subtle rapport between interior and exterior, from solid, blank walls rendered immaterial by a curtain of foliage, from grilles that make exclusion intolerable by the very image they offer of the inaccessible, from windows high enough to embrace the landscape while simultaneously frustrating indiscretion, which would also have to contend with the protective wooden screens called kafes.

DWELLING À LA TURQUE

What is a style of living and dwelling if not a specific relationship between space and time, a relationship that is itself movement? Already dynamic, this interrelated trilogy – space, time, movement – becomes all the more so in the present instance, where each of the three breaks down into a pair of opposite elements in a perpetually creative confrontation.

THE INSIDE AND THE OUTSIDE

The city and the house would become the two polar opposites of the Oriental world, the first being the domain of men and the second the realm of women. Yet, true as this may be, we must also acknowledge that the richness of the Ottoman city consists less in some rule than in the exceptions to it. For example, the most intense and colorful moments in urban life occur when women make their way across the city, in ox-carts festooned with flower garlands and headed for picnics in suburban orchards, in carriages destined for an exchange of visits, in small boats known as caïques powered by paired rowers on the Golden Horn or the Bosphorus, in procession, preceded by servants and followed by children, towards the *hamam* or baths, capturing the attention of men seated at their cafés, at work in the shops, passing by on foot or on horseback.

Further, one can never be certain when the city ends and the house begins. The space traversed by a visitor moving from the central city to the heart of a residence is one continuous progression from the public space towards the private. Taking leave of the swarming bazaars, we aim for the center of a quarter with a mosque, sometimes a few shops, and a fountain where women patiently queue. Next, we turn into a lane, often to arrive at an impasse, where children are playing in the middle of the roadway, while women call to one another from windows or knit on their doorsteps. Now comes the moment when someone will surely inquire what we are about. This is because the urban tissue just described was not made to be indiscriminately crossed end to end, but rather to gain access from some particular place to some particular person's home.

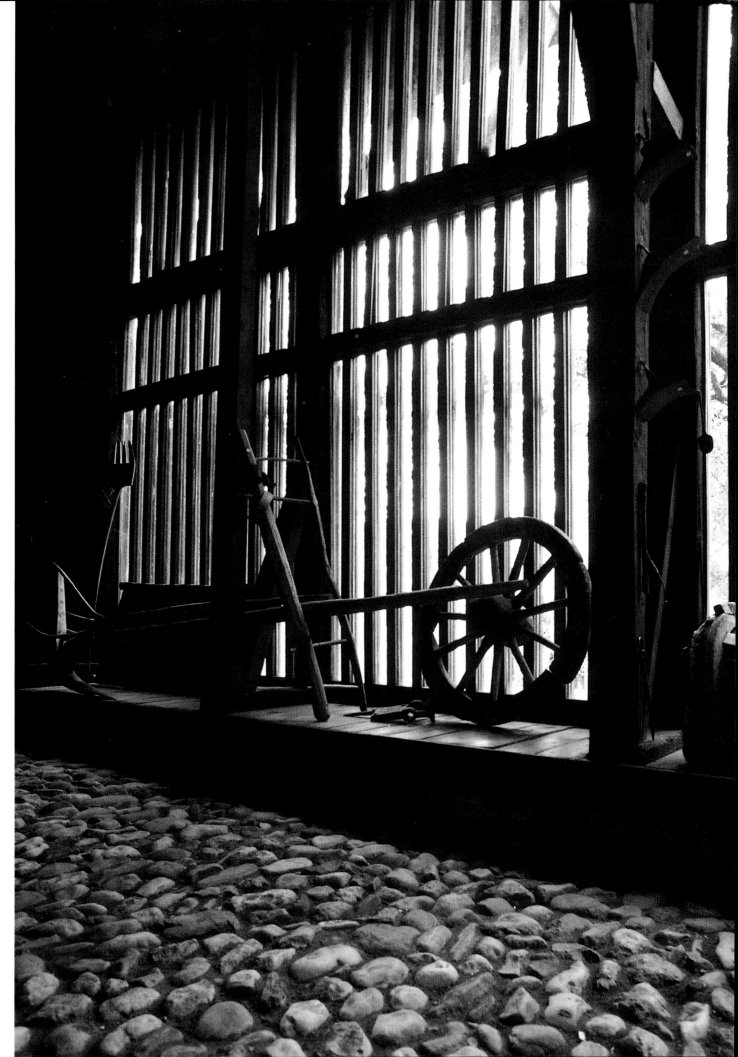

*I*n the houses at

Safranbolu, the tall

wooden screens that run

the length of the ground

floor and the mezzanine

protect both implements

and harvests stored there,

while also providing

the ventilation necessary

to their preservation.

Once in front of the house, you will not see it, or, at least, you will not grasp its contours, its limits. The street is bordered on either side by walls, all of them blind except for a door here and there, and surmounted by overhanging upper stories whose aligned windows are either shuttered or covered with wood grilles (pages 24 - 25, 129). Still higher, there are canopies or cornices, so prominently cantilevered that they almost meet at the center from opposite sides, thereby plunging the street in deep shadow, the penumbra cut by shafts of harsh, brilliant light as if by blows from a sharp knife.

The Ottoman house has no façade; rather, it ostensibly turns its back on the street or leans casually on the wall of its enclosure. Meanwhile, protected from indiscretions by this feigned disinterestedness, the house simultaneously keeps an eye on the street, constantly watching by the overhang's side windows, which, as part of a series, permit the person seated inside – merely by parting curtains with a flick of the hand – to observe whoever knocks at the door.

The façade, in every culture, is a surface on which the building and the world outside engage in dialogue. It is the membrane through which the natural elements penetrate – aridity and humidity, hot and cold, light and darkness – where people interact and affirm their social status. It announces by every conceivable means – position on the street and signboards, balconies and loggias, colors, motifs, styles, and fashions – the profession, rank, and wealth of the proprietor. In the Ottoman house, all relationships are mediated in the extreme, which is why the dwelling does not, properly speaking, have a façade. It opens to air and sun on the side of the courtyard. On the street side, however, it possesses no windows, except on the upper story, where the apertures are coupled in tiers, with those on the top treated like stained glass, so as to transmit a filtered, multicolored light above the heads of the occupants, and those below, originally free of glass and closed only with wood shutters, providing for the circulation of air (pages 22, 154 - 155). To eliminate all temptation, the lower windows may very well be equipped with sliding grilles made of wood (*kafes*, page 25). In this way, from behind screens, the inhabitants can communicate with their neighbors across the way, see passers-by, do business with peddlers by lowering a basket at the end of a rope or string. But all

encounters of a more direct sort must be successively filtered through the entrance door, the court-yard, the service area on the ground floor, the antechamber on the main floor above, and finally a reception room. Moreover, if, under the Empire, the proclaimed egalitarianism scarcely prevented deviations into personal wealth, the precarious condition of the latter in the face of absolute power rendered ostentation prudent, with the result that opulence revealed itself in stages, only gradually as one progressed towards intimacy. Thus, the social function of the façade was limited to the entrance door, often an imposing portal, utilizing an ensemble of codes designed to make anyone who enter-ed there understand the importance of the place (page 121).

THE EPHEMERAL AND THE ETERNAL

A dervish – according to legend – arrived as night fell at the palace of a potentate and asked if he could find lodgings in that inn. The servants reported his inquiry to the master, who, much offended, had the dervish brought before him to demand why he had called his mansion an inn. "Who lived here before thee?" was the reply. "My father," avowed the lord. "And before him?" "His father, and so on throughout generations," the master asserted. "Well, then," exclaimed the dervish, "how else wouldst thou wish me to call this place where so many have passed?" Jean Chardin, the Huguenot jeweler who has left us the best eyewitness account of Persia in the 17th century, confirms the moral of this story by writing that each of the lords of the Ispahan court, once he had succeeded his father, hastened to build a new residence, thereby abandoning the paternal house.

The need to emphasize the transitory character of human life, in every undertaking related thereto, became a fundamental principle of Ottoman civilization, especially in the synthesis it effected be-tween architectural creation and its materials. By contrast with the mosque and other public build-ings (caravanserais, baths, hospices, etc.), designed to endure and thus fashioned of stone for all eternity, the structures for sheltering the private lives of individuals are in wood, made to be rebuilt from one generation to the next. And this was true, first and foremost, of the royal precinct

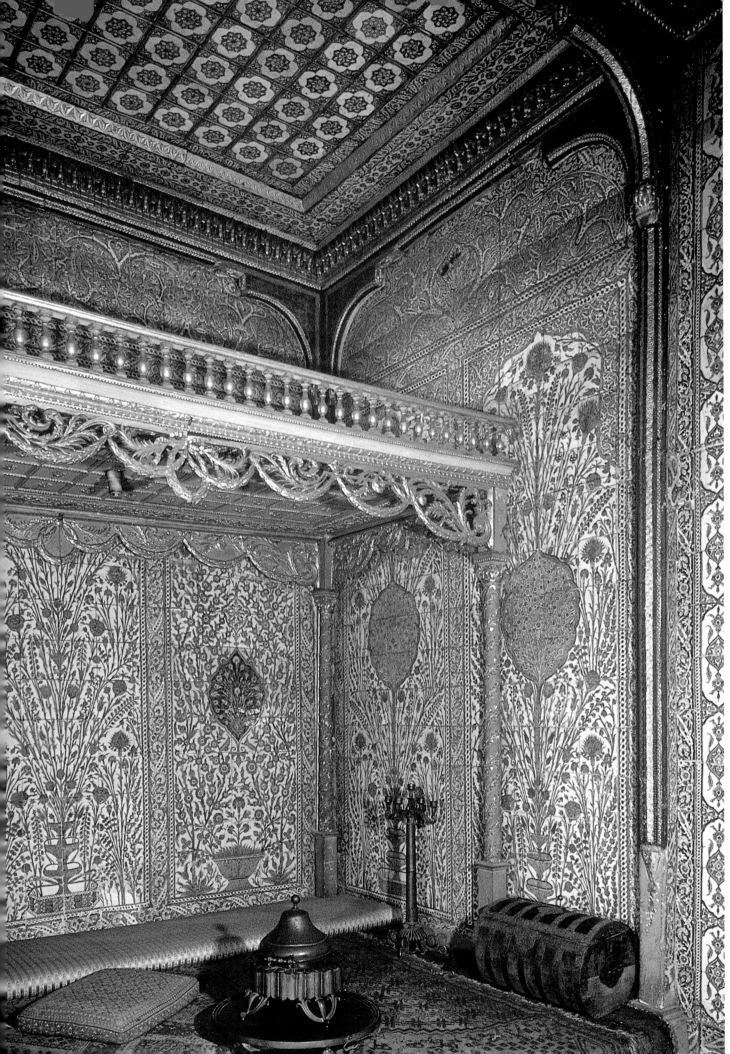

*I*f, with very
rare exceptions, Turkish
ceramic tiles remain
relatively small,
measuring from 25 to
30cm (c.10" to c.12")
square, they also lend
themselves to
combinations forming
large floral compositions.
Here, the room of
Roxelana (Haseki
Hürrem Sultan), the wife
of Süleyman the
Magnificent (1520-1566),
in Topkapı Palace.

itself, if one may make a subtle distinction between a masonry building dedicated to public life and the light materials used for kiosks and harems at Topkapı Palace. However abundant the material within the relevant geographical area, we cannot attribute the choice of wood to pure necessity, especially since the Ottomans gave up the use of brick that had been so prevalent in Byzantium.

The principle of impermanence, so beautifully realized in wood, a substance as ephemeral yet alive as humanity, saves the individual from all suspicions of lèse-majesté, thereby freeing him to push the material to the very limit of its capacity. Thus were born the airy kiosks or pleasure pavilions in orchards and on the edges of water, all the while that the house took off into lightness and pliancy, ready to submit gracefully to the proprietor's every wish. The fragile carcasses of walls empty of all superfluous material transformed rooms into light-absorbing lanterns (page 81); the play of beams and brackets would, thanks to the most daring cantilevers, impose spacious rooms upon cramped sites; and carpentry as fine as it was subtle combined grace with comfort in cleverly fitted-out doors, cupboards, and partitions. Finally, the whole would be crowned by sumptuous canopies or cornices and the geometric rigor of a four-part pitched roof, the last neatly pulling together all the various manifestations of the building in one, continuous sheath.

Yet, despite this dazzling mastery, the intrinsic modesty of the material brings us back to the essential issue: a simplicity of forms as a support for the permanence – the enduring nature – of daily pursuits. Here, then, is where the synthesis of the ephemeral and the eternal occurs. Constructed spaces are reproduced endlessly but always based on the same principle. Generations, self-renewing, come and go in order to relive the same quotidian experience, tirelessly repeating the cycle of life through which the human species is aware of existing for the purpose of bearing witness to the power of its Creator. Like little else, sturdy though perishable wood gave renewed proof of its congruence with this way or conception of life. The terrible fires that ravaged Istanbul, as well as provincial cities – conferring upon a wood-built house a life expectancy of some thirty

Ottoman ceramic art (FOLLOWING PAGES) attained its apogee in the second half of the 16th century with the discovery of colors fired under glaze, a process that renders them both transparent and delicate, and with the invention of the color coral red, the manufacture of which lasted only a half-century in the workshops of Iznik before it was lost, evidently forever. Beginning in the 17th century, Kütahya replaced Iznik as the center of ceramic production in Turkey.

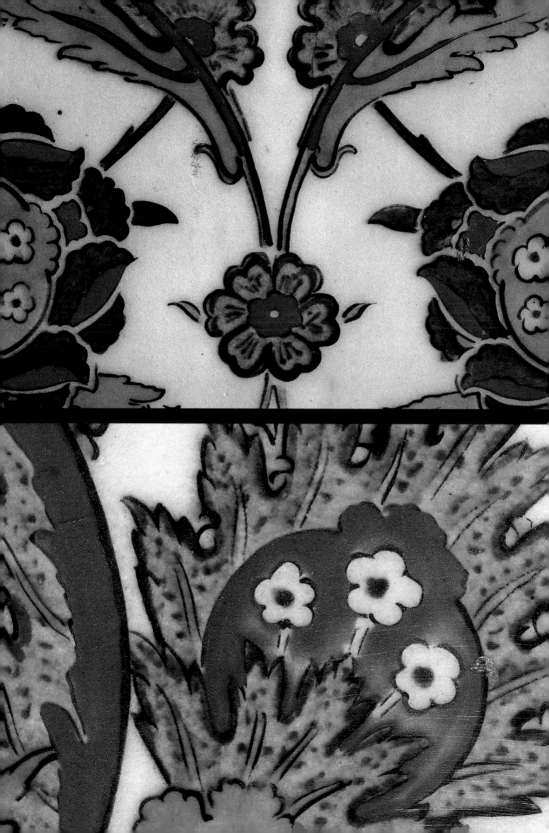

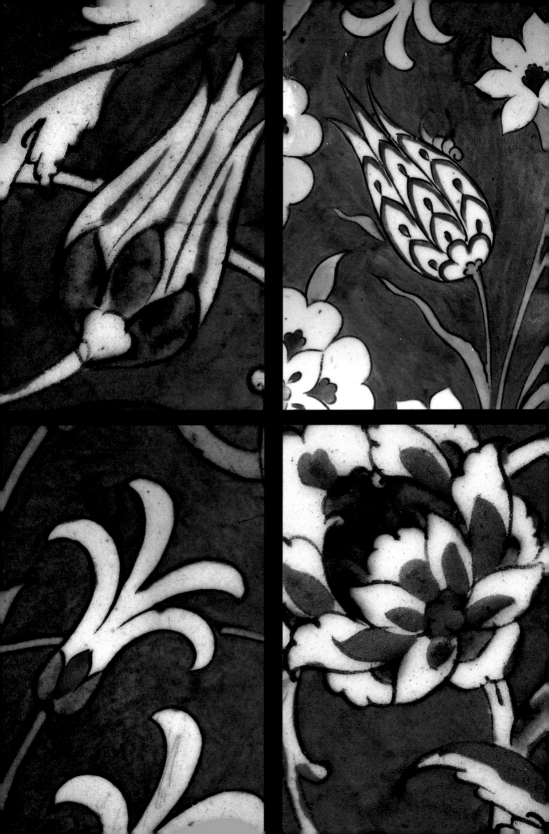

years, while also stressing the futility of all notions of timelessness in the world here below – gave comfort to the occupants in their search for the eternal within the ephemeral.

THE MOBILE AND THE IMMOBILE

Jean Thévenot, the 17th-century French traveler, tells us of how astonished the Orientals were at the European habit of walking the full length of a room or of pacing up and down in an antechamber. Then, he added that the Turks sat down as soon as they entered a room and rose only when ready to leave it. The same observation has come from the tradesman or merchant Jean-Baptiste Tavernier, a contemporary of Thévenot, this time in relation to gardens. These contained none of the footpaths characteristic of Western gardens, for the simple reason that Orientals did not stroll there, but instead sought a shaded spot as soon as they arrived and settled down, remaining until it was time to leave. Two witnesses, among countless others, to the Oriental mode of existence, which could be seen as quietude or as immobilism, depending on the point of view. While the Ottomans mocked the inability of Westerners to remain still, Europeans looked with condescension upon the "kief" (*keyif*): Turkish indolence.

This could be seen as contradictory, given the doubly nomad experience brought by the Ottomans, who subsumed not only the tradition of the Central Asian Turks but also that of Arab Islam at its origins. But it is precisely herein that resides the opposition between the movement of active life and the quietude of private spaces. For humanity, moreover, the latter is the sign *par excellence* of wisdom and social distinction. The genuinely powerful man, having contemplated the agitation all about him, cuts with a single gesture, decides with one word. For a woman, immobility is the sign of opulence, but also of authority. The true matron manages her household without stirring from her place, through orders as succinct as they are well phrased and delivered to a mob of domestics. The system is therefore one of concentric circles, progressing from the great bustling world at the perimeter towards the total quietude at the center, a system that in turn yields the internal disposition of the

The tapestry-covered and cushion-strewn banquettes that invariably run along three sides of living rooms are called sedir. In the West, they often go by the name "sofa," an adaptation of the Turkish word for "waiting room." Modernization has broken the banquette into canapés, which today replace the sedir in contemporary Turkish houses.

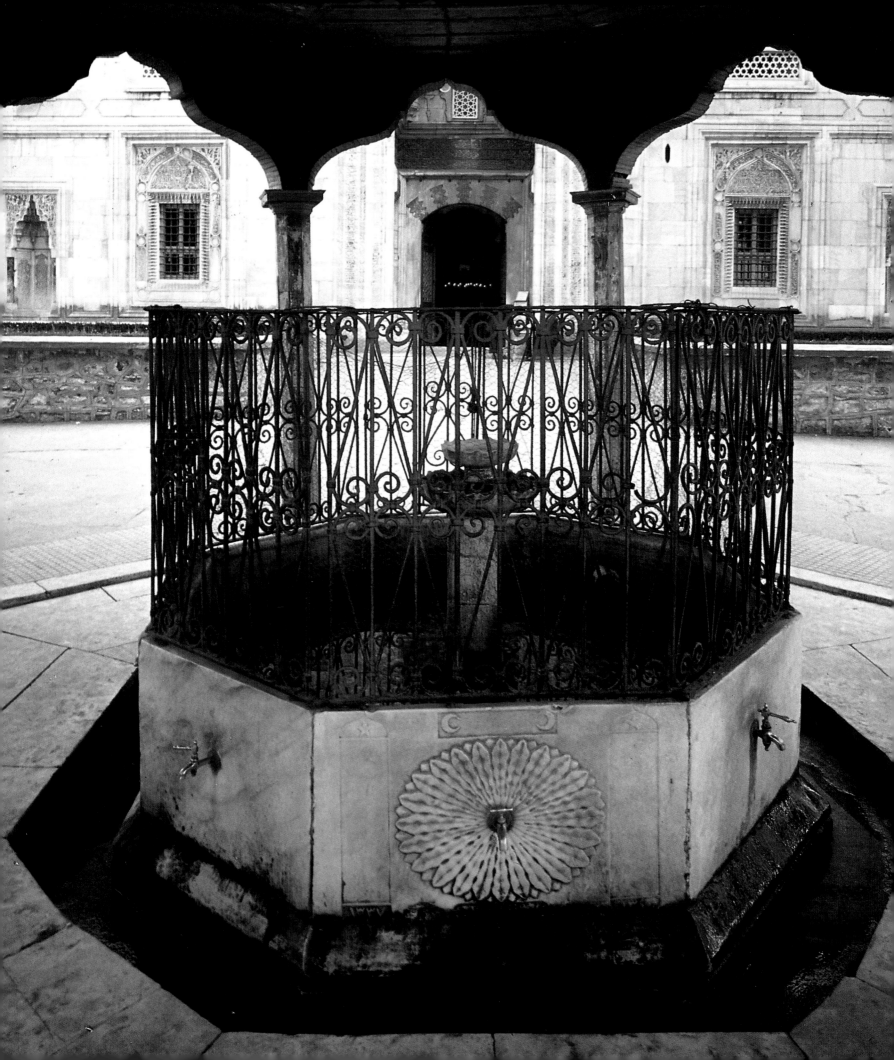

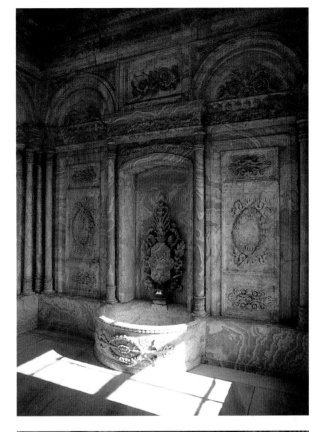

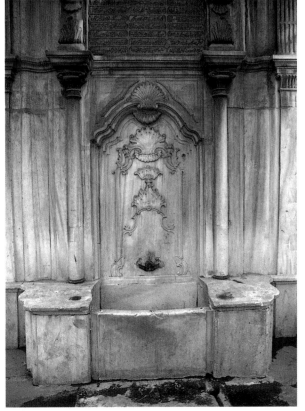

\mathcal{W}ater, the
purifying element so
important to Islamic
ritual, makes its presence
felt in Ottoman
architecture by engaging
the five senses all at once:
the sounds of flowing,
the smell of humidity,
the taste and feel of
coolness, and the sights
reflected in pools and
fountains. Here,
an ablution basin in the
courtyard of a mosque
(OPPOSITE), an alabaster
fountain in Dolmabahçe
Palace (ABOVE), and a
public fountain (LEFT).

Ottoman house. The masters live on the top floor, while the domestics work on the ground floor and sleep, most often, on the mezzanine, but also in the courtyard or in the antechamber of the main floor, according to their sex and the degree of their closeness to the masters. The ground floor is composed around a courtyard paved with flagstones (*avlu* or *taşlik*, pages 116 - 117), a place open to the sky as well as to the garden. It can be entered from the exterior directly, wherever there is a door at the center of the building, or indirectly, provided the garden wall has a gate. Arranged about the courtyard are the various spaces for work and service: cooking, laundry, stables, toilets. At the bottom of the courtyard unrolls a garden that, depending on its size, includes a vegetable patch, an orchard, and spaces for pleasure, together with wells, a basin, or fountains.

Stairs, frequently separate, lead to the mezzanine and the upper story. The house usually includes an apartment for male guests (*selâmlık*) wherever the master holds a public office, requiring him to receive at home; otherwise, this space may be reduced to a single room on the main floor with a separate entrance. As for the rest of the private quarter, it belongs to women. The stairs give access to the main floor, either from the exterior by way of a space in the rear part of the house, a space open onto the courtyard and called *hayat* (pages 150 - 151, 160 -161), or on the interior, where they debouch into a central antechamber, known as the *sofa*, a room day-lit on one or several sides, or possibly even illuminated indirectly and from one side only (pages 88 - 89). In either case, the spaces are intermediate ones, reserved for the everyday activities (weaving, sewing, etc.) of the "secondary" members of the family – children, daughters, daughters-in-law, and their servants – as well as spaces for circulation, since it is into the *hayat* or the *sofa* that the doors of all the rooms on the floor open.

It follows, therefore, that these unique spaces are often divided into subspaces, set apart by a step (*seki*) or platform where one removes shoes (slippers, inasmuch as shoes will already have been left at the entrance to the house or at the bottom of the stairs) in order to pass from a subspace for coming and going, where one stands, to a subspace for work, where one remains seated or departs

◆

altogether. In a *hayat*, subspaces are found either at the extremities overlooking the courtyard – in which case they become *köşk* and may be partially or entirely glazed (pages 160 - 161) – or inserted between two rooms, where they form an alcove on the street side, there becoming an *eyvan* (pages 150 - 151). Similarly, the *sofa* may be reduced to a dark space situated at the center of the house and open to rooms on every side; it may also stretch across the floor, from the courtyard to the street, while giving access to rooms on the left and right; or it may be T-shaped, or yet formed like a cross, with wings or alcoves making an *eyvan* (pages 90 - 91), and provide entrance to rooms in the corners.

As for the *oda* or rooms served by the *sofa*, they bring us to the heart of the house. Among them is the principal room called *başoda*, located at a corner so as to have two walls with windows, which most often results in a two-sided overhang on the street façade (pages 119, 128). The *başoda* is ente-red by way of a corner door, diagonally facing the corner flanked by windows (pages 152, 154 - 155). Once again, the interior space is hierarchized. Thus, the part near the rear wall, where niches and cupboards (*dolap*) have been installed, is for service, all of it separated from the main part by a step (*seki*), a balustrade, and even a colonnade terminating in an arcature on the ceiling. Moreover, the ceiling above this – usually square – part is molded, painted, or richly treated in some other way (pages 148 - 149, 153, 154 - 155). A low banquette (*sedir*), covered in carpet, embroidery, and a generous array of cushions, runs along the lower section of three walls, including the two with win-dows (pages 72 - 73, 90, 92). But here as well, not all positions are equal, for the place of honor is the one at the corner farthest from the door and between the two windows, where the master or the mistress, propped up on cushions, receives callers and manages the household.

This rigid hierarchy, linked to the status of persons, stands in marked contrast to the mobility of the household's daily functions. Thus, the Ottoman dwelling possesses neither a room nor any other space for taking meals or for sleeping. Bedding, stored during the day in cupboards, is retrieved at night and spread over the floors of the *oda*, therewith turned into bedrooms. Too, a pewter or cop-per sheet, placed on the same floor, or on a low trestle table, serves as a support for meals taken in

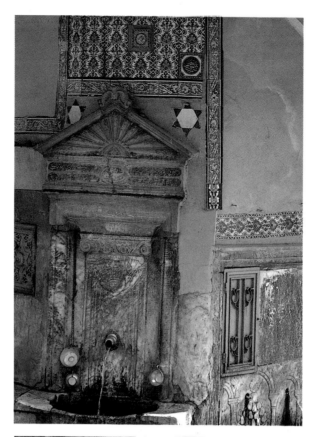

*P*roof, should

this be required, of the

importance placed upon

water may be found

in the imaginative décor

surrounding it,

a mobilization of the

entire arsenal of Ottoman

art: bas-reliefs in stone

and marble, mosaics of

brick, calligraphy

unfurling sentences and

entire passages from the

Koran, and, finally,

ceramics, with the colors

and floral motifs of the

East evoking an ideal

image of Paradise,

abounding with verdure

and water.

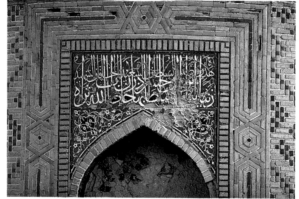

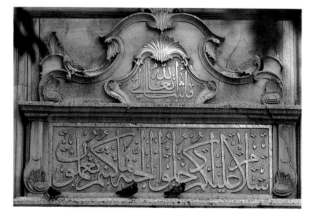

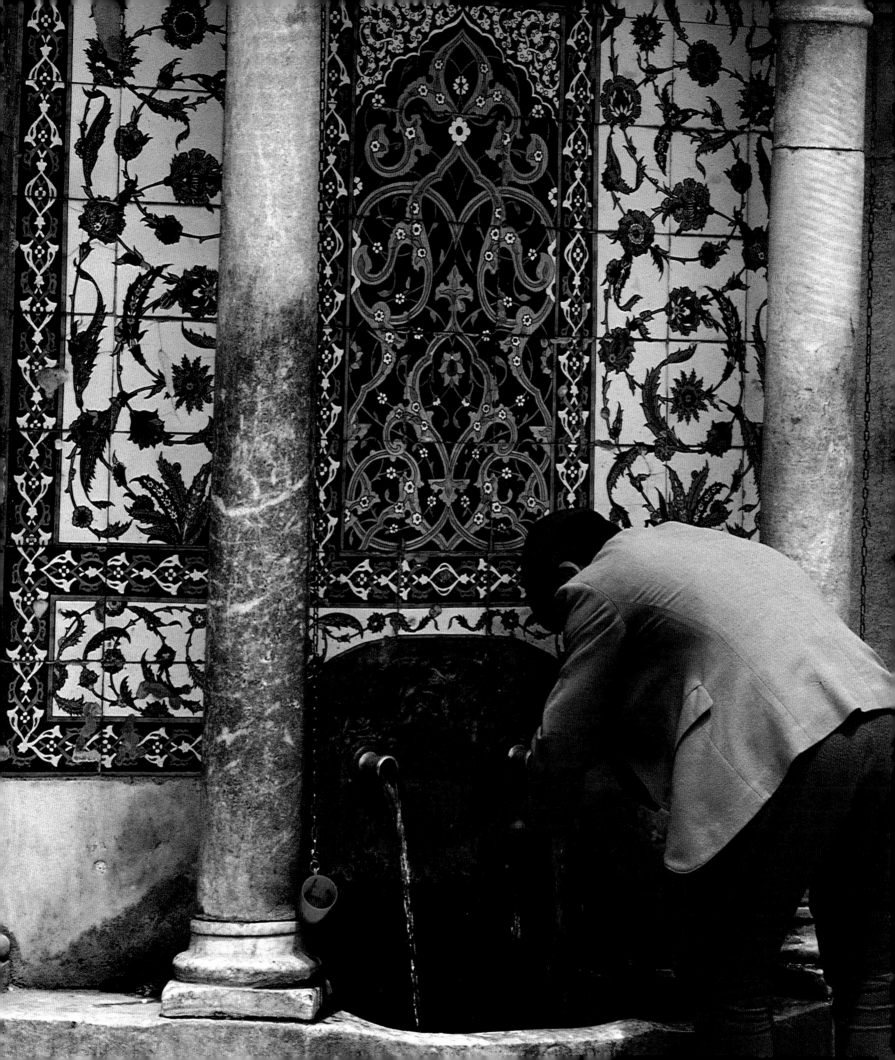

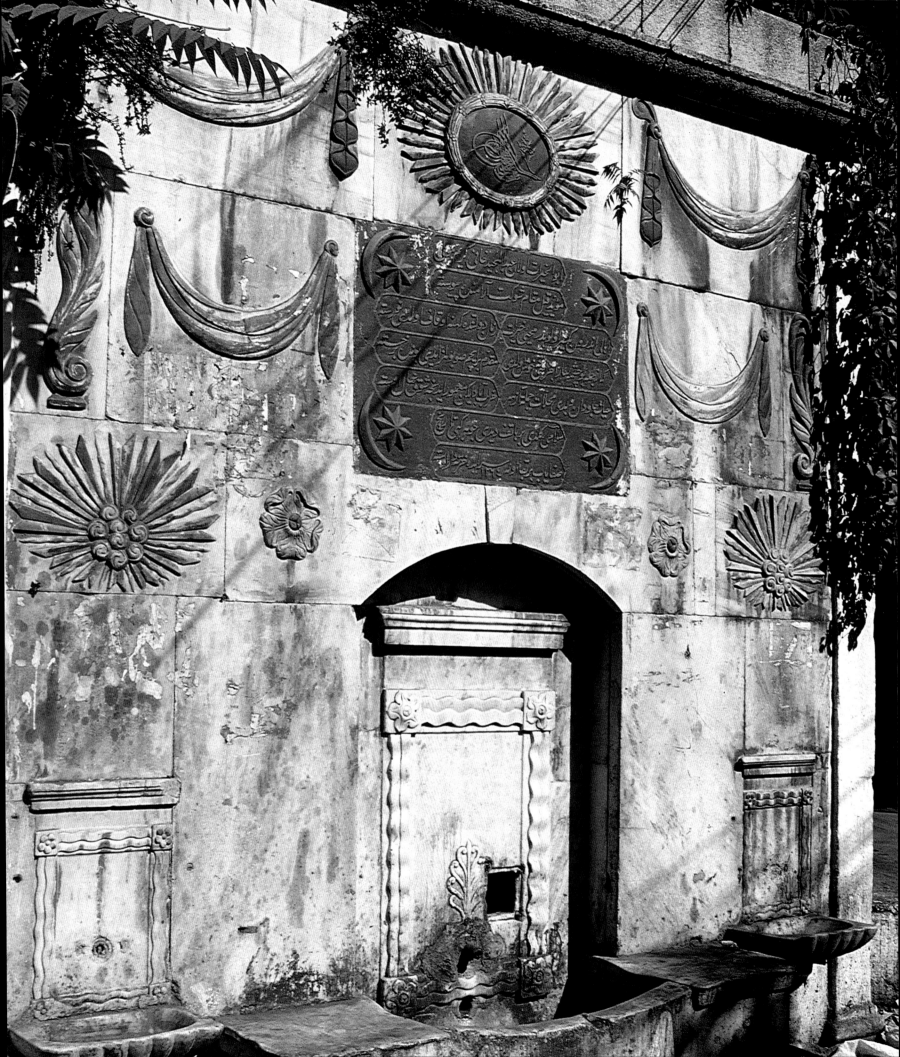

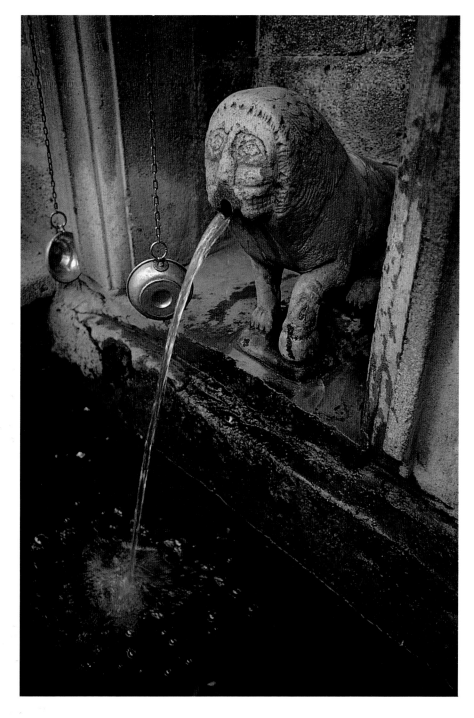

The public fountain is the offering par excellence of the wealthy man. A high functionary, a respected notable, or a rich merchant takes account of his fellow citizens in order to arouse their gratitude and thus their prayers of thanks, which will in turn assure him the opening of the doors to Paradise. Consequently, he will not fail to inscribe his name thereon in some suitable manner, the better to perpetuate his memory in that of posterity.

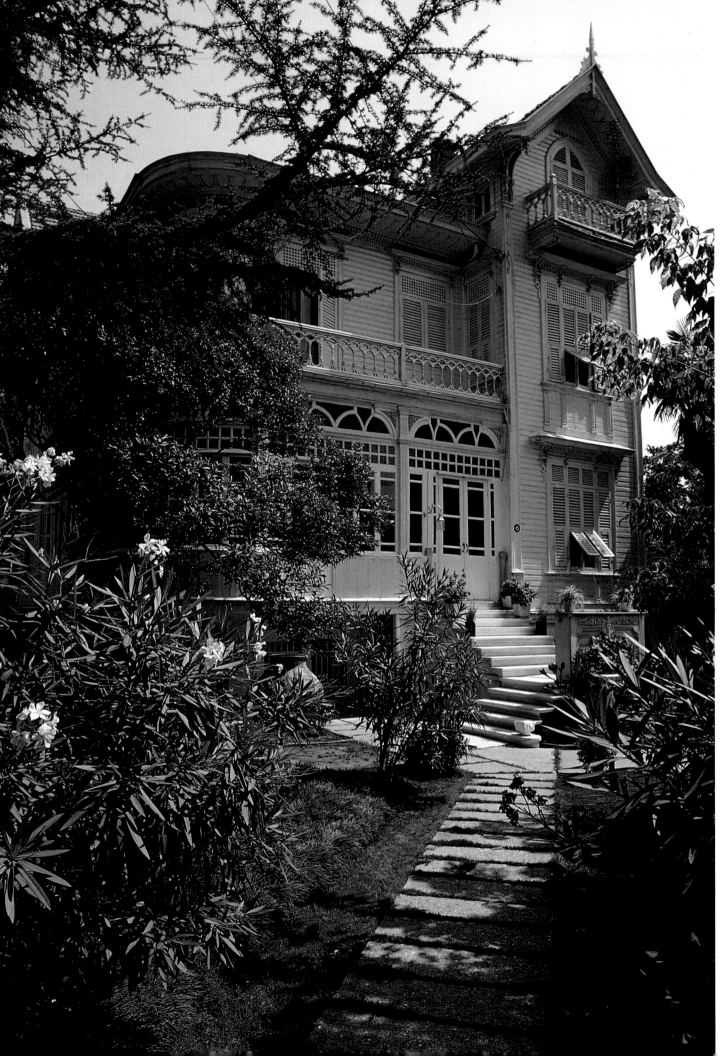

When the traditional Turkish dwelling evolved into a holiday house, the garden retained its protective role. Resisting the obsessive alignments of the French model, householders prefer informal, overgrown, lush foliations somewhat like the labyrinthine spaces of the English garden.

the same rooms. This multiplicity of function brings flexibility to the otherwise formal order of the Ottoman residence. It prevailed in homes ranging from the most modest to the imperial palace, where the Sultan, possessing neither a dining room nor a specific bedchamber, decided to take his meals or to retire for the night precisely where he was working.

THE YALI, THE KONAK, AND THE VILLA
DWELLINGS ON THE WATER'S EDGE

Ten years after taking Constantinople, Mehmet II the Conqueror chose the promontory on the outskirts of the city facing the Bosphorus – a place bathed by the Golden Horn as well as the Sea of Marmara – and there had his palace built. He surrounded himself with gardens and constructed a series of edifices about a succession of courtyards that progressed from the most public to the most private. Following the first courtyard, designed for services and the military, the second was reserved for administration – a place where twice a week the Council of Ministers (the imperial divan) met – whereas the third was dedicated to the sovereign's residence. To the left of this, oriented towards the Golden Horn, the Conqueror had his winter quarters built, in a square, massive structure divided into equally square rooms, each with a portico. On the right, overlooking the open sea, he erected a summer pavilion, together with a *hamam*, and a corner terrace providing a view of the Bosphorus at its mouth. Elsewhere about the courtyard were aligned the dormitories for pages and eunuchs, while at the center, before the door leading to the second courtyard, stood the throne room for the reception of ambassadors and dignitaries. In all, this courtyard consisted of an ensemble of independent structures more or less linked together by a portico running entirely round the enclosure.

Succeeding Sultans completed the complex, mainly by bringing in the harem, or women's quarters, until then located at the center of the city, which resulted in a continuous, proliferating extension of the palace on the side facing the Golden Horn. The charm of this ensemble lies precisely in the absence of a fixed, preestablished plan. While banishing symmetry and every other aspect of façade

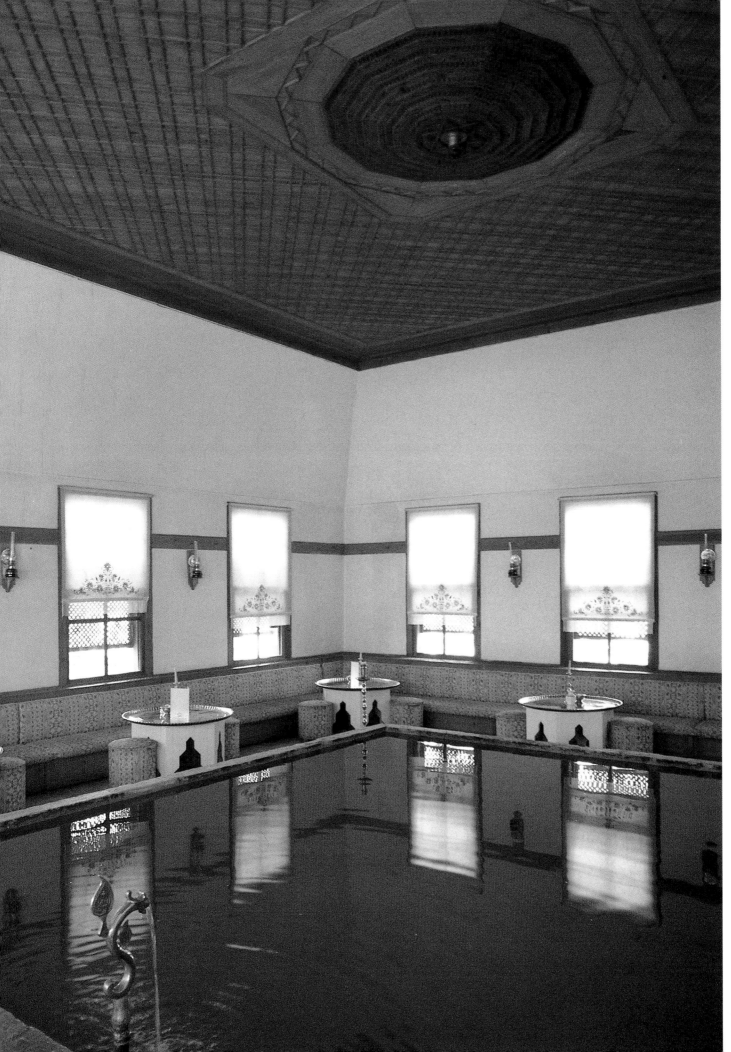

*W*ater often surges up at the very heart of the living space, in the form of fountains and wall cascades — but also in pools. Builders had to overcome the structural problem of placing such a feature at the center of an upstairs room on the main floor, as here at Safranbolu, in a traditional house now converted into a hotel.

or perspective, the cobbled-together palace nonetheless achieved majesty through the quietude of its forms and the openness of its spaces – in brief, by the tranquil presumption of power rather than by some grandiloquent assertion of it, a show more suitable to feudal lords than to the master of the Empire of the East.

Nevertheless, if the principles are already there, one searches Topkapı in vain for the future Ottoman house. Or, rather, we would find it less in the core buildings than in the light, wooden kiosks, structures gradually run up in the garden and on the edge of the sea, each composed of a vast *oda*, generally open to the exterior, accompanied by an embryo of service rooms and the whole crowned by a pyramidal roof with huge eaves.

The Sultans also fashioned light structures in their gardens along the Bosphorus, sometimes content merely to install the entire court there in a "palace" of tents pitched and then folded in the same day as a kind of enchantment. Bit by bit, somewhat more permanent structures appeared, forming slight pleasure palaces for the duration of a single reign. Dignitaries and courtiers followed suit, fleeing the old city ravaged by fire and regularly decimated by plague. Thus, it was probably on the banks of the Bosphorus that the Ottoman house came into being or, at least, attained its maturity. But it was undoubtedly from the hillsides and interiors of gardens that the dwelling would progressively make its way towards the great bodies of water. There, gradually, it ceased to be a holiday house or pleasure pavilion and became the principal residence of officials commuting every day to the capital. Traveling in caïques powered by several pairs of rowers – the number depending on the passenger's rank – they took advantage of the most direct route to and from their homes. At the end of the 18th century, this imperial waterway became a wide avenue, a Grand Canal, bordered by dwellings (pages 6, 9, 78 - 79, 84 - 85, 106 107) called *yalı* (from the Greek *ghialos* meaning "edge of the sea") and plied by boats of every sort.

By this period already, the sisters and daughters of the Sultans were having sumptuous palaces built at seaside, where, behind Baroque or Neoclassical façades, they perpetuated the same plan of suc-

cessive *sofa* giving access to *oda*, just as the harem accommodated itself to harpsichords and Parisian fashions. Midway through the following century, the Sultan took a great leap and, departing Topkapı forever, established his palace on the Bosphorus. This consecration of site – as so often happens – proved to be the beginning of the end. Occidental influence was already approaching flood tide – with Dolmabahçe, the palace in question (pages 72, 75), erected by virtue of a loan from Great Britain – and the Ottoman way of life would soon drown in it.

PEASANTS, BUSINESSMEN, AND NOTABLES

The Turkish provinces succumbed to influence from the capital just when the latter was loosening its command of the countryside. The steady weakening of the imperial administration in the 18th century gave rise to a host of local potentates: tribal chiefs, self-appointed governors, tax collectors, or simply notables, heads of villages. The Ottoman bureaucracy, incapable of controlling this element, was content merely to collect a fixed tax from each local leader, leaving him free to assess his constituents and the possibility of keeping whatever surplus he might extract. Greek furriers of Kastoria, big landowners of Gjirokaster, Bosnian merchants of Mostar, Turkish or Macedonian tradesmen and artisans of Ohrid and Monastir, Bulgarian notables of Plovdiv, Jewish drapers of Salonika in the Balkans, Greek producers of resin in Chios, of muscat on Samos, of olive oil at Mytilene in the islands, Turkish and Greek silkworm breeders in Bursa, Armenian wool-traders of Ankara, Turkish and Armenian weavers and tinsmiths of Tokat in Anatolia – all competed with one another not only in business but also in splendid houses – *konak* – the supreme exterior sign of success.

This *de facto* regionalization of the Empire appears, oddly enough, to have triggered a diffusion of the Istanbul house as a model, thanks to eagerness on the part of local potentates and notables to imitate the life-style of the capital. Wood became the standard material for the main floor, even if, for reasons of security and prestige, stone was often employed on the ground floor, while the principles

of distribution – the order or arrangement of the *oda* – remained largely the same from one end to the other of the entire central part of the Empire. Istanbul Baroque spread its interlaced volutes and flowers on *dolap* and ceilings from Ohrid to Tokat, with the beacon-like role of the capital symbolized in the idealized view of Istanbul that invariably ornamented the far wall of the *başoda* (pages 148 - 149), from the hinterlands of the Adriatic to those of the Black Sea. At the end of the 19th century, how-ever, it was Westernization that increasingly invaded the provinces, sometimes directly, through ports – such as Izmir or Salonika – wide open to European influences. More often, it was still the capital that played the dominant role in the spread of models and ideas – but with a marked difference. Now, the driving force behind the change came from the Christian communities, the groups most responsive to Westernization, albeit soon followed by the Muslim notables. Thus, the *hayat*, deemed too rural and uncomfortable, because exposed to the elements, would be replaced by the *sofa*, an antechamber that tended to become a salon (pages 196 - 197), while the *oda* progressively acquired specific functions, such as those of a bedroom in the Occidental manner.

Above all, it was the façade that underwent the most spectacular shift, in this case towards a desire for individual appearance and affirmation, characteristic of the rise of Western values. The traditional Ottoman house – which was mainly a play of volumes overflowing the upper story in several directions, thanks to cantilevers or overhangs – now oriented itself towards a principal façade on the street. Even if the main floor remained upstairs, the concern to save visitors from having to pass through service areas placed the entrance on the first rather than the ground floor, thereby creating an exterior stairway, which became a particularly well-tended element of the façade. Next, the stairs, sometimes double-ramped, joined with the entrance door centered between two windows (lighting what was no longer a *taşlık* but instead a vestibule) and under the overhang of the principal room – itself situated equidistant from the adjacent spaces – to create the axis of a symmetrical façade. Soon this order of things would spread everywhere from rental apartments to rectilinear streets, which began to proliferate around the turn of the century. Only wood persisted to the end – which

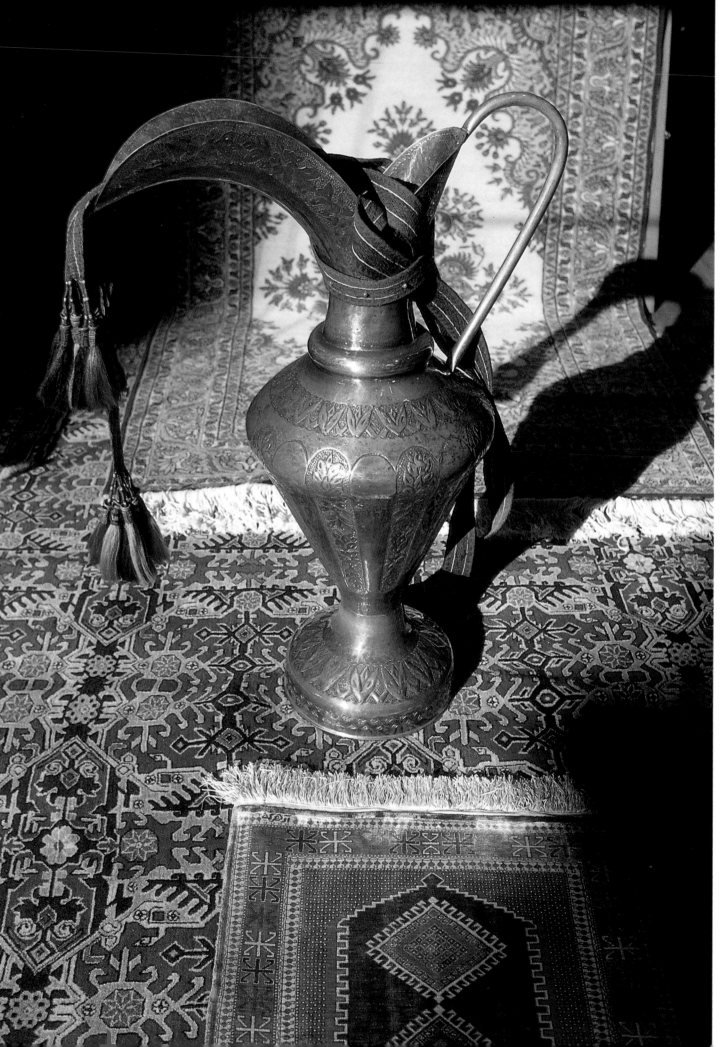

*O*verlying
the simplicity of the
Ottomans' architectural
language is the infinitely
subtle discourse of
the decorative element,
applied to supports as
diverse as woven linen,
terra-cotta, chased metal,
and carved stone.
Here, a copper ewer and
a prayer rug (seccade)
have been placed upon
a carpet ornamented
with motifs from the
steppes. Such carpets are
known as "Lottos" after
the Venetian painter
Lorenzo Lotto, who often
included them in
his pictures.

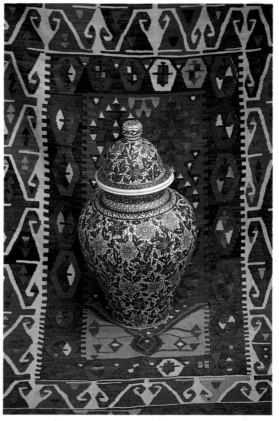

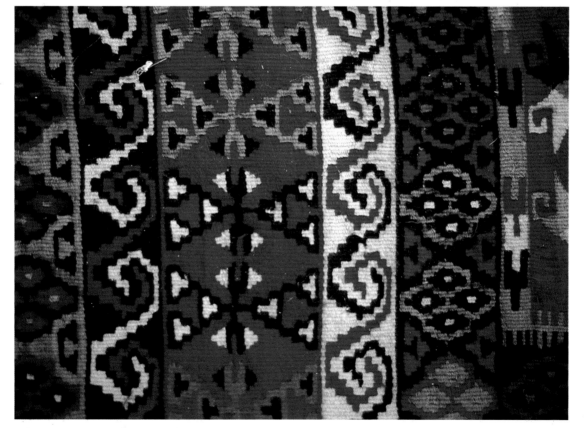

*T*he kilim,

rugs without nap,

are distinguished by their

geometric motifs, which,

while close to the

nomadic tradition, in no

way prevent their being

extremely rich and

complex. For the most

part, they embellish walls

and banquettes.

The Islamic rules governing pictorial art came into effect rather gradually. More rigorous with regard to the human image, which remained almost entirely confined to books of miniatures, they would tolerate the representation of animals and permit everything in the vegetable kingdom and the realm of inanimate objects. As a result, floral motifs and landscapes are frequently found on the interior walls of important dwellings.

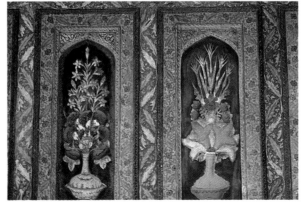

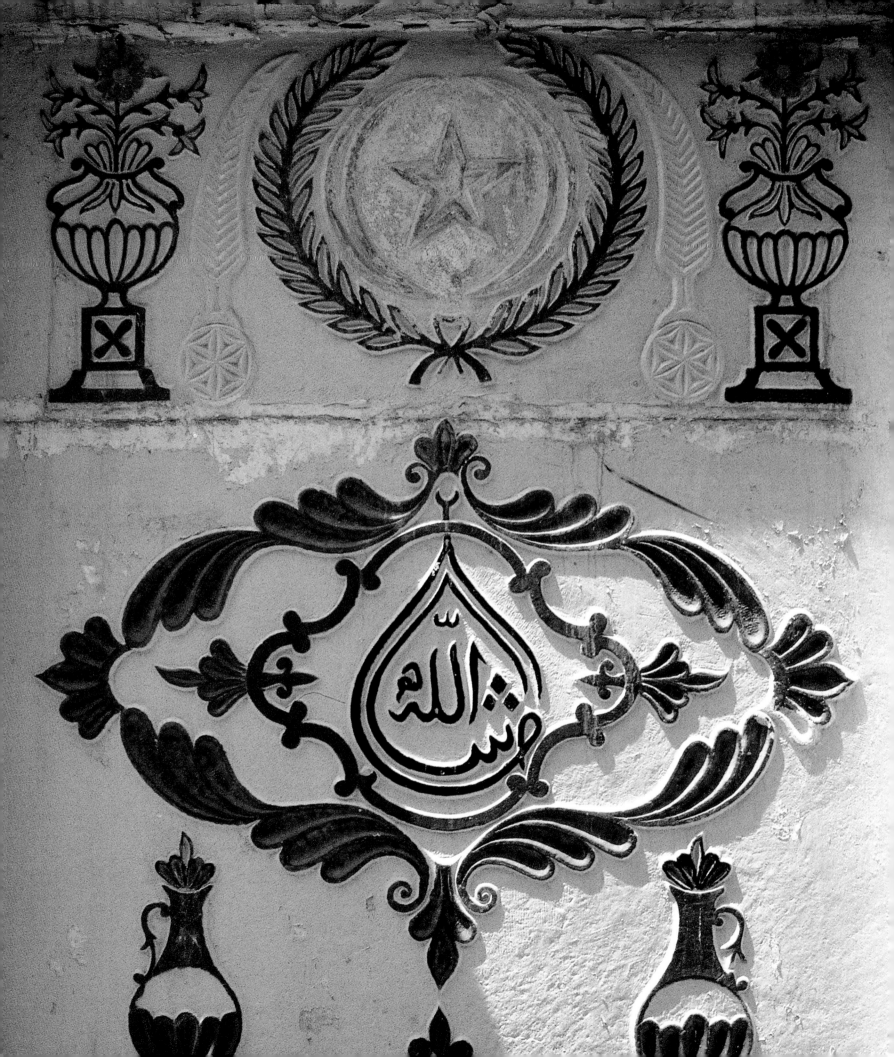

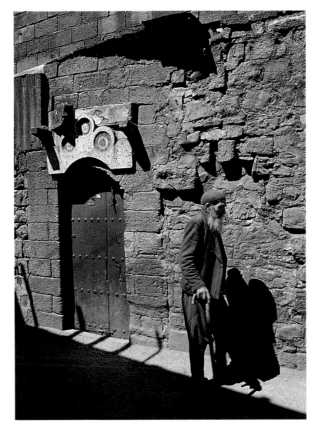

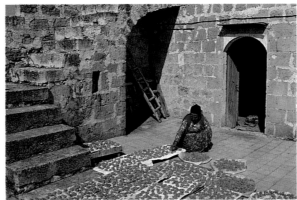

The system of
impasses or dead ends,
of courtyards and vague
or undefined areas runs
oddly counter to the
principle of closure in the
Turkish house, which
requires all manner of
intermediate spaces,
domains for domestic
work, but also spaces for
play and relaxation.

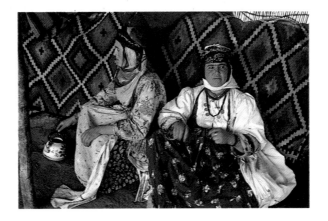

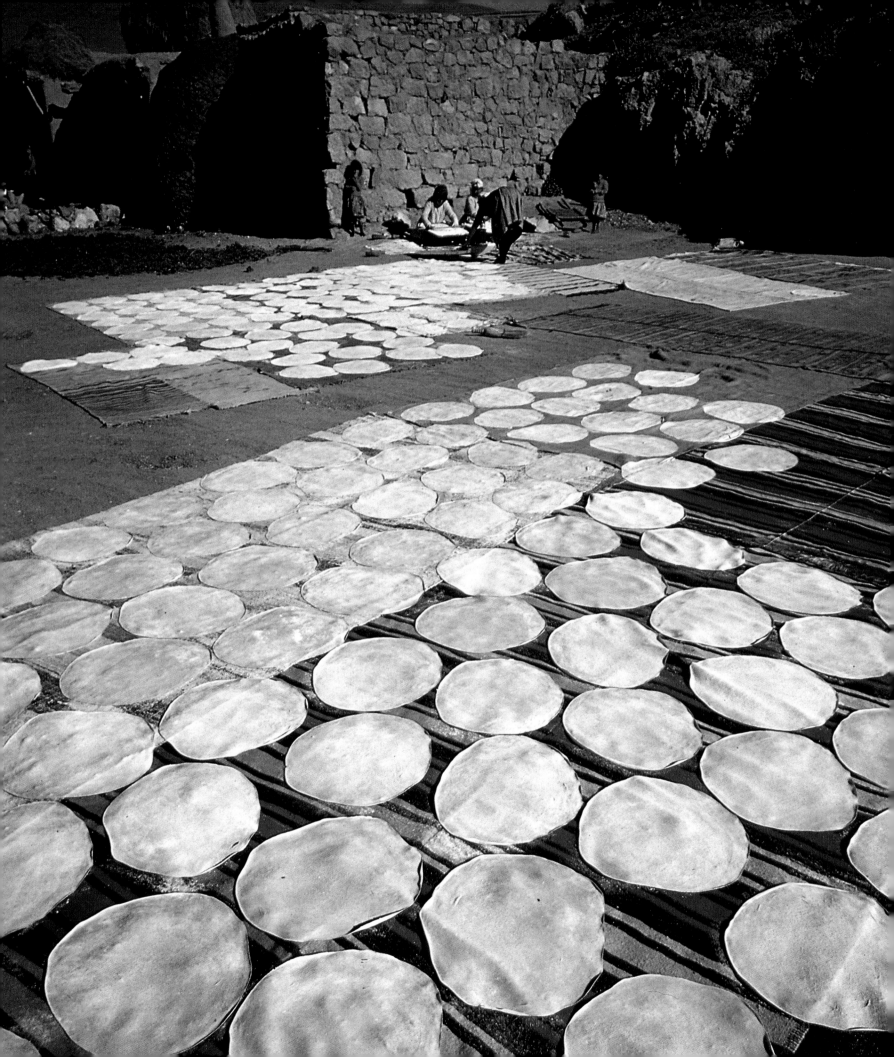

occurred during the 1940s in Anatolia – the irreplaceable material for a dwelling that would cease to be Ottoman and become Turkish.

THE CHARM OF WOOD AND THE WARMTH OF WOOL

With the fracture of the Ottoman Empire into national states, one of which is the Republic of Turkey, the Ottoman house became Turkish for the simple reason that the Turks, more than any other group, assumed its heritage. Even as the Balkan nations claimed to be the originators of the house, which thus made it variously Greek, Bulgarian, Macedonian, etc., they could not entirely escape awareness of its belonging to an Oriental culture they now challenged. Consequently, these countries sometimes hesitated to take on the responsibility for conservation; furthermore, they refused to consider the Ottoman dwelling a source of inspiration for a modern habitat. Meanwhile, the Turks, who insisted quite as much as the others on discovering exclusive ethnic qualities in the Ottoman house, continued to reproduce it in the provinces until the diffusion of reinforced concrete after World War I. Yet, while claiming the house as their very own archetype, the Turks have not been too careful about keeping its contemporary development free of contradictions or trial-and-error experiments.

The Ottoman dignitaries, although still resident in their *yalı* on the Bosphorus, launched upon the modernization of the capital. For this, the devastating fires that regularly swept through Istanbul provided a prime opportunity. Beginning in the mid-19th century, every quarter ravaged by fire became subject to systematic redevelopment, consisting of grid-plan streets, standard parcels of land, and *masonry-built* row or terraced houses. The new material would prove the most difficult aspect of the campaign. Citing cost as their excuse, the citizens of Istanbul insisted upon wood, with brick used only for a fire wall erected between adjoining houses. The pretext was false, at least in part, because Ottoman pashas and aristocrats paid whatever was necessary in order to have their façades designed after the latest imported styles – including Neoclassicism and Art

Nouveau – all the while that they adhered to wood construction, right to the end of the Empire. Nonetheless, fire by fire, the planned developments succeeded in obliterating the ancient urban tissue of Istanbul. Other programs, on the outskirts of the city, introduced new Westernized quarters, where Turks, Christians, and Jews mingled in rental blocks of flats several stories high. Even if the *sofa* of the traditional house had a final surge, right in the middle of European-style apartment buildings, it was clear that the Ottoman house had had its day. The dwelling disappeared from the capital right along with the last Sultan, and if it survived a few more decades, thanks to inertia, the directors of the new Republic, by creating a new, resolutely modern city at Ankara, seemed determined to efface all memory of the past.

When the last pashas died in their *konak*, which their heirs hastened to sell to real-estate speculators, nothing, it seemed, could arrest the inexorable advance of modernity. True enough, wealthy Turkish tradesmen and industrialists have always preferred the individual residence to the apartment house, but the model had now become the suburban American villa. Meanwhile, those who inherited the Bosphorus *yalı*, though without the right to demolish, preferred to torch their properties for the sake of replacing them with villas built of concrete and glass. Sudden awakening came late, and again possibly from the West, where the protection of patrimony had emerged as the order of the day – but never mind. It began with the *yalı*, which, moreover, a few owners had already and religiously preserved. Other houses were bought back, carefully restored, and inhabited. Then, more and more, rare houses still surviving in old quarters were sought out, together with those in small provincial towns.

However, living in the old entails a degree of servitude – to the problems of comfort, of maintenance, etc. Further, the desire to dwell in this fashion is limited by the number of recoverable buildings. Thus, quite apart from the question of conservation – indispensable as this may be – there remains the issue of the willingness and capacity to seek a viable synthesis of the traditional and the contemporary. Some remarkable architects have taken on the challenge, and enlightened persons

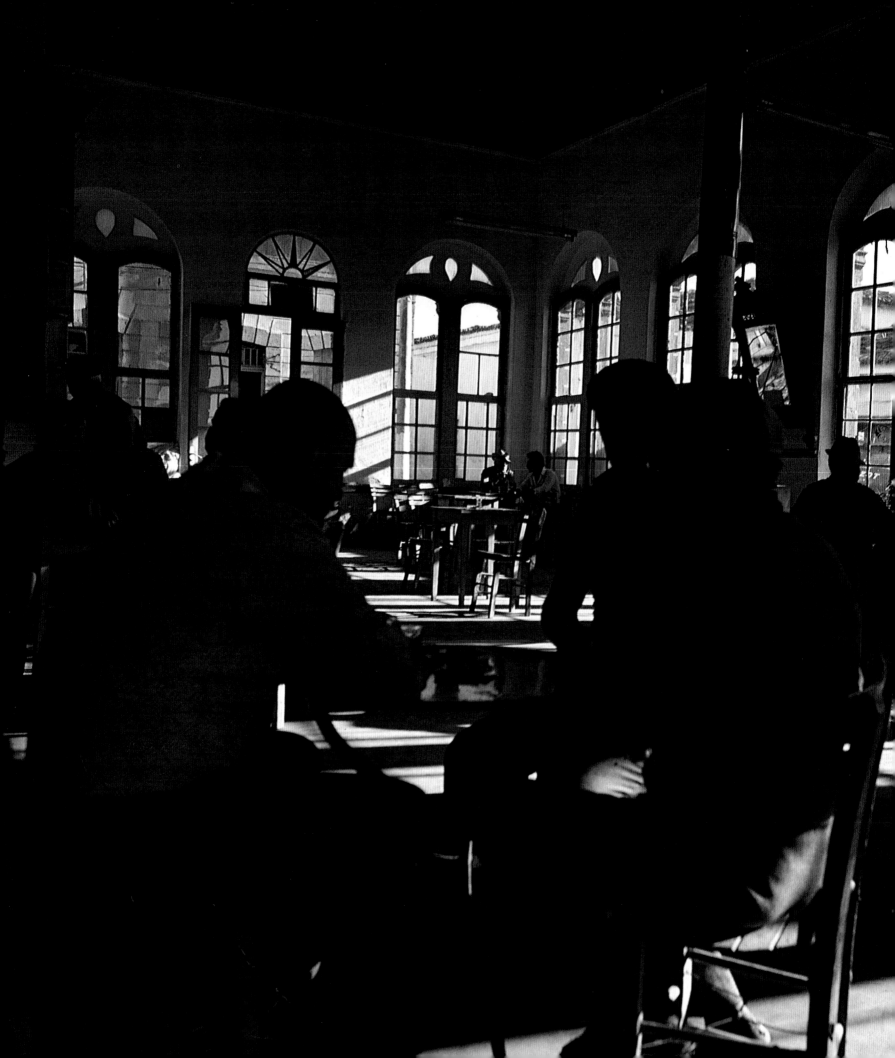

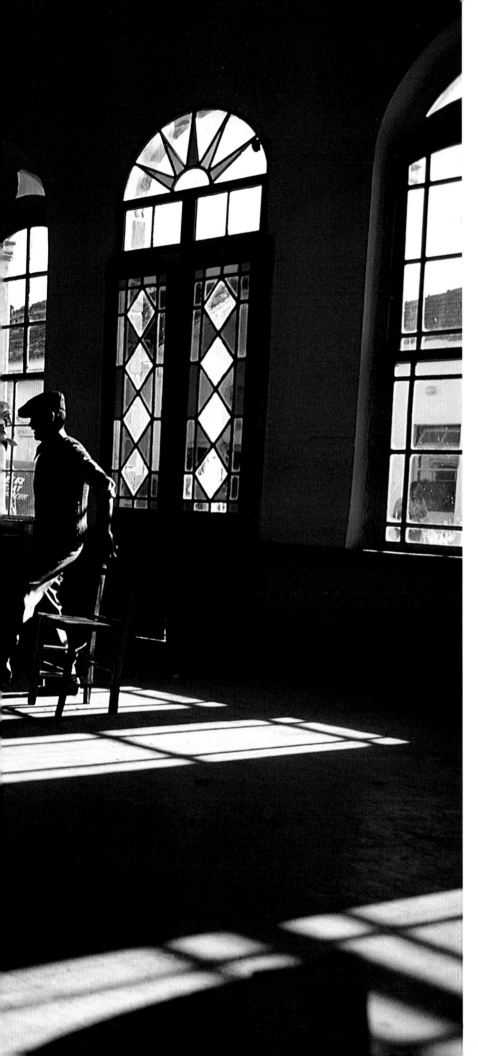

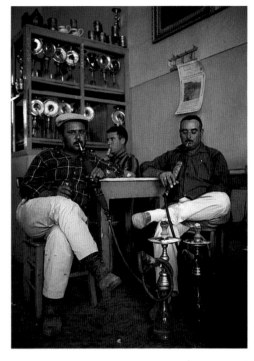

*W*herever the Turkish house is reserved exclusively for family activities (other than the great mansions with a wing known as the selâmlık *set aside for male guests), the public coffeehouse becomes the traditional and only meeting place. Here, the patrons drink coffee – and, for the last century, tea – smoke pipes or the* nargile, *play cards, dominoes, or backgammon, discuss politics, or transact business.*

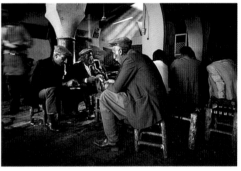

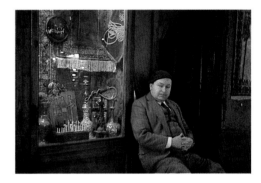

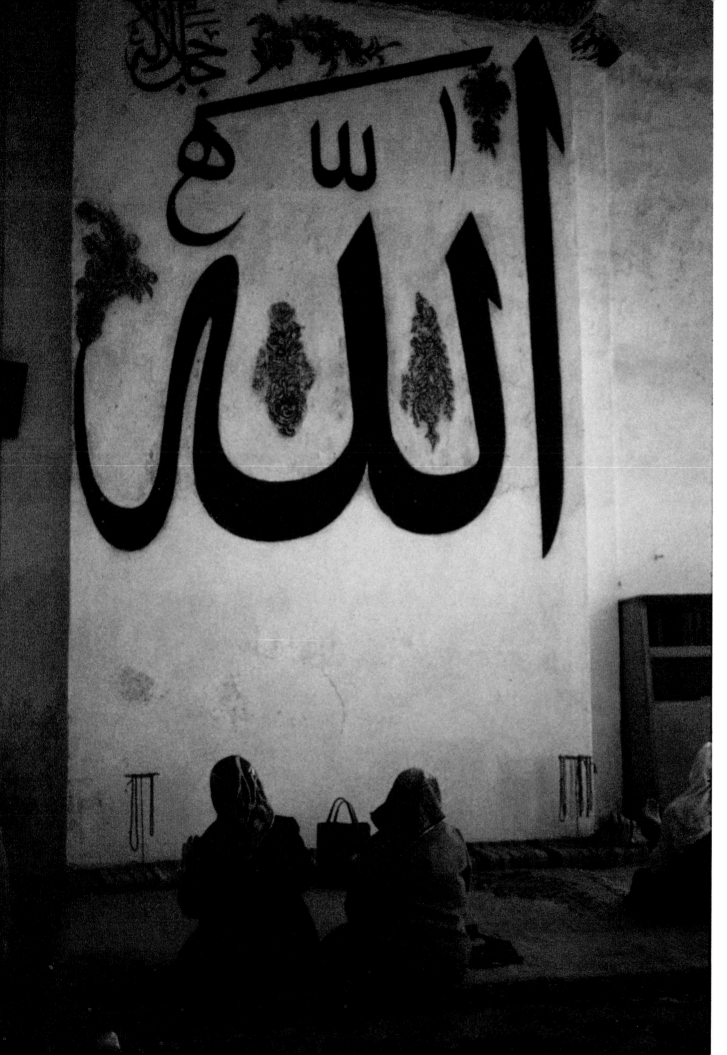

*I*n religions of the
Book (Christianity, Islam,
Judaism), the beginning
is the Word, forever fixed
by Scripture. In Islam,
the written text, like God,
tolerates no surrogates
and thus excludes all
other forms of
representation. There
remains only the name
of Allah, unique
manifestation of
the divine.

have invested in the effort, but the difficulties are manifold. First of all, the strict social hierarchy that determined the organization of the Ottoman house is now beyond the pale. Then, too, few would agree to sacrifice the present partition of space according to function in order to recover the flexibility of yesteryear. What remains is the interplay of external and internal volumes, of closure and aperture, of shadow and light, where, it so happens, tradition and modernity join. There also persists the question of materials. Even though contemporary humanity automatically assumes the conflict between the increasingly rapid obsolescence of forms and the haunting durability of their material – concrete – it is nonetheless disturbed by the idea of using a relatively perishable substance, albeit one more consistent with the never-ending changes of taste from one generation to the next – wood. Then comes the present inability to handle the medium decently, which always ends up awkwardly painted or improperly varnished.

The architect, the decorator, and the proprietor seem to hesitate in present-day Turkey between genuine commitment to a synthesis of forms and the practice of merely referring to the past through a game of "quotations" or "appropriations," which is nothing more than the introduction of a few old elements into a modern setting. The charm of wood and the warmth of wool – will they be reduced to a pair of *dolap* doors hung on a concrete wall or to a kilim thrown over an English couch?

PATRIMONY AND AN APPROACH TO IT

The modernization of Istanbul undertaken in the mid-19th century by the Ottoman authorities stripped the city of its ancient fabric, the indispensable tissue of a peerless and well-tended monumental center. On the other hand, the provincial cities, which continued to weave this web right up to the middle of the present century, preserved it in good estate until the 1970s. Subsequently, the demographic explosion and the rural exodus, as well as a certain notion of modernity, have very rapidly taken their toll on the old quarters, and today it is only the exceptional solicitude of the inhabitants, as at Safranbolu, or a slower rate of suburban development,

as at Kukla or Divriğu, that has made possible the preservation of a few urban communities.

In between comes the random change – a one-dimensional development conserving the external parts of a house – which has nonetheless saved several quarters at Kütahya, Afyon, Tokat, and elsewhere. In most cases, however, the former proprietors have taken up residence in apartment buildings in the new city, leaving their old places to recent migrants from surrounding villages. The result is not necessarily negative, since the rural way of life encourages the utilization of traditional spaces. Still, modified habits combined with problems of maintenance generally produce alterations. Too grand to keep up and too vast to heat, the noble spaces on the top story are often abandoned in favor of the mezzanine or the ground floor, which in turn leads to casualness about roof repair, and eventually to a rapid decay of the entire structure.

Official classification of old houses and quarters has not always been effective, primarily because unaccompanied by financial incentive. The Ministry of Culture restores exceptional houses and turns them into museums (the Şemaki house at Yenişehir, pages 192, 195; the Kossuth house at Kütahya, pages 156, 158), but it is essential that this concern for the monumental structure should not cause neglect of the overall urban scene, a neglect that encourages the idea, now common among local authorities, that it is enough merely to salvage one house per city and to modernize all the rest.

Finally, it is not up to the state but, rather, to the whole of society to take responsibility for its patrimony – to restore and conserve but also to weld together the past and the present, without which any search for roots will remain forever frustrated. Increasing numbers of individuals are taking up the cause, and to them this book pays tribute. But the appropriation of the past must not be reduced to booty stored away in residences transformed into sarcophagi of history, thereby fostering an even more certain and rapid destruction of ancient dwellings, whose deracinated fragments become as much a mockery as paltry merchandise. The Ottoman house, the heart of an entire way of life, adopted by several peoples on three continents throughout four centuries, surely deserves more.

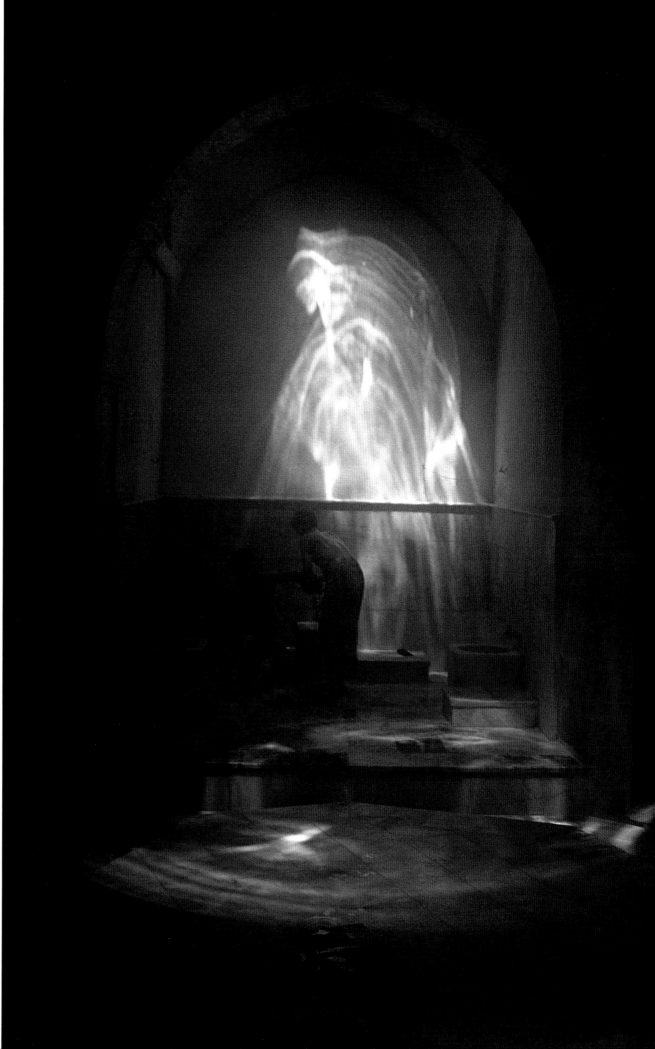

In the traditional Ottoman city, the hamam remains the only communal space open to women, at the same time that the coffeehouse continues to provide rare spaces for the conviviality of men. Women go to the bathhouse well prepared and spend the whole day there, once or twice a week, while the men gather at their coffeehouse in the evening, often in the same building that alternately serves both sexes.

The social role

of the hamam *in the*

Ottoman city required,

after the manner of

Roman thermae,

constructions of

a monumental order,

which elicited the whole

of the Empire's

magnificence and the

expertise of its architects.

In addition to these

sumptuous buildings,

several of which have

retained their fountains

right into present times,

the great private

houses also possessed

bathing facilities.

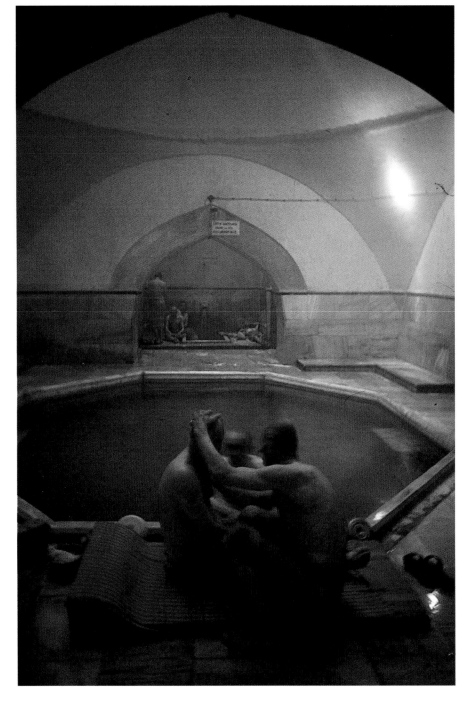

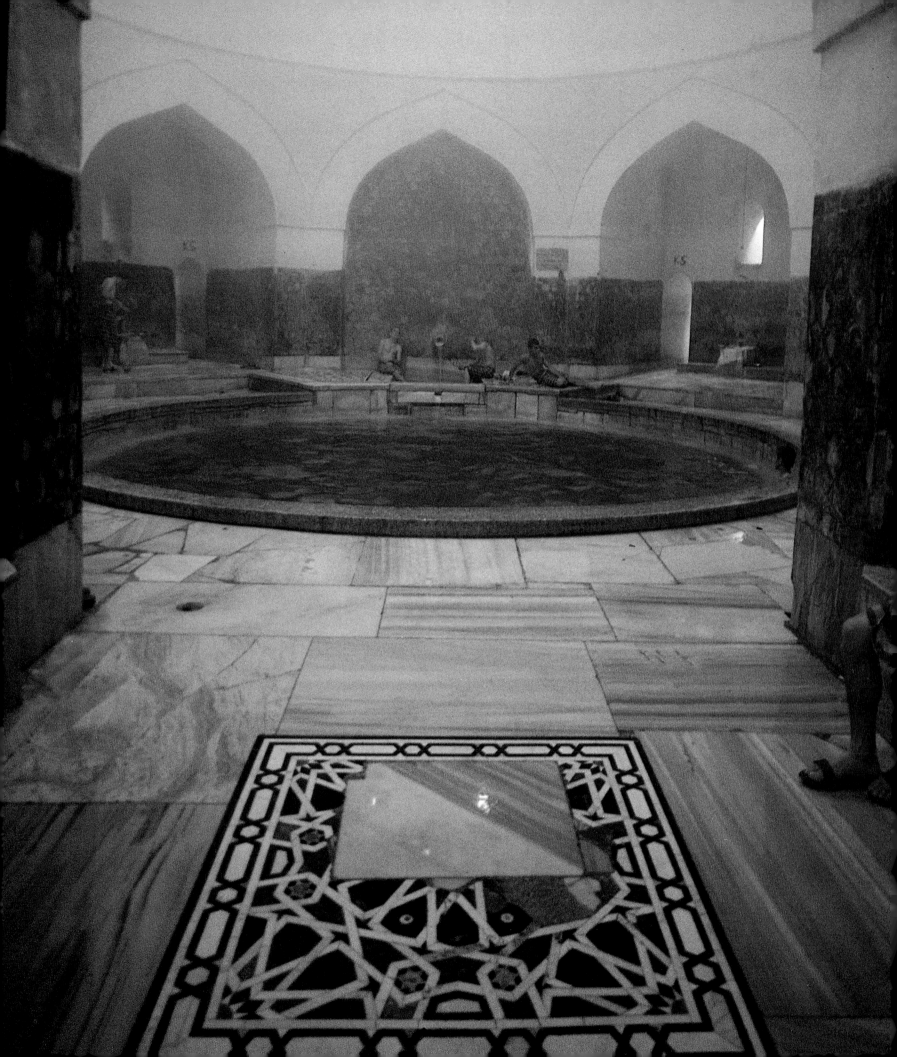

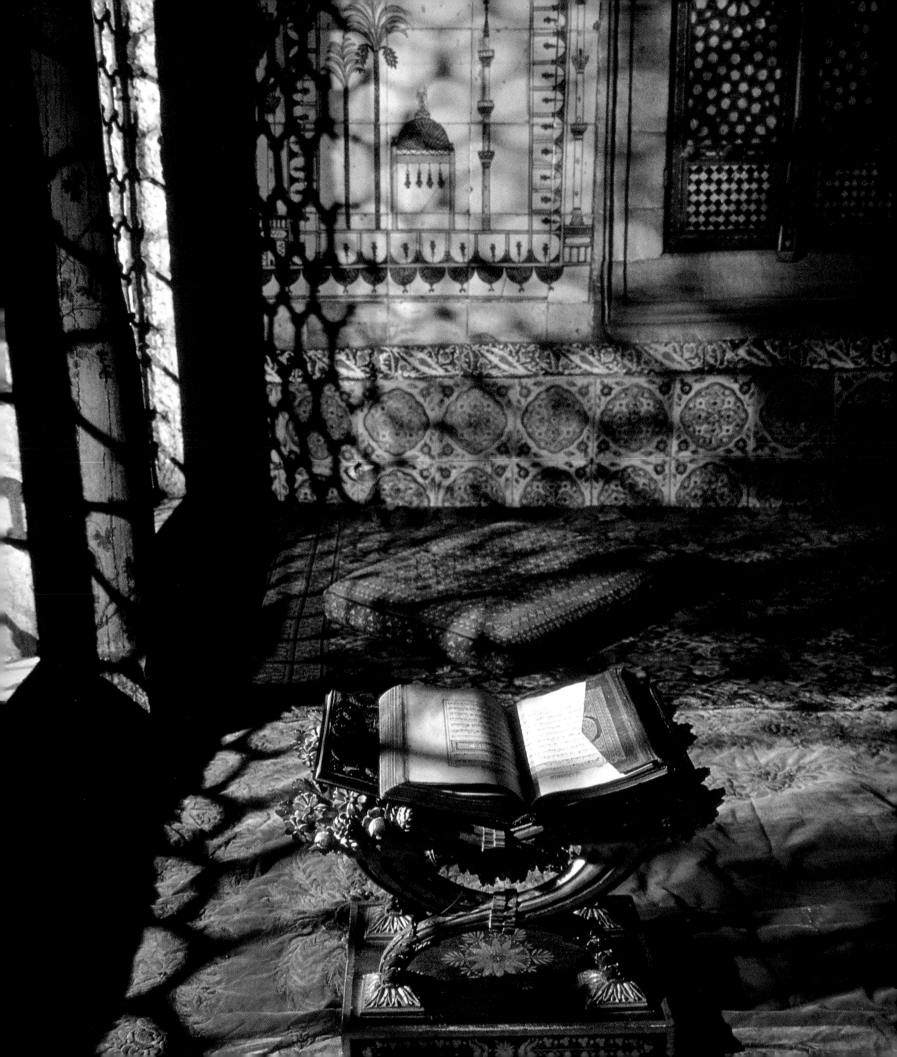

OTTOMAN SPLENDORS

I stanbul, the capital of the Empire, is probably the cradle of the Ottoman house and, most assuredly, the place where the dwelling attained its fullest expression as well as its greatest variety. The first examples of the model created and spread by the court were the kiosks or pleasure pavilions in the gardens at Topkapı Palace. These were then emulated and developed by the pashas and dignitaries of the Empire, but on the banks of the Bosphorus, in structures called yalı, whose presence transformed the great waterway into a splendid maritime avenue, after the manner of the Grand Canal in Venice. Finally, in the 19th century, the Sultan also took up residence there, in a new and sumptuous palace, this time built under influence from Europe. Gradually but inexorably, Ottoman architecture underwent Westernization, even while preserving its own forms, such as the material of local choice – wood.

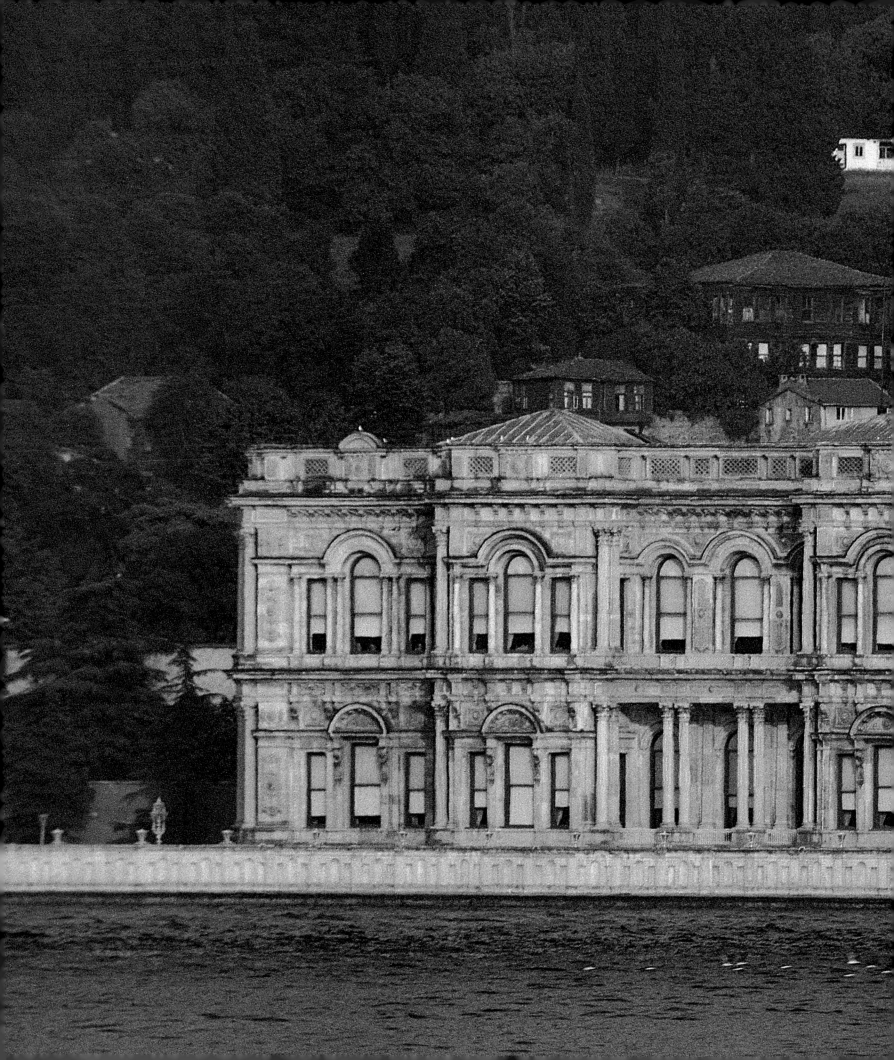

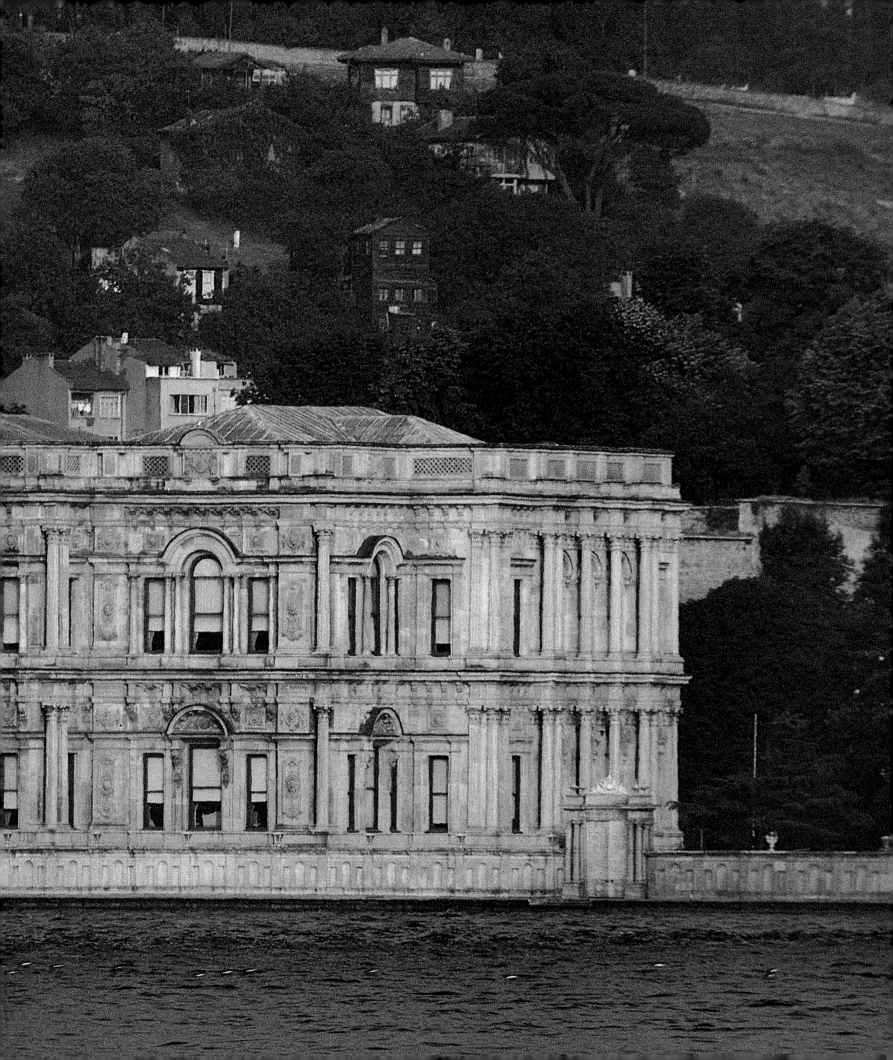

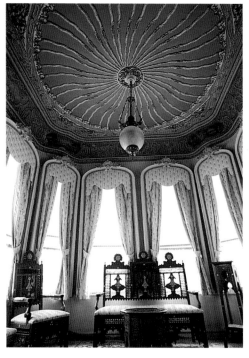

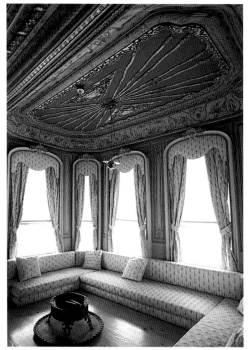

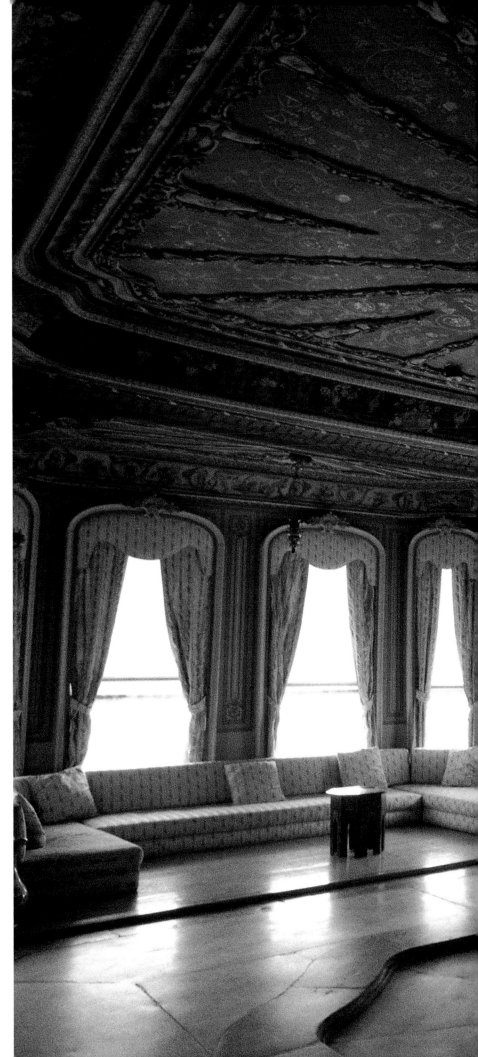

\mathcal{T}he meditative
darkness of Topkapı
(PAGE 66) vanished before
the light bathing the
Bosphorus, once
the Sultans, soon followed
by their dignitaries,
left the old city in order
to settle along a waterway
rivaling the Grand Canal
of Venice. Beylerbey
Palace, a summer
residence built on
the Asian side (PRECEEDING
PAGES) at the beginning
of the 1860s by Sultan
Abdüluziz (1861-1876)
and opposite, at Emirgân,
the yalı of the Şerifler.

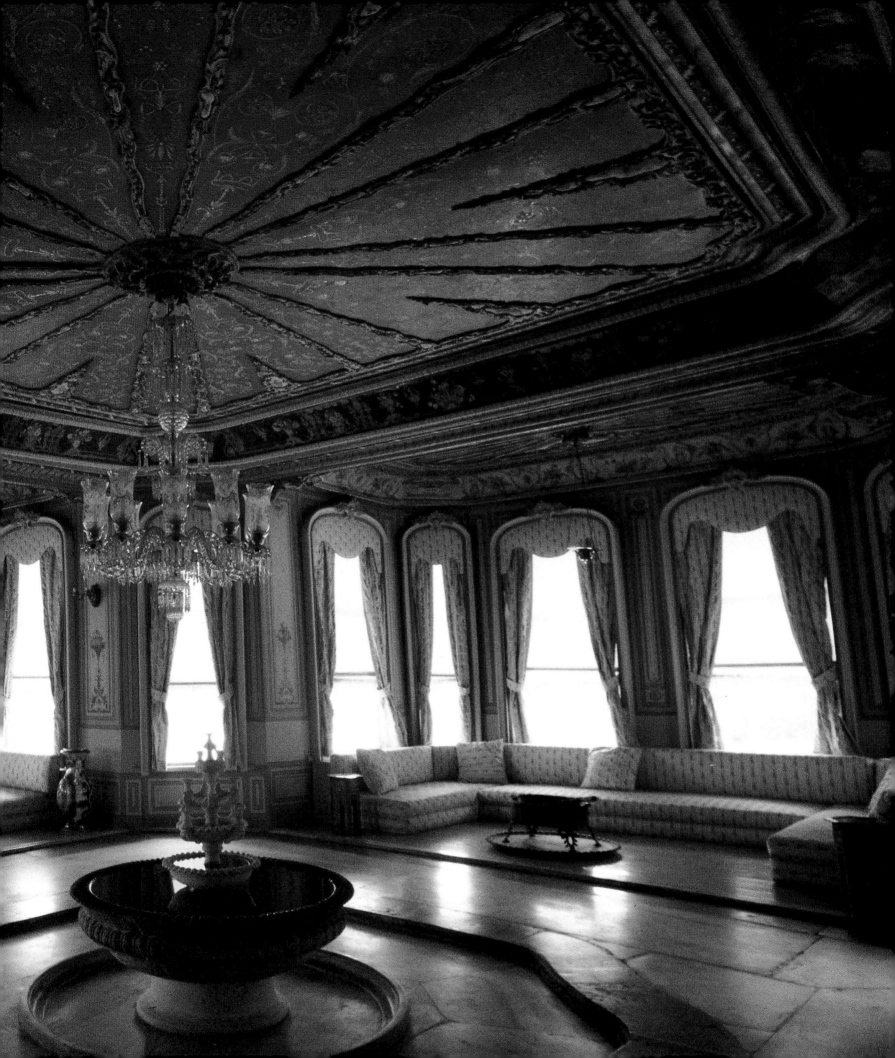

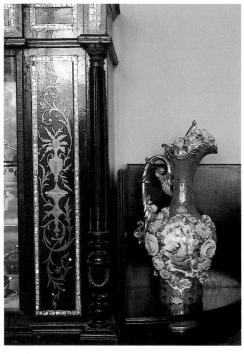

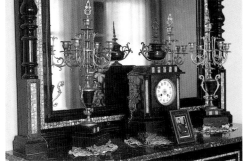

*W*hether it is a palace (saray), a köşk (a kiosk or pleasure pavilion), a konak (the master's house), or a yalı (a country house near water), the principal room of an Ottoman residence is the başoda, where the hosts receive on a low sedir running beneath a series of windows under a sumptuously decorated ceiling. The place of honor is always in a corner, diagonally opposite the entrance to the room.

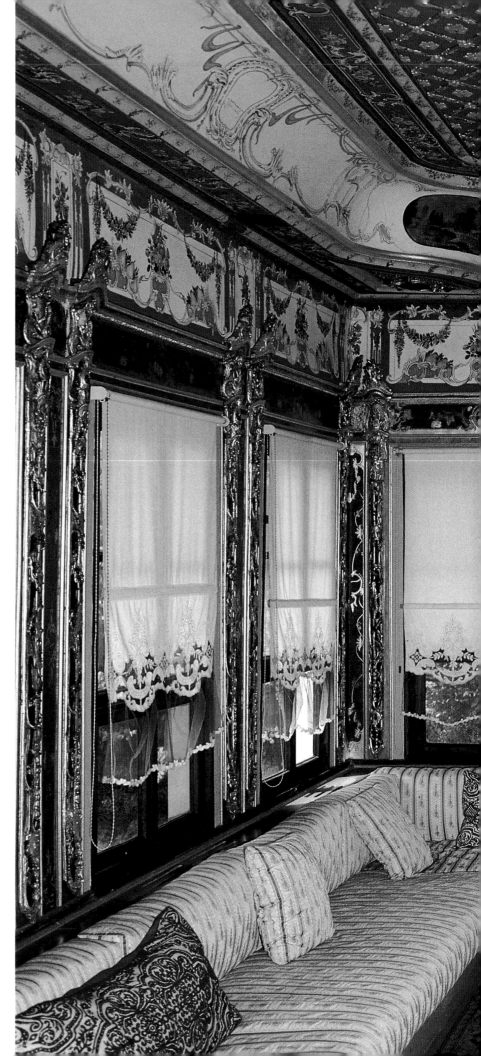

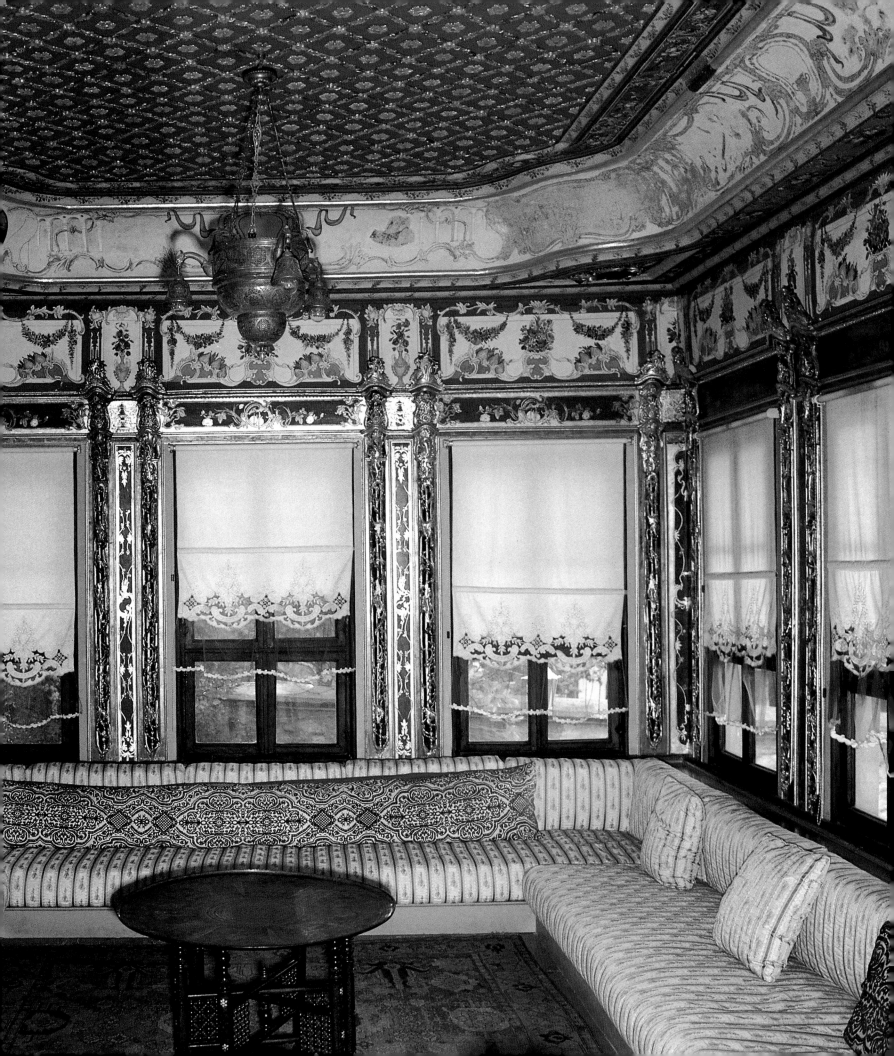

\mathcal{P}ermanently
abandoning Topkapı
at the beginning
of the 1850s, the Sultan
Abdülmecid (1839-1861)
commissioned the
Balyan – a family of
Armenian architects in
Ottoman service – to
build Dolmabahçe
Palace, thereupon
launching the string
of extravagant palaces
along the shores of
the Bosphorus.
The disposition of spaces
– still quite traditional –
contrasts with the sudden
appearance of new
architectural and
decorative elements.

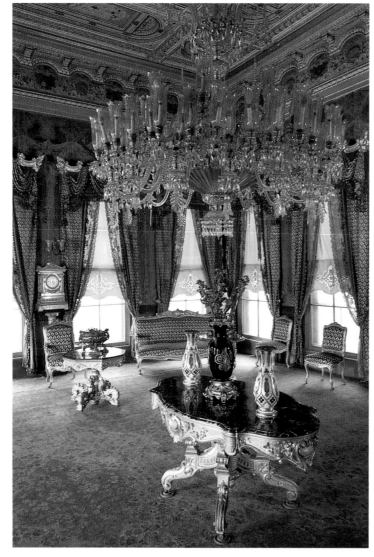

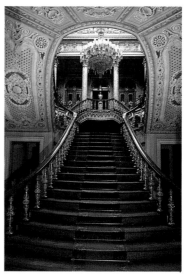

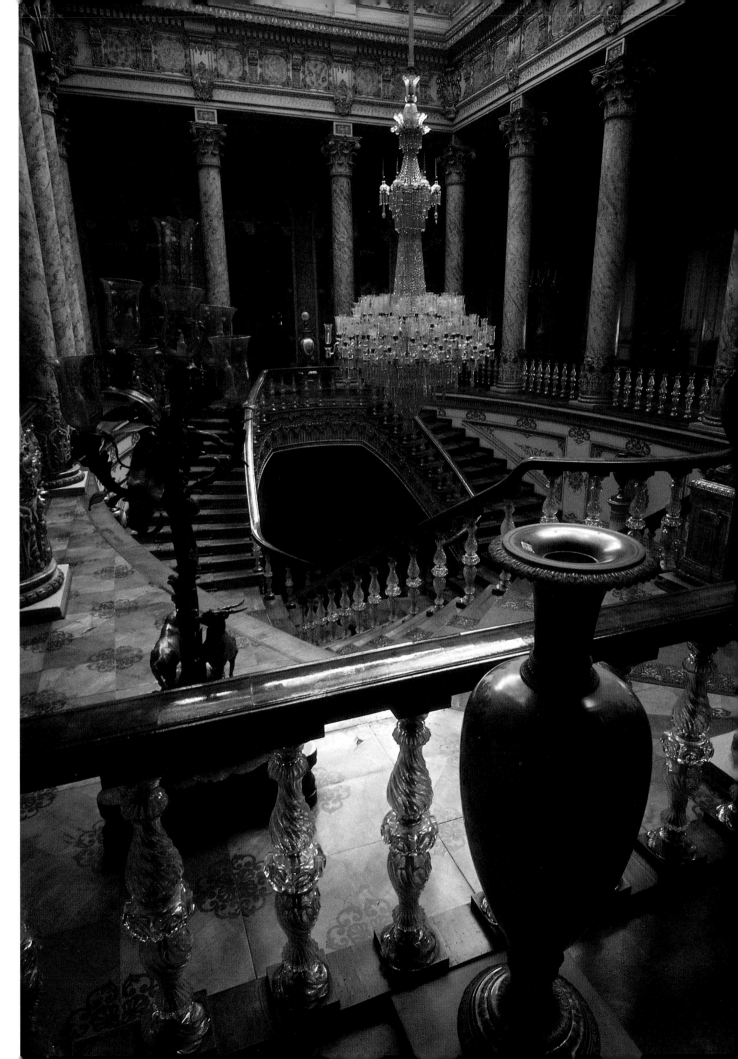

\mathcal{A} long with
Neoclassical colonnades,
on the façade as well as
on the interior, came
monumental stairways,
new features in Ottoman
architecture. The crystal
stairs in Dolmabahçe
Palace are justly
celebrated; here, a stick,
or a ringed finger,
casually trailed along
the balusters generates
harmonious sounds
to accompany a journey
up or down the stairs.

*T*he infatuation with crystal was unquestionably one of the great novelties then flooding into the Ottoman residence. It brought cascading balusters that capture the light of candles, but, most of all, an extravagance of luminary means – chandeliers, standard lamps, and candelabra all made with a profusion of crystal.

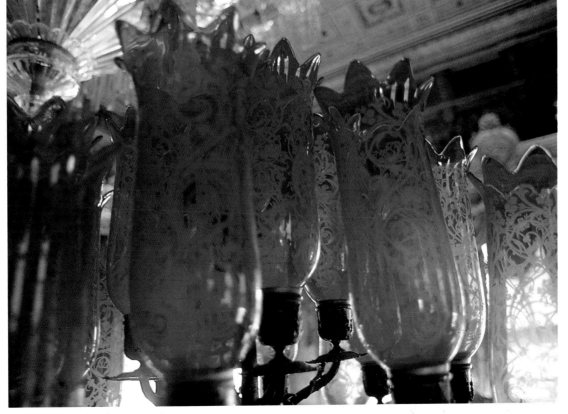

That passion

for crystal climaxed

in the chandelier given

by Queen Victoria to

the Sultan – four and

a half tons of crystal cut

into millions of facets all

reflecting light from

750 candles. It hangs

at the center of the great

state room in

Dolmabahçe Palace.

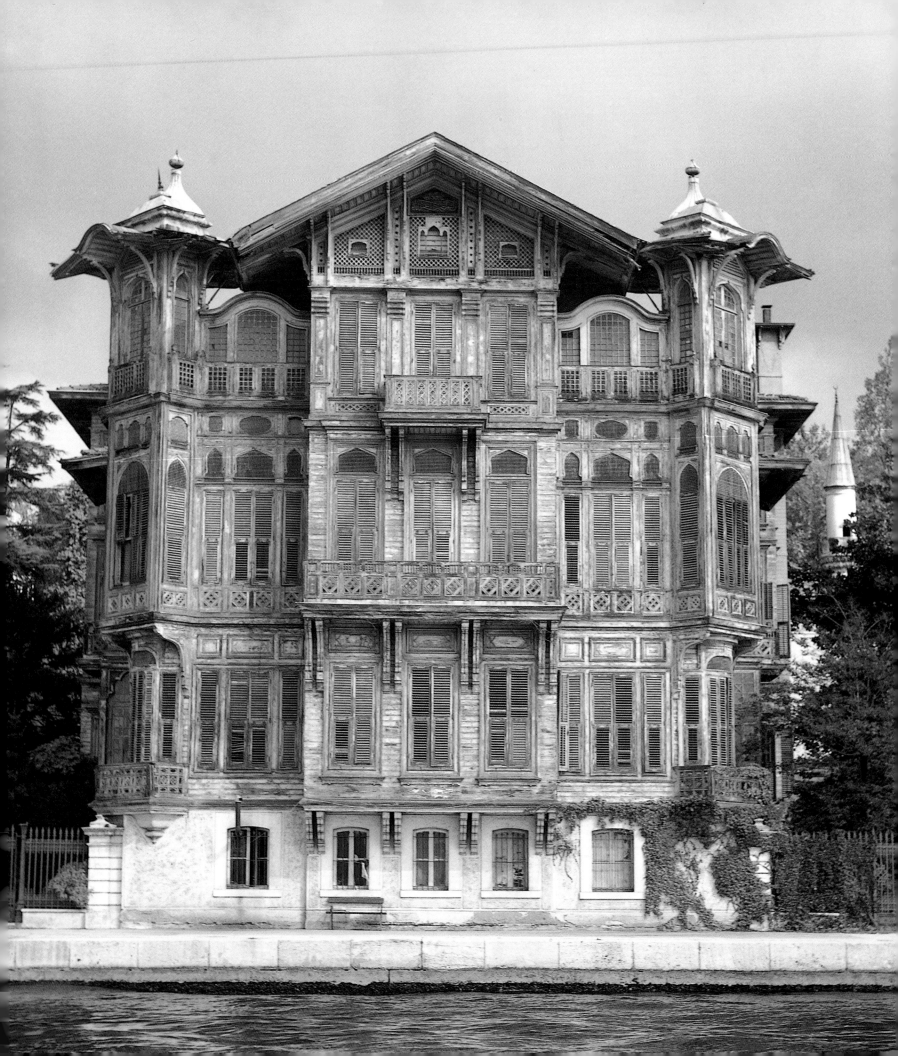

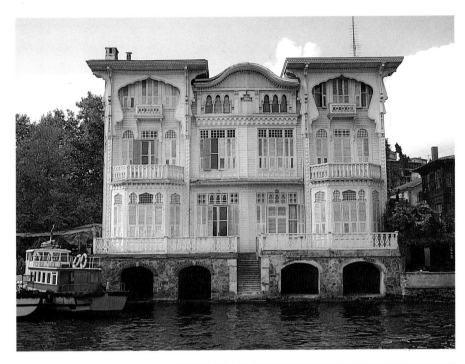

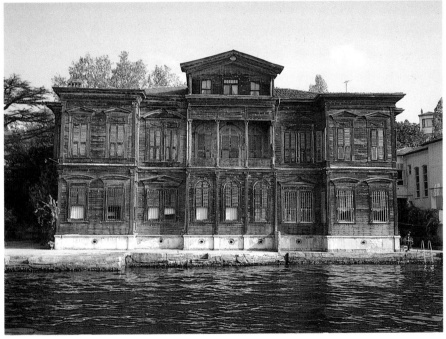

Even as their wood

construction was

jealously preserved,

the yalı of the pashas

and other dignitaries

succumbed to influences

from every source.

Neoclassicism made

its appearance in timid

colonnades and discreet

cornices, as did Indo-

Mongolian architecture,

by way of strange detours

through British colonial

styles, from Brighton

and Deauville to

the Bosphorus.

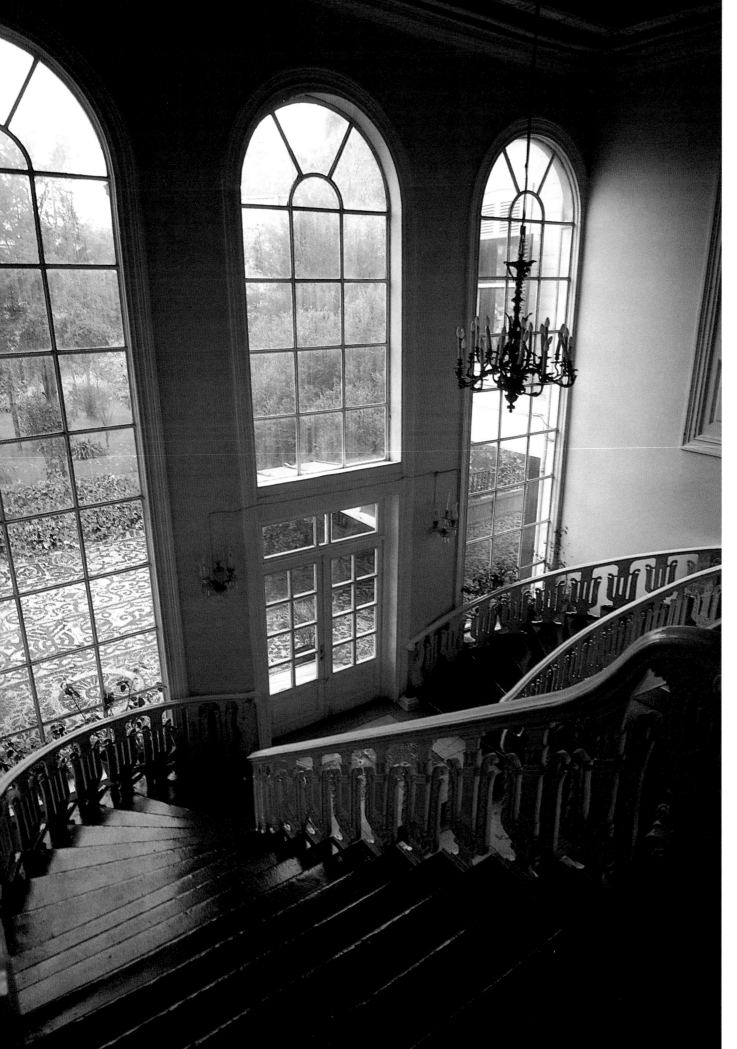

The assured

intimacy of the yalı with

the surrounding water

and verdure shattered

the last concerns about

enclosure. And so,

encouraged by wood

construction – which

explains why the

Ottomans clung

so tenaciously to this

material – the building

became an immense

lantern, given over

to perpetual movement,

the movement of foliage

and its shifting shadows,

of reflections on waves.

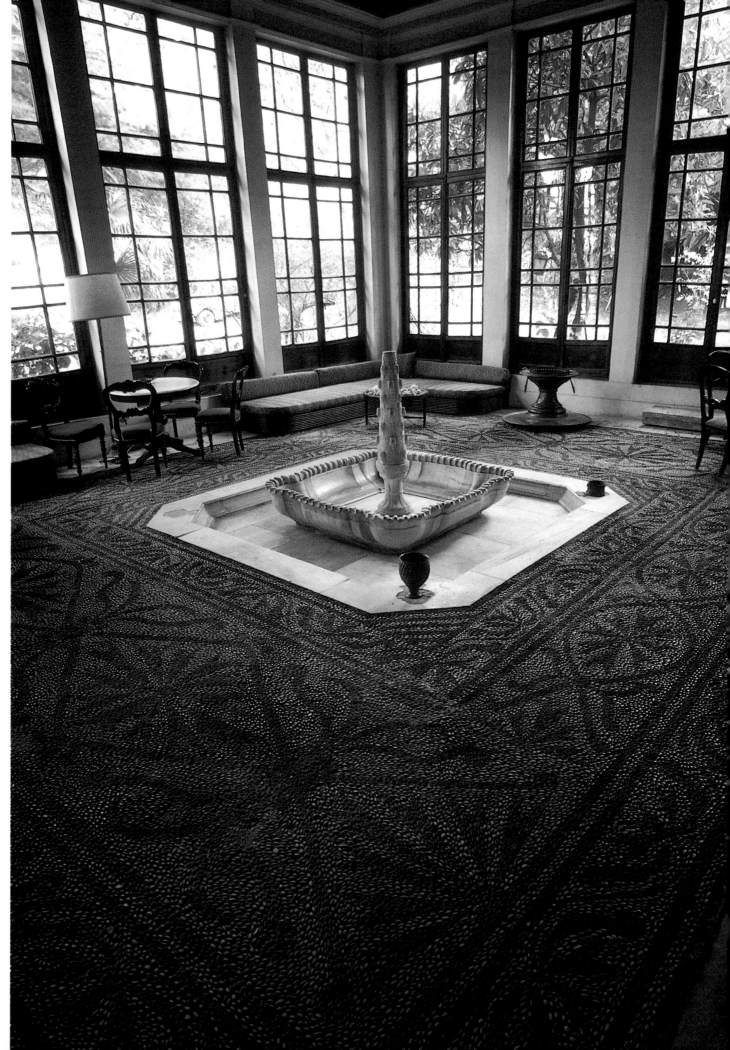

K *ıbrıslı Mehmed*

Paşa, Ottoman Grand

Vezir, was a native

of Cyprus, as his name

suggests. It is not known

whether he recalled his

origins while building his

yalı (OPPOSITE AND RIGHT);

nonetheless, the house

contains the very sort of

pebble-mosaic pavement

so prized in the

Mediterranean and the

Aegean archipelago.

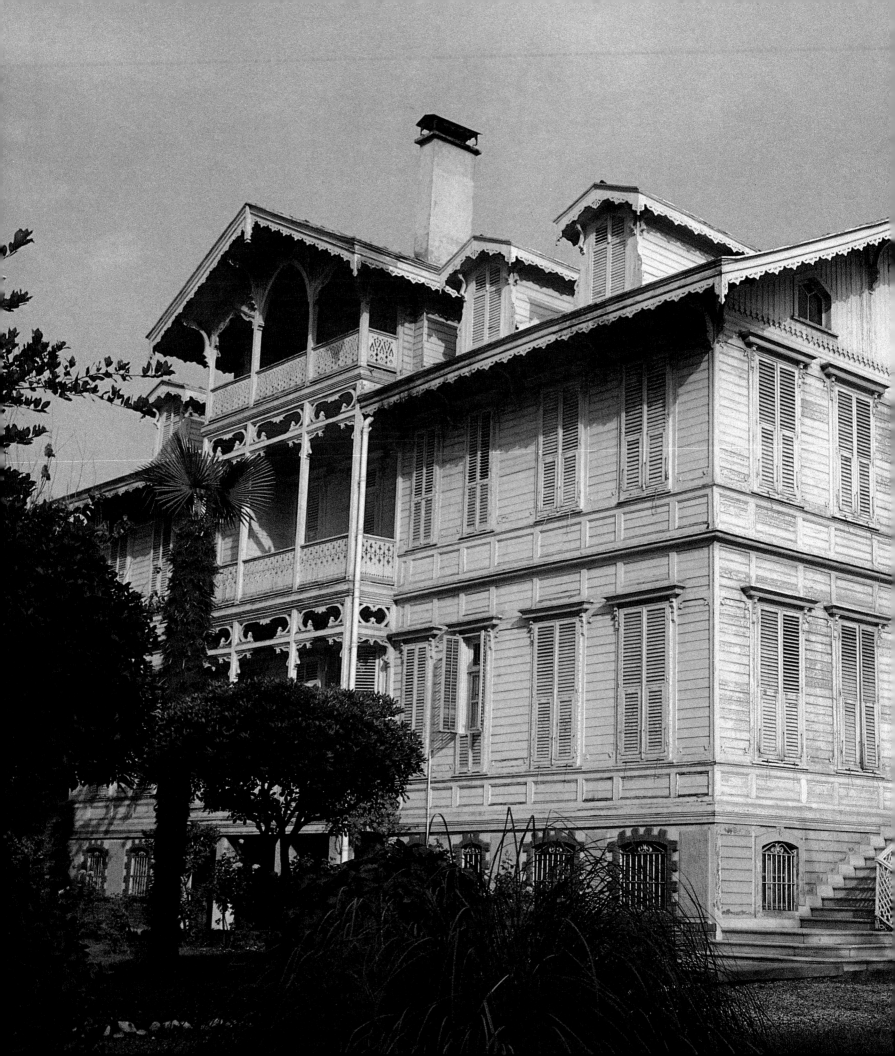

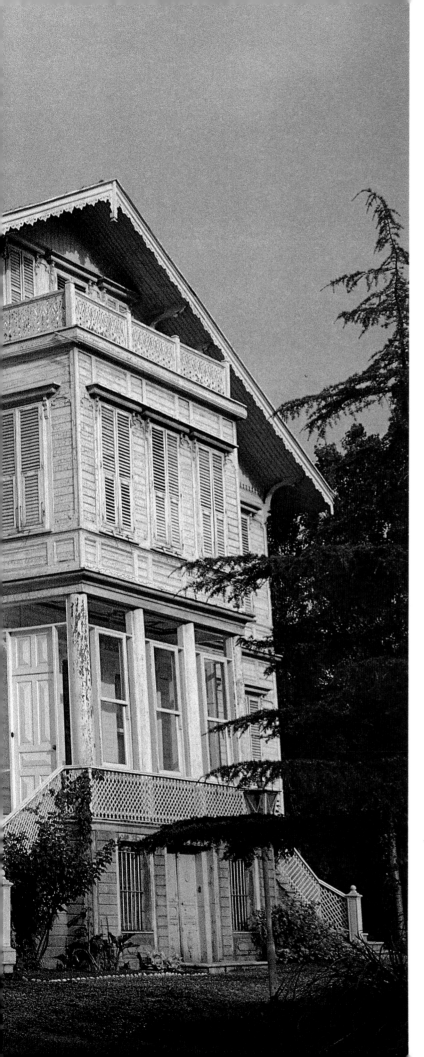

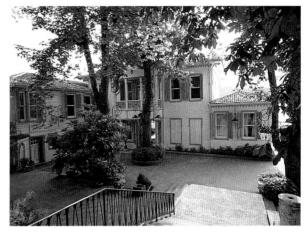

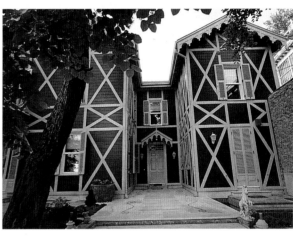

The Ottoman dignitaries who inhabited the Bosphorus yalı commuted daily to and from their offices in town, at first in oared caïques and then in the paddle steamers of the maritime company. Meanwhile, they also made it a habit to take their summer holidays on Princes' Island, several miles from the old city. Here the houses look even more like those of European resorts.

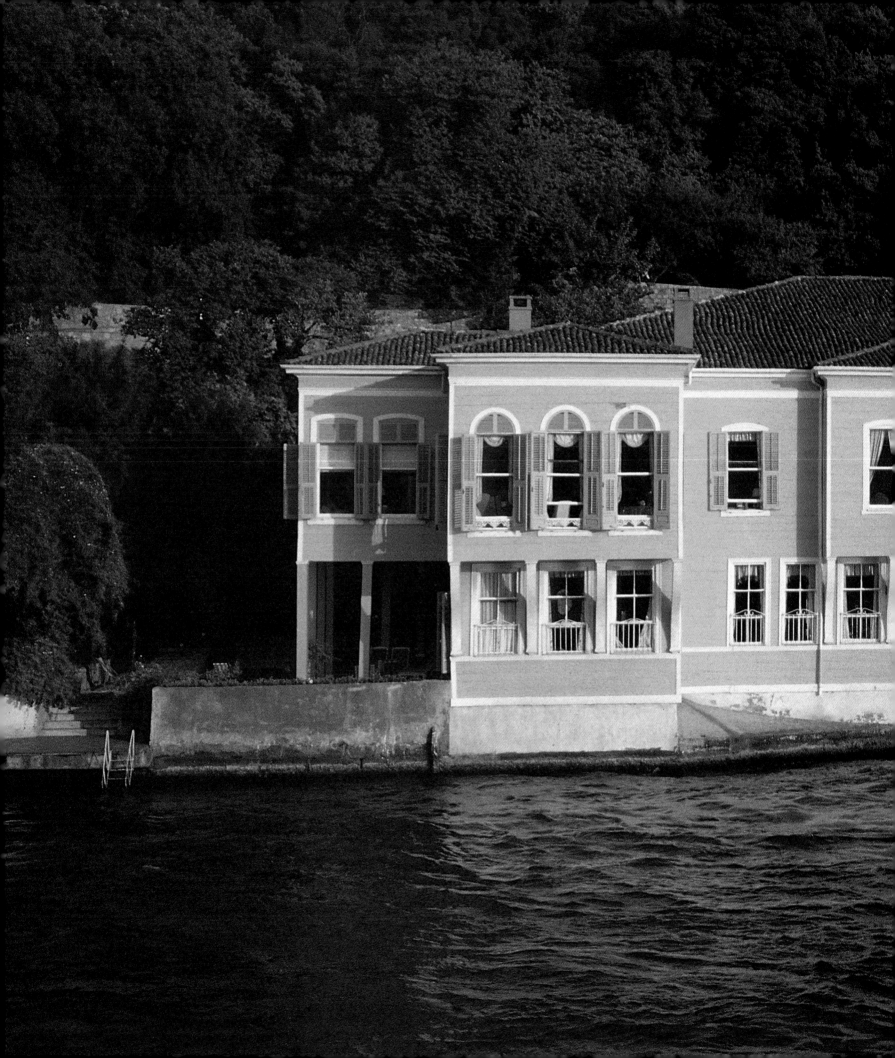

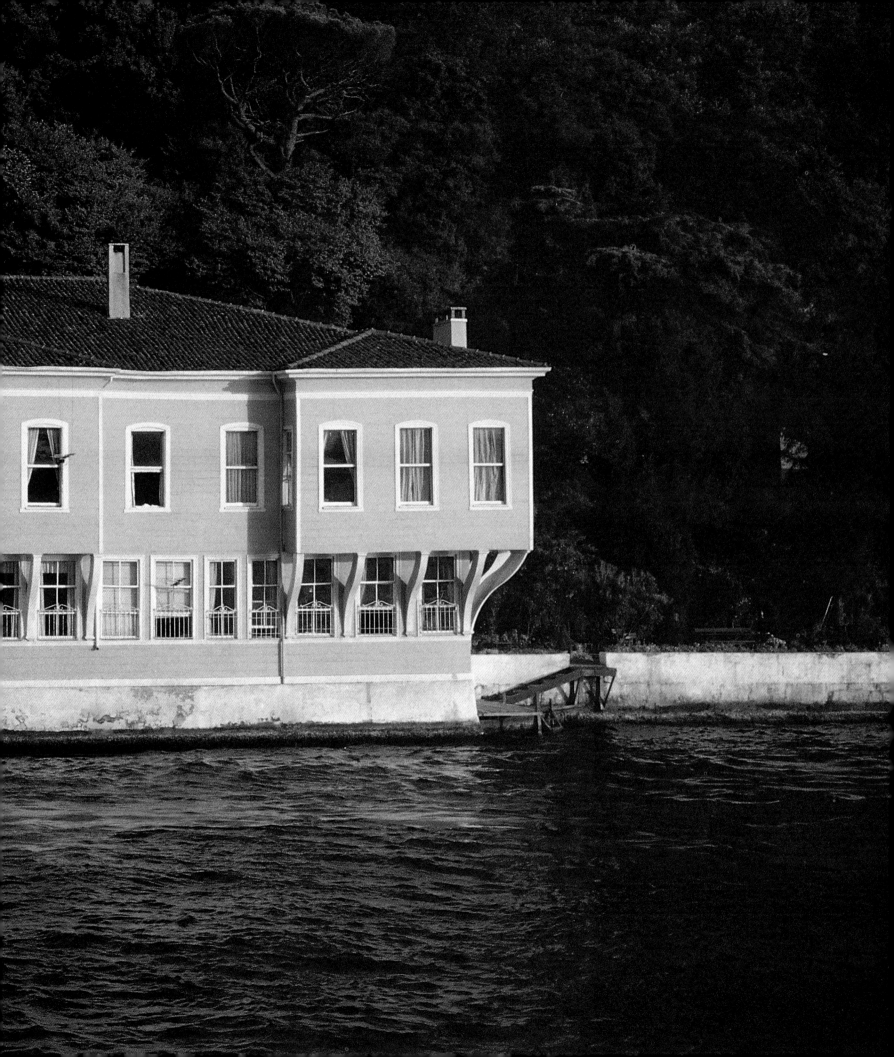

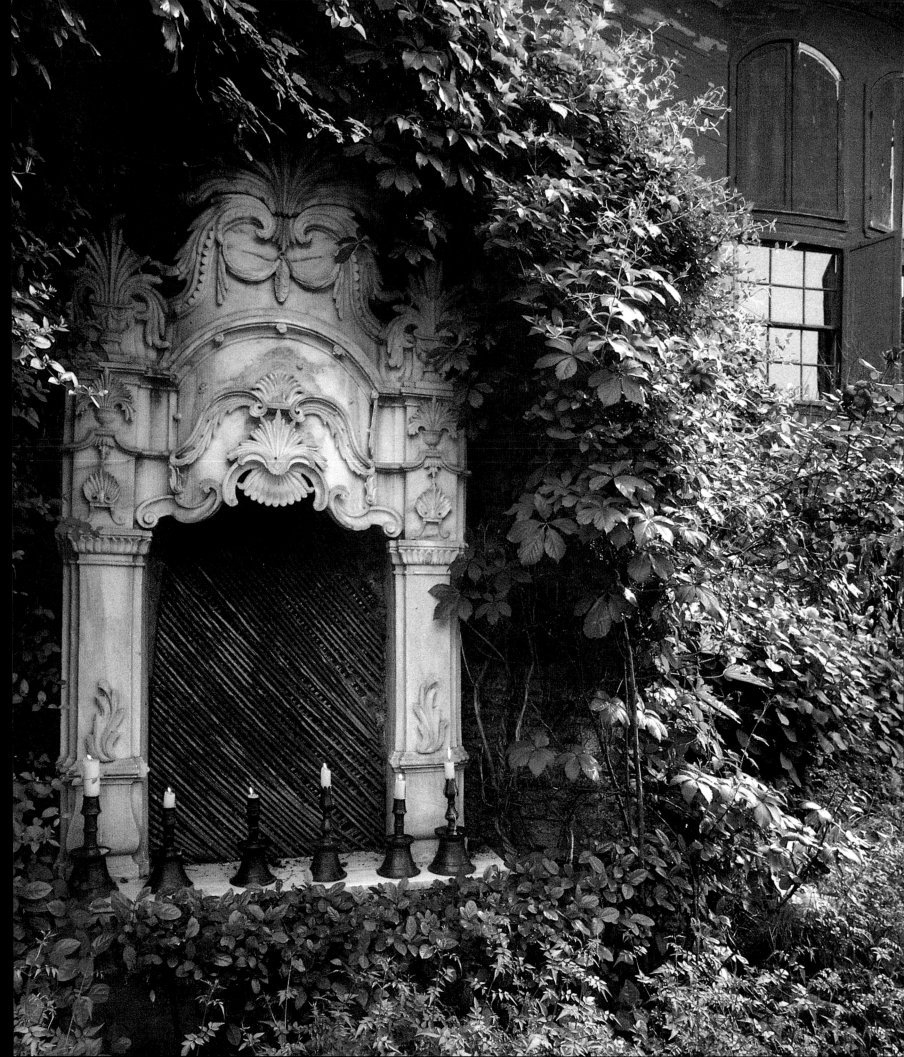

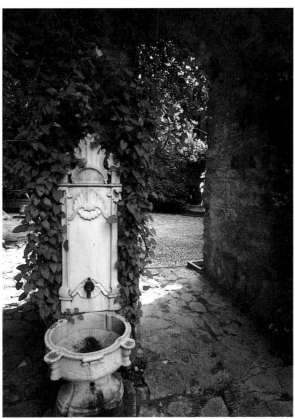

\mathcal{A} s in Venice,

the main façade of the

yalı gives onto the water,

and it was from there

that the owners took to

their caïques, tied up

directly below the

building (PRECEEDING

PAGES). On the land side

are the courtyard and

service facilities, as well

as the garden, a place

of no particular order,

but rather a labyrinth

of foliage marked

by points of water,

installed as retreats

in the shadows.

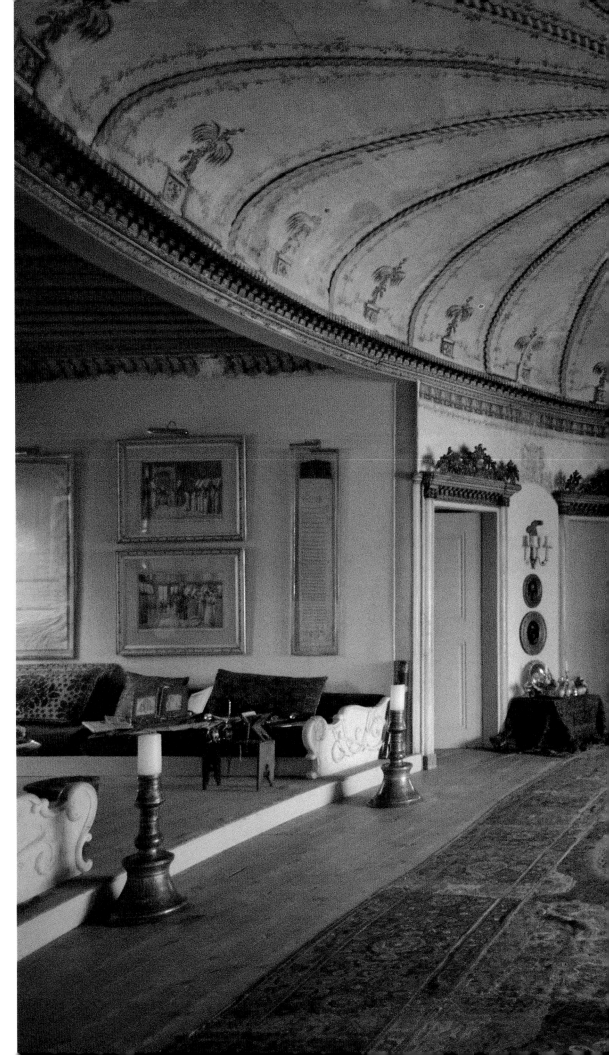

*T*he classic Ottoman
house is organized
about a sofa, the central
room of the main floor,
which – contrary to
Western houses – is
always an upper story.
The sofa is served directly
by the stairs and feeds
into all the other rooms
on the same level, which
leaves the house free of
corridors. Here is the sofa
in Sadullah Paşa's yalı,
embellished with a
magnificent flat dome,
and its dependent rooms.

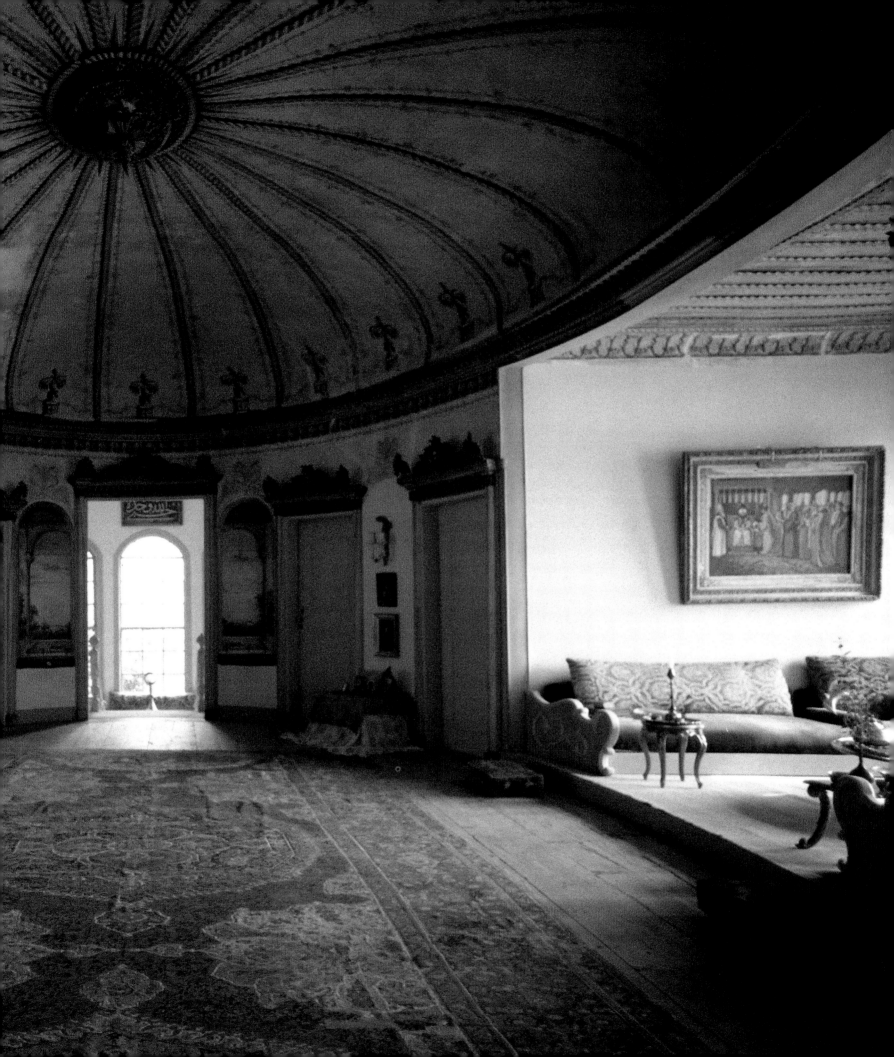

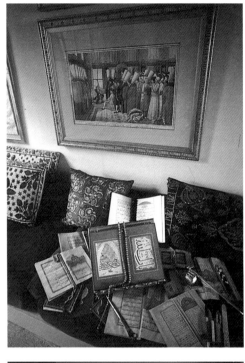

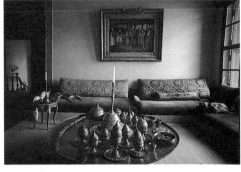

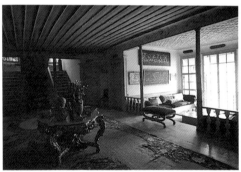

\mathcal{T}he sofa frequently opens into wings or alcoves, which provide intervals between rooms and assure communication between the central space and the exterior. Called eyvan, the wings in turn allow the sofa to be penetrated by daylight. Sometimes, as here in the yalı of Sadullah Paşa, they also form a cross, composed of three eyvan adjacent to the central space and a fourth wing, this one consisting of the staircase.

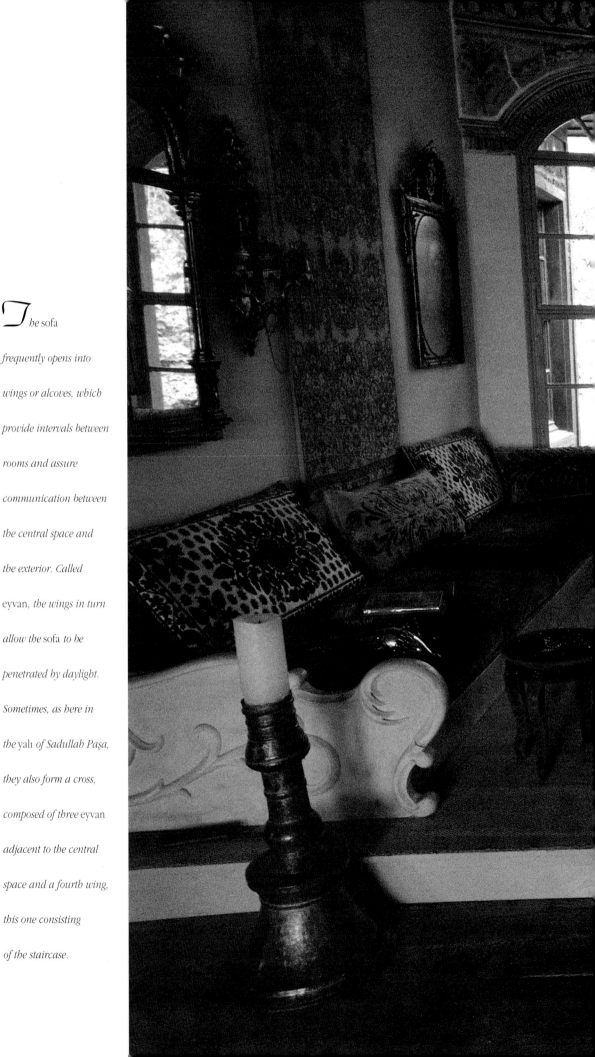

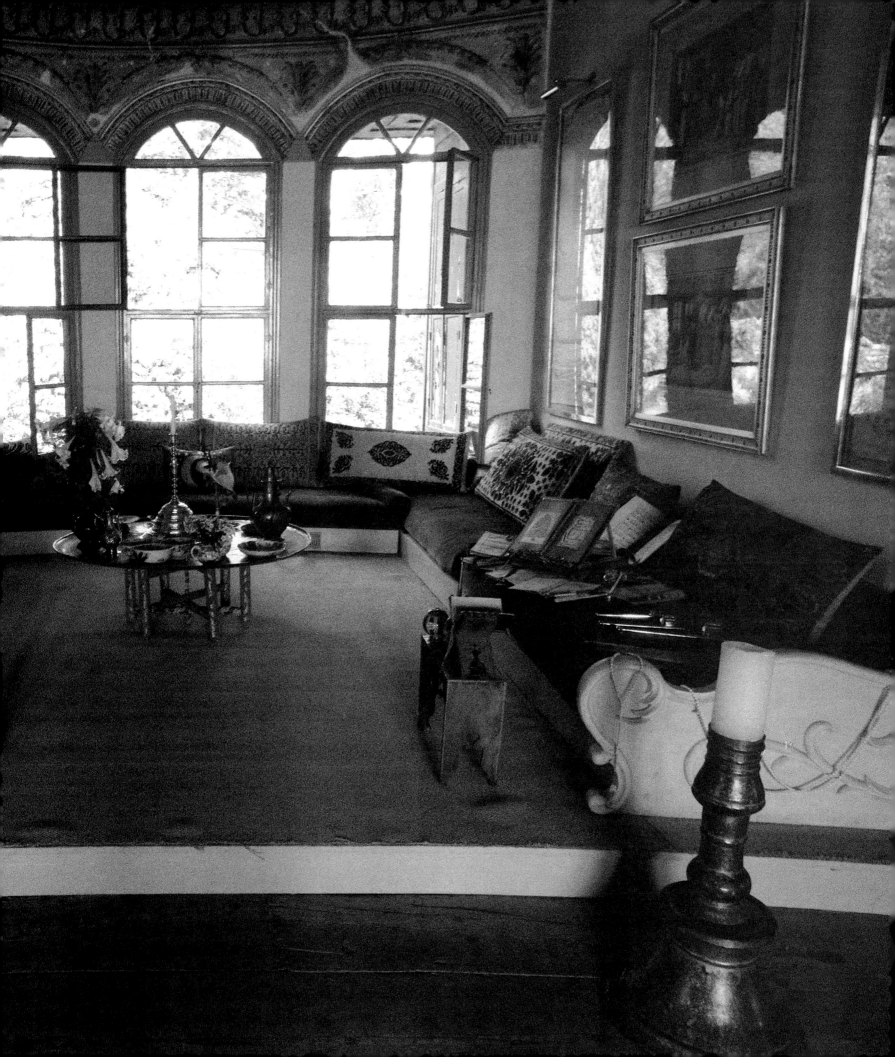

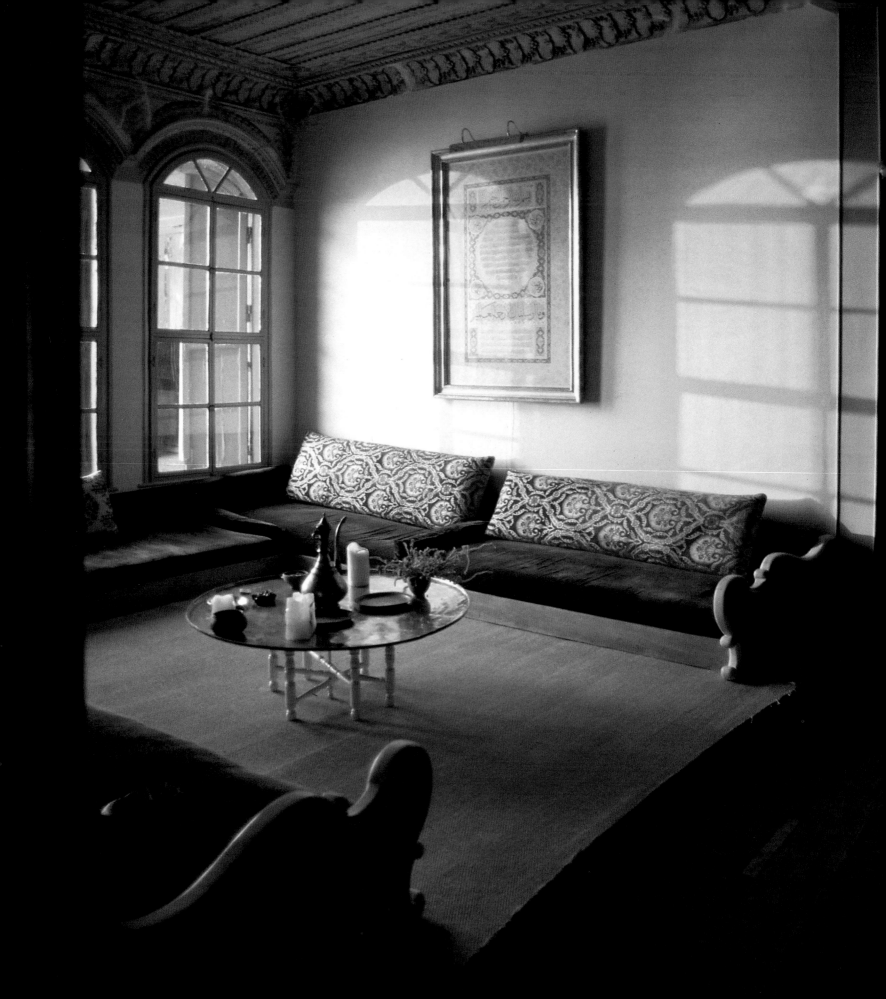

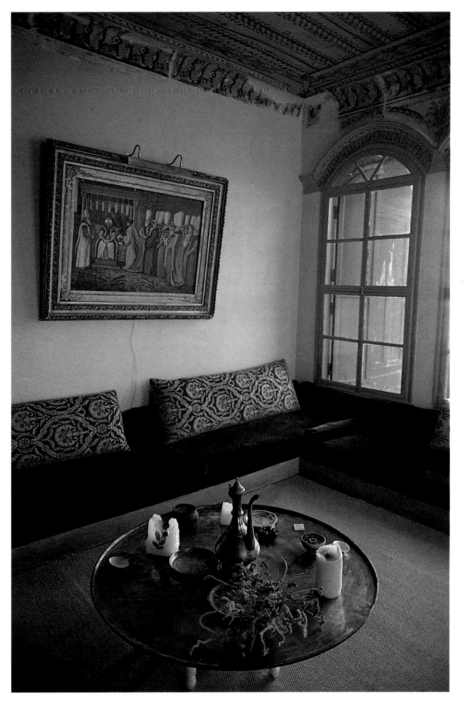

The yalı of
Sadulla Paşa not only
preserves intact its
structure and period
décor; it also holds fast
to the old system of
furnishings, demanding
simplicity and spareness
without denying luxury
and refinement. Here,
a copper sini, set with
ewers and plates
in the traditional way
for a meal, together with
a stand and candles for
reading, all placed close
to the floor.

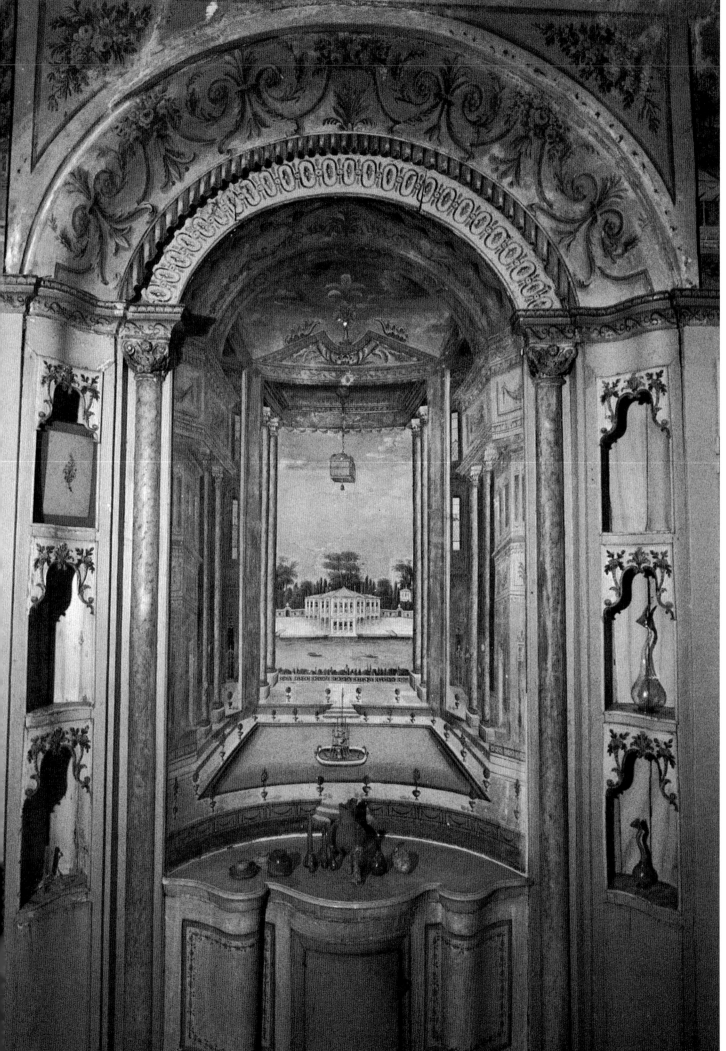

*T*he most decorated
part of the principal room
(başoda) *is the entrance
wall facing the* sedir,
*the sitting area.
At the center of the wall
is usually a niche for
flowers, which is therefore
called the* çiçeklik *(from*
çiçek *for "flower").
This illustration shows a
sumptuous niche in
Sadullah Paşa's* yalı,
*where Western elements –
colonnettes, trompe-l'oeil
imagery – mingle with
representations of
Oriental pavilions.*

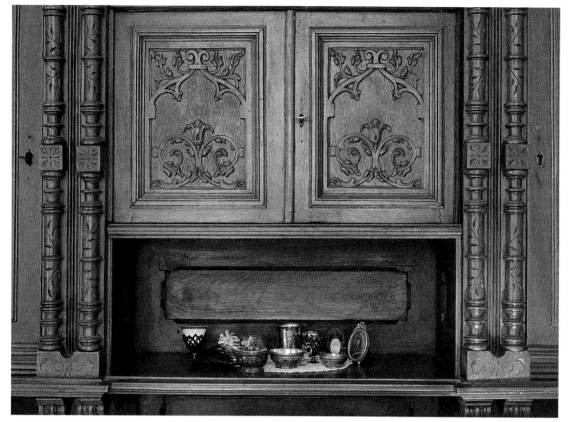

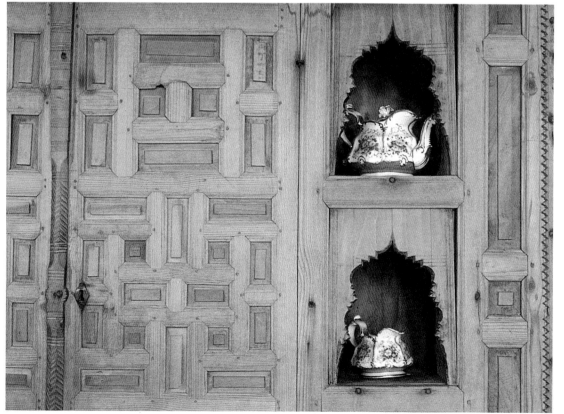

*O*n either side of
the niche there are dolap
(cupboards) with
elaborate doors for
storage, mainly of metal
utensils and bedding,
since the Ottoman house
possesses neither beds
nor bedrooms, and its
occupants sleep in the
same rooms where they
spend their waking
hours. Niches installed
in the connecting spaces
are reserved for valuable
objects, or, in older times,
for the kavuk, *the turbans*
of distinguished guests,
which accounts
for the niches' being
called kavukluk.

Beginning midway through the 19th century and in the wake of the Imperial palaces, the Ottoman house gradually became Westernized, a transformation first seen in the furniture and decorations even as the general disposition of rooms remained the same. Here the sofa has been transformed into a salon, with its freestanding furniture placed in the middle of the room. Too, the doors giving access to the other rooms or oda are no longer in the corners but, rather, placed at the center of walls.

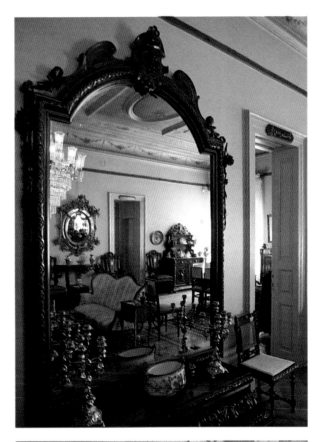

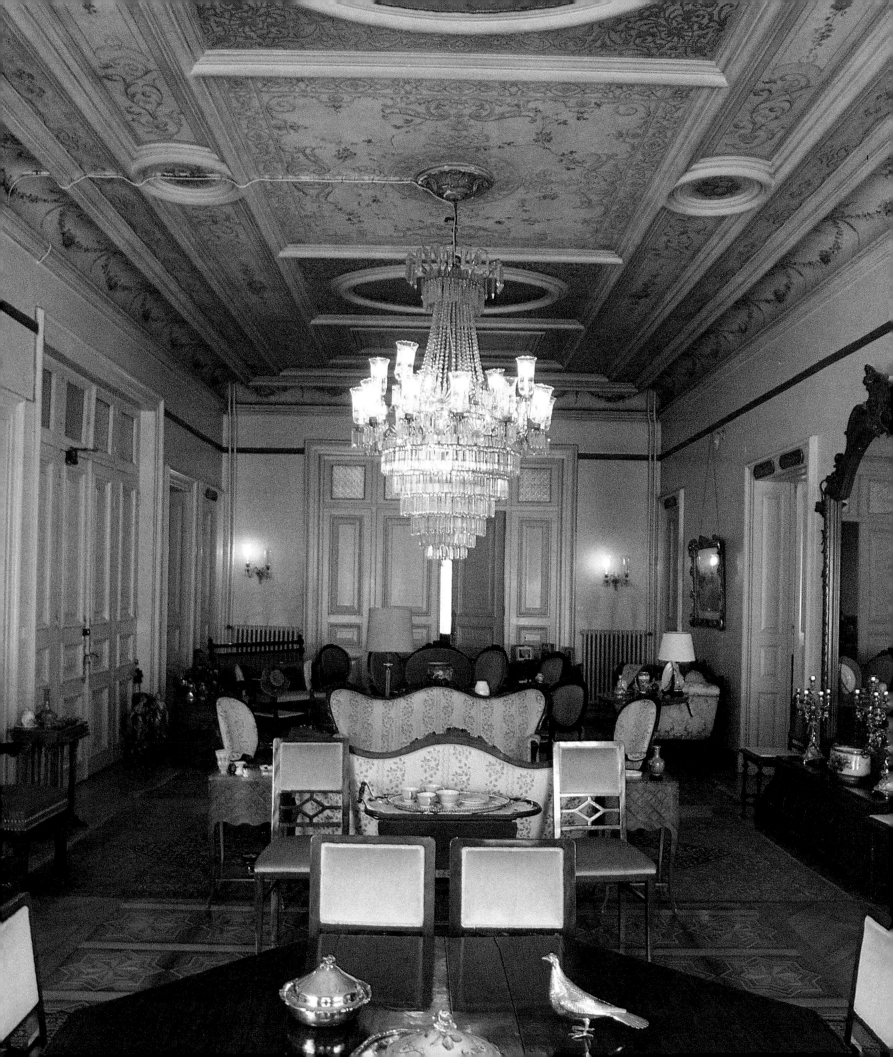

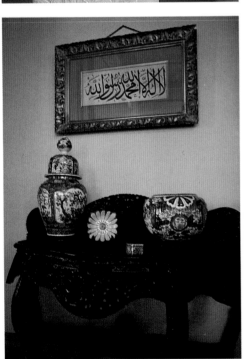

*W*esternization of the stairs evolved in a complex manner. A feature altogether secondary, and sometimes on the exterior, in traditional houses, the stairs at first assumed a monumentality comparable to that in Occidental houses (PAGES 75 AND 80). Later, they became distinctly functional and formed no part of a monumental composition.

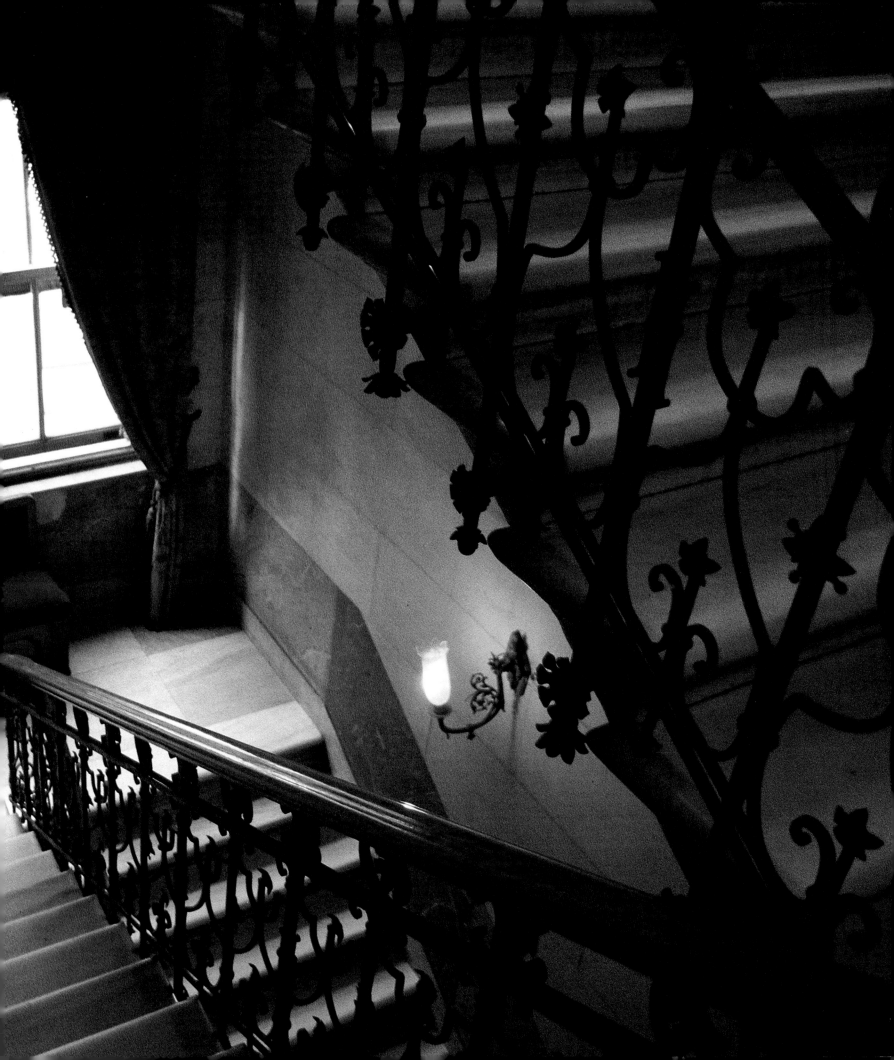

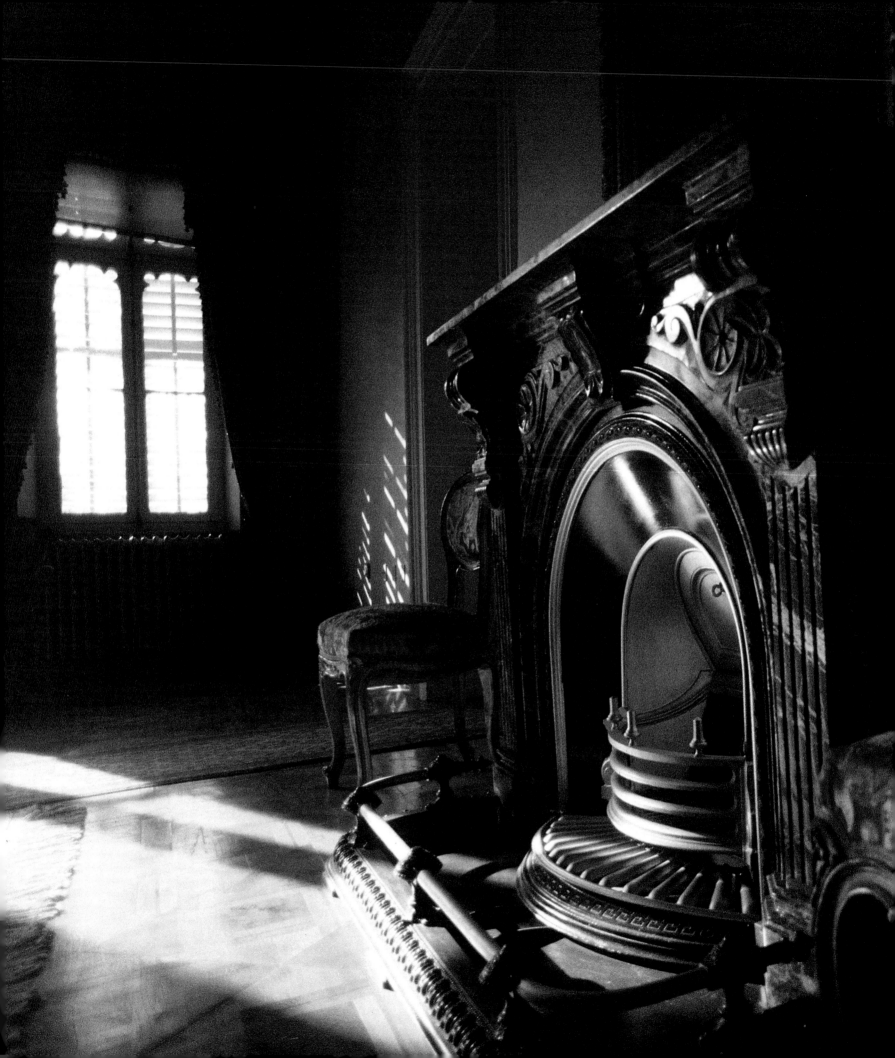

The plaster fireplace

decorated with stuccoed

or painted motifs is

a feature of the başoda

or of "winter" rooms

in colder climates.

Thus, the marble

mantelpiece constitutes

another sign of

Westernization.

In this illustration, a

room in the kiosk of

Maslak, a "folly" built

for Abdülhamit II

(1876-1909) while he

was heir apparent.

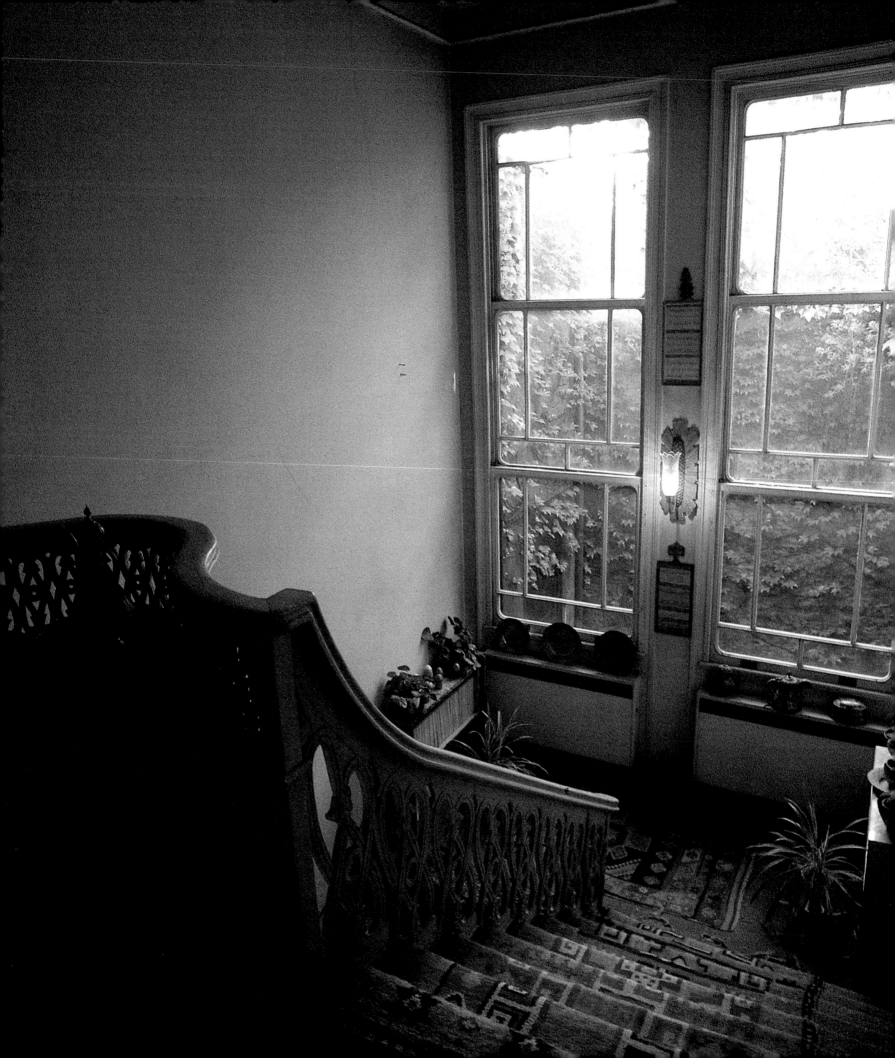

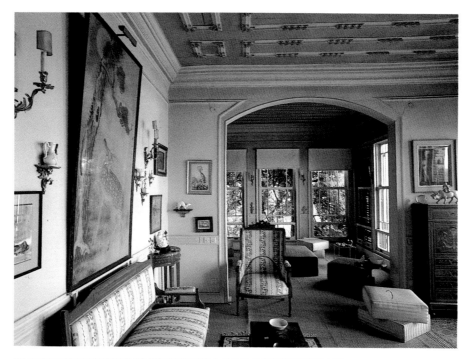

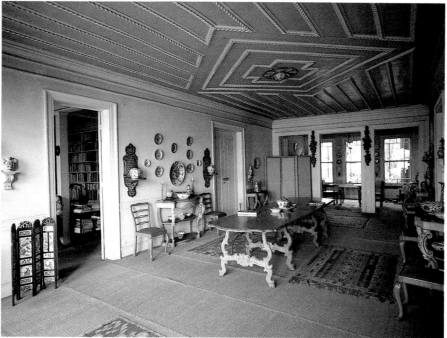

The salon,

the principal room in

a Westernized house,

could not lend itself

to the same requirements

as the sofa, the central

room most often deprived

of direct daylight.

It thus gradually

acquired autonomy

either by absorbing

the old dependent rooms

or by serving the same

purpose as the eyvan.

Simultaneously, furniture

progressively shed every

vestige of its Oriental

character.

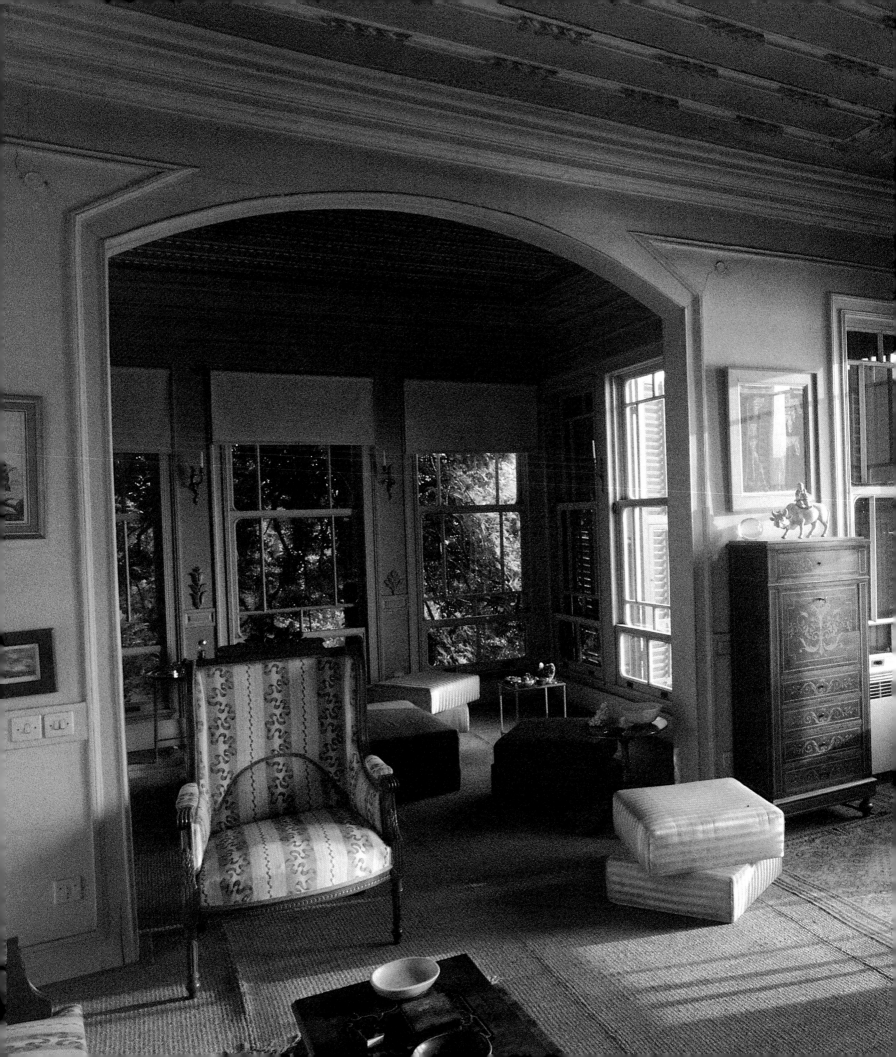

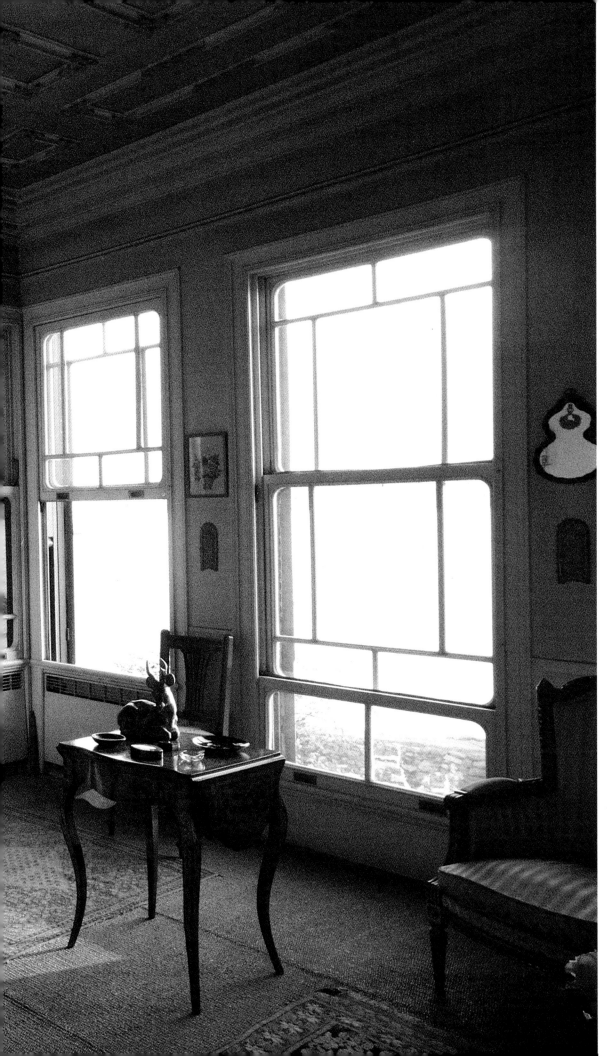

This suite of
reception rooms retains
nothing of the Ottoman
tradition, other than the
large "guillotine" or sash
windows, which allow
one to sense, through the
thickness of the walls,
the house's wood
construction, the most
resistant vestige of the old
Ottoman house.

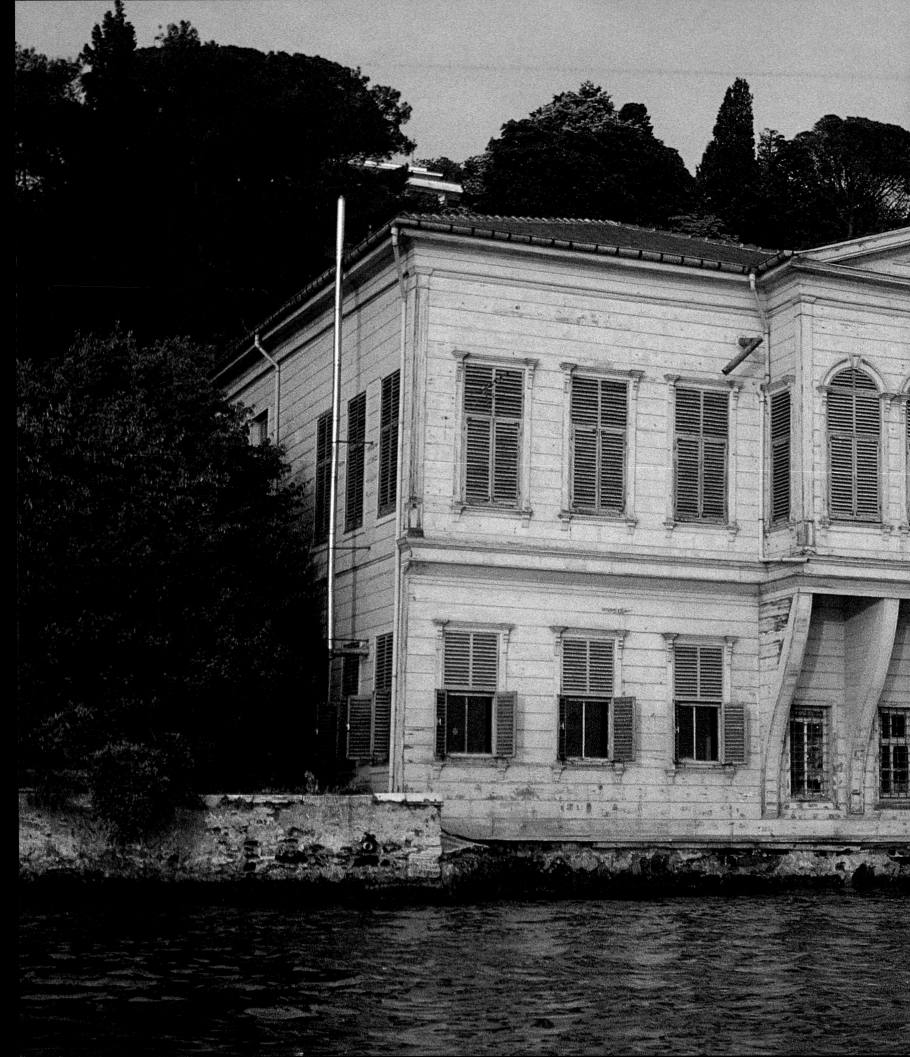

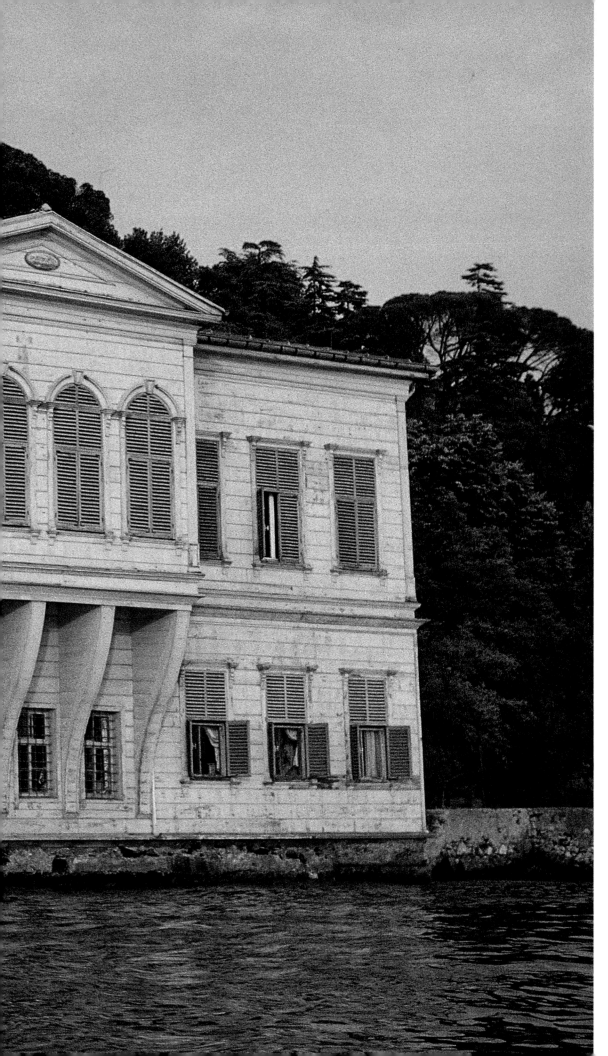

osed on the edge

between land and sea,

plunged deep in nature

only a few strokes of the

oar from the capital

of the Empire, massive

but self-evidently simple

in plan – its sofa spread

across the main floor

towards an eyvan and

thence towards the sea,

flanked by rooms

and thus closed yet open

through numerous

windows to watery

reflections and rich

greenery – the Istanbul

Ottoman house is

the quintessence of

the art of living.

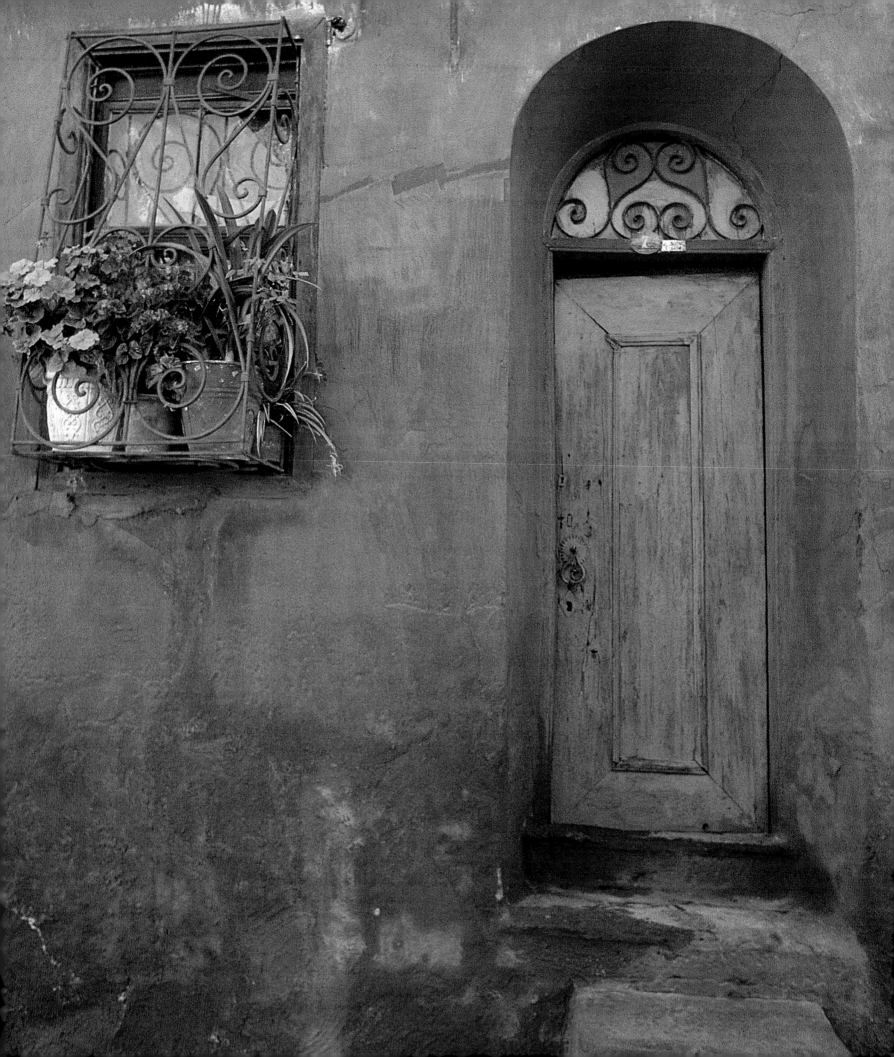

TRADITIONAL HOUSES

◆

Within the vast sphere of its influence, from the Balkans to Anatolia, the unity of forms, materials, and internal order of the Ottoman house impeded neither the development of variations nor the process of evolution. From the konak, or mansions, of Anatolian officials – all power bases as much as residences – to peasant houses, from the dwellings of rich Balkan merchants to the habitats of Aegean fishermen, every householder adapted the givens of the tradition to his own sense of possibilities. The open spaces related to rural life mingled with more sophisticated elements originated in Istanbul to create a kind of unity in which rigor posed no obstacle to mobility, where simplicity did not exclude refinement. A new concern for appearance, manifested in the 19th-century emphasis on façades, merely added to the overall charm of the Ottoman house.

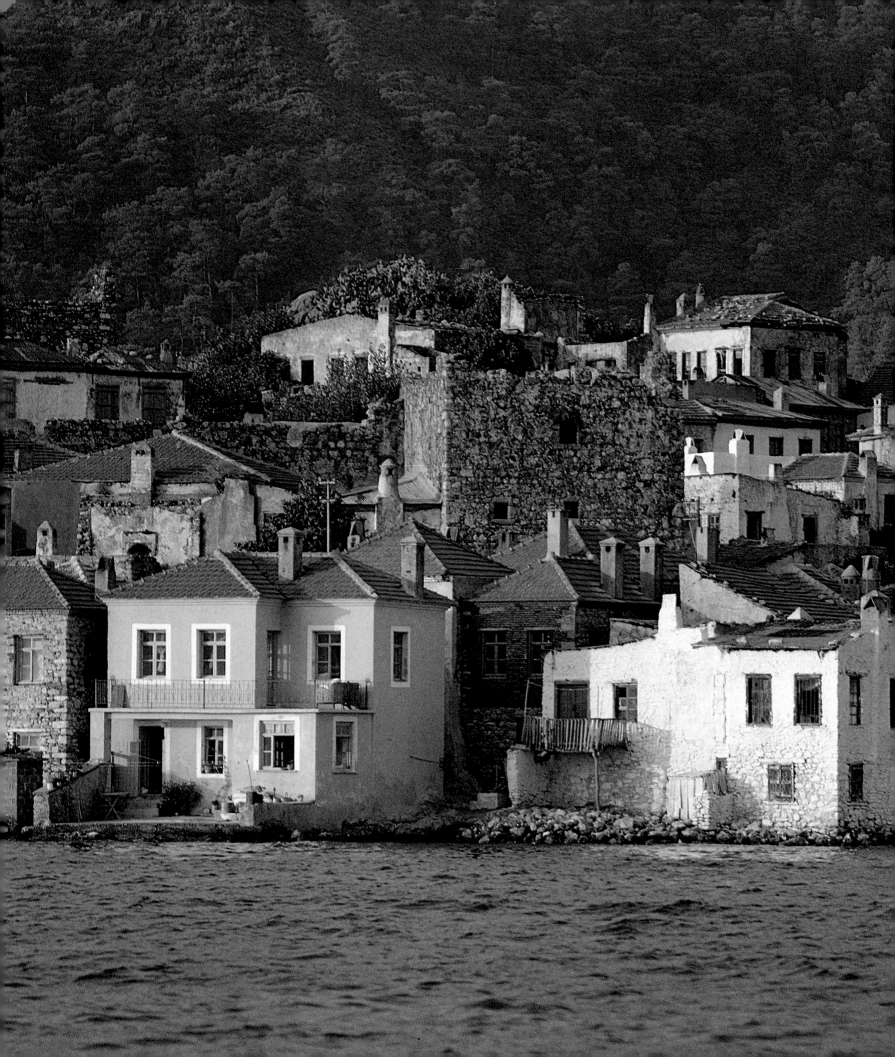

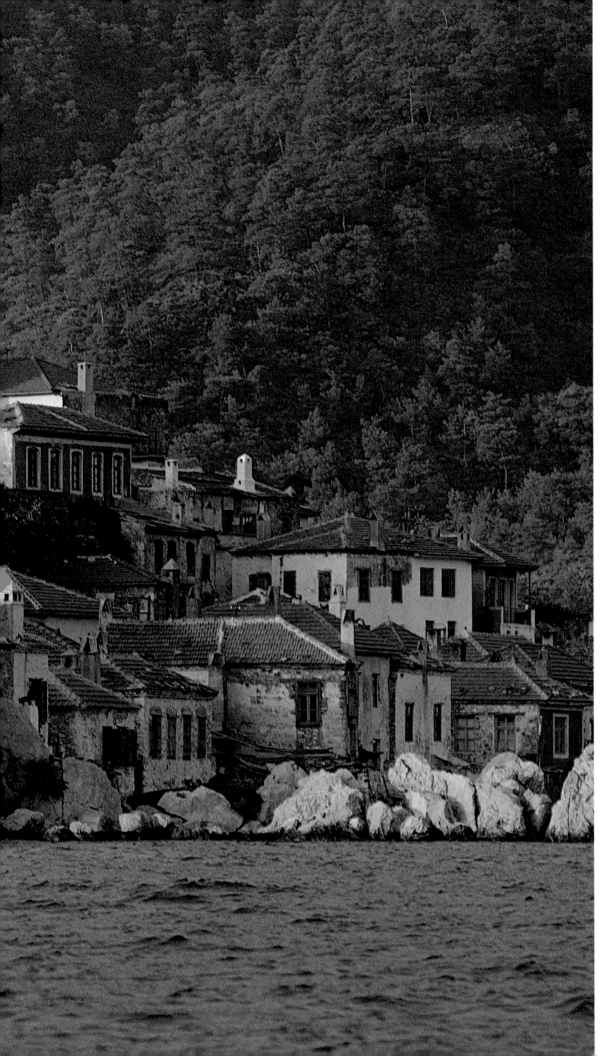

On the Aegean coast,

where wood is rare,

houses are built of stone.

The one here, at

Marmaris, is roughcast,

but while the Cyclades

insist on white, the Greek

islands near the

Anatolian coast and

the Turkish littoral facing

them prefer color,

in keeping with Ottoman

tradition. This makes for

a play of multihued cubic

volumes, rising from the

blue of the sea to the edge

of the green forest.

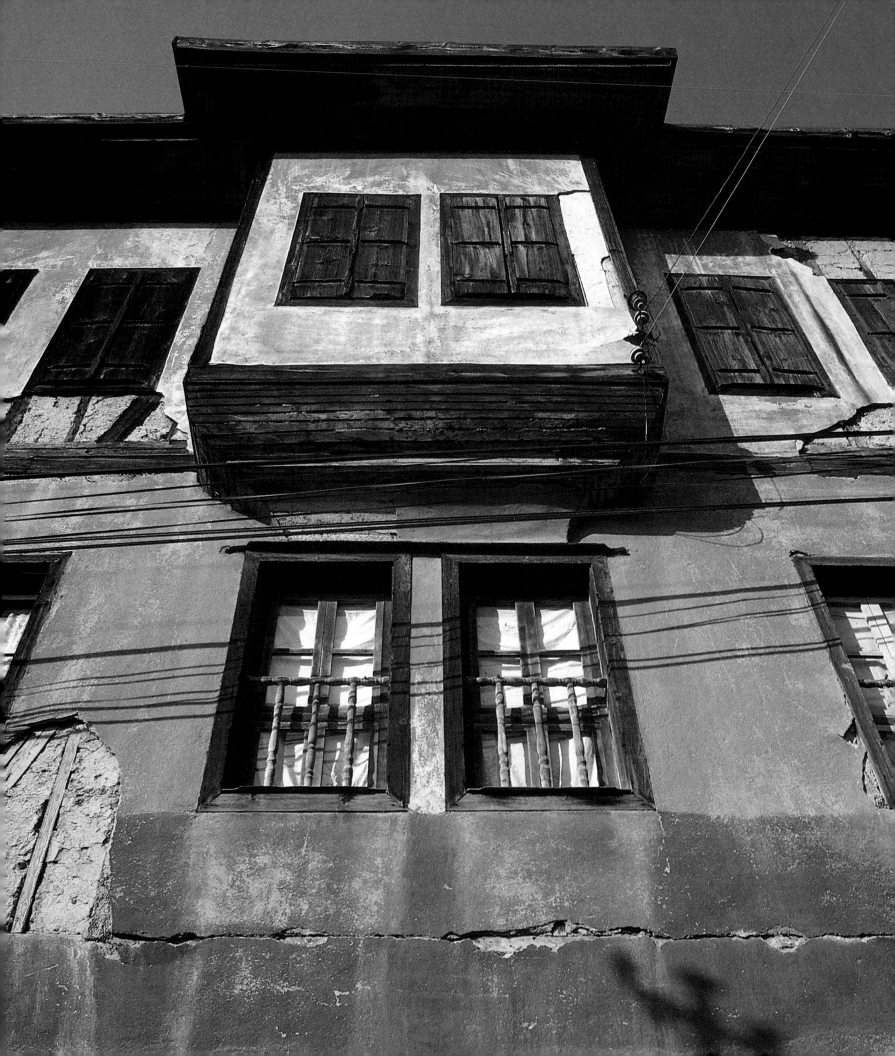

In a house where the forms of the façade reflect the spaces inside much more than a desire to assert a certain status to passers-by, the sole element affirming the socioeconomic qualities of the proprietor is the door, which, in the Ottoman house, summarizes the symbolic attributes of the façade. Marquetry, ironwork, wood sculpture, and stone combine to signify to whoever crosses the threshhold the standing of the occupant.

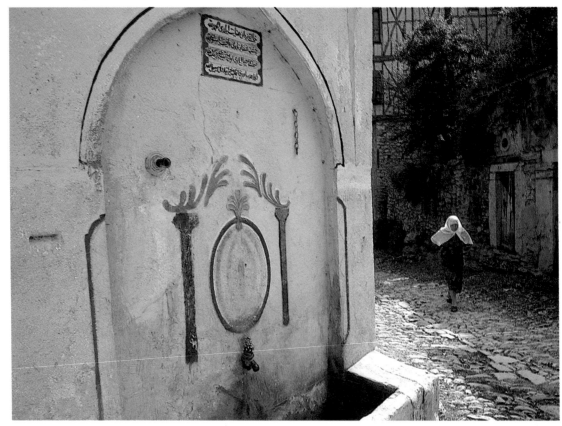

The peculiarities of the façade considerably modify the relationship of the house to the street. These are never immediately evident, but initially mediated by the character of the street. For instance, houses rarely open onto main thoroughfares; moreover, access to them is often through culs-de-sac that are semiprivate spaces to begin with. Finally, they are also affected by the position of the house, which appears to turn its back on the street while still keeping an eye on it.

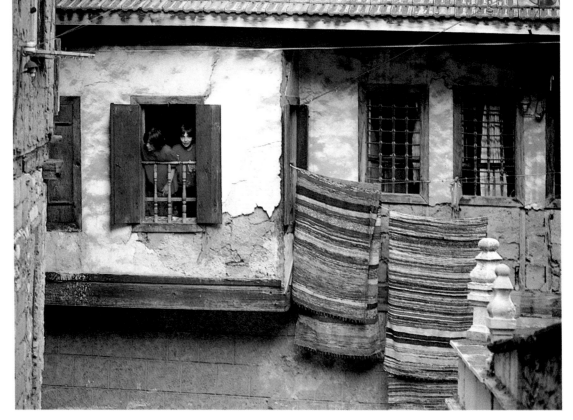

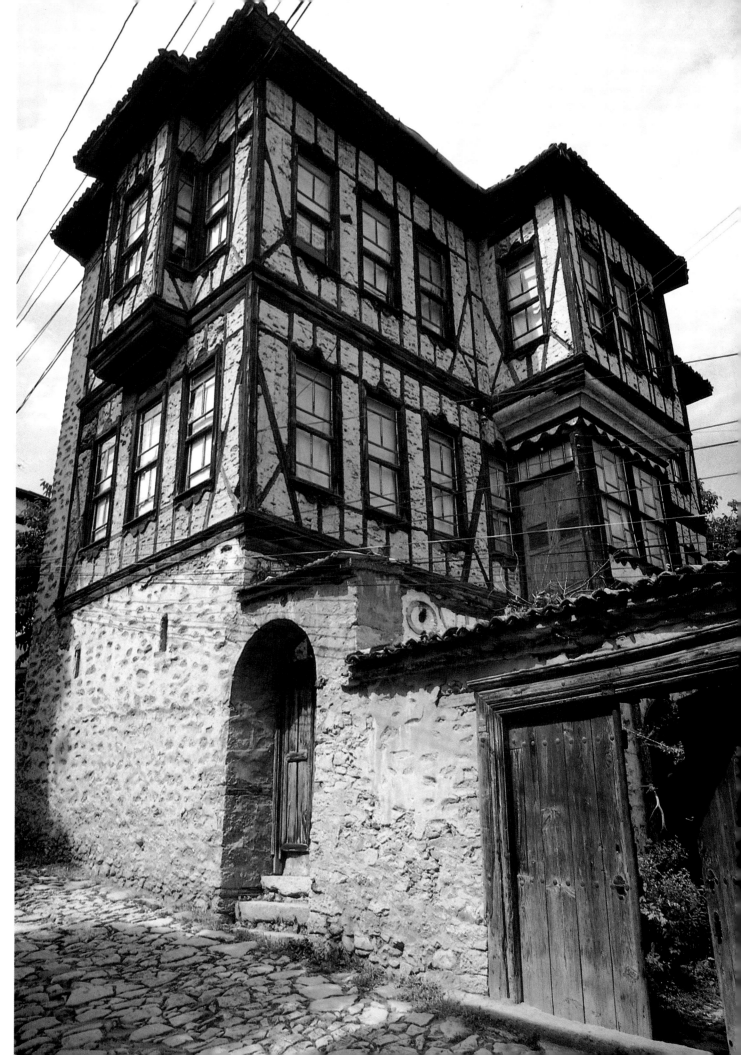

*I*n the traditional
Ottoman house
of a certain importance,
one enters first the
courtyard or the garden,
and sometimes the
entrance divides into
door and gate for animals
and carriages. The family
quarters, perched above
a wall that renders the
ground floor blind,
are turned towards the
interior, but the lateral
windows, opened on the
projected or overhung
part of the façade, offer a
direct view upon the axis
of the street, making it
possible to see from behind
curtains whoever is
knocking at the door.

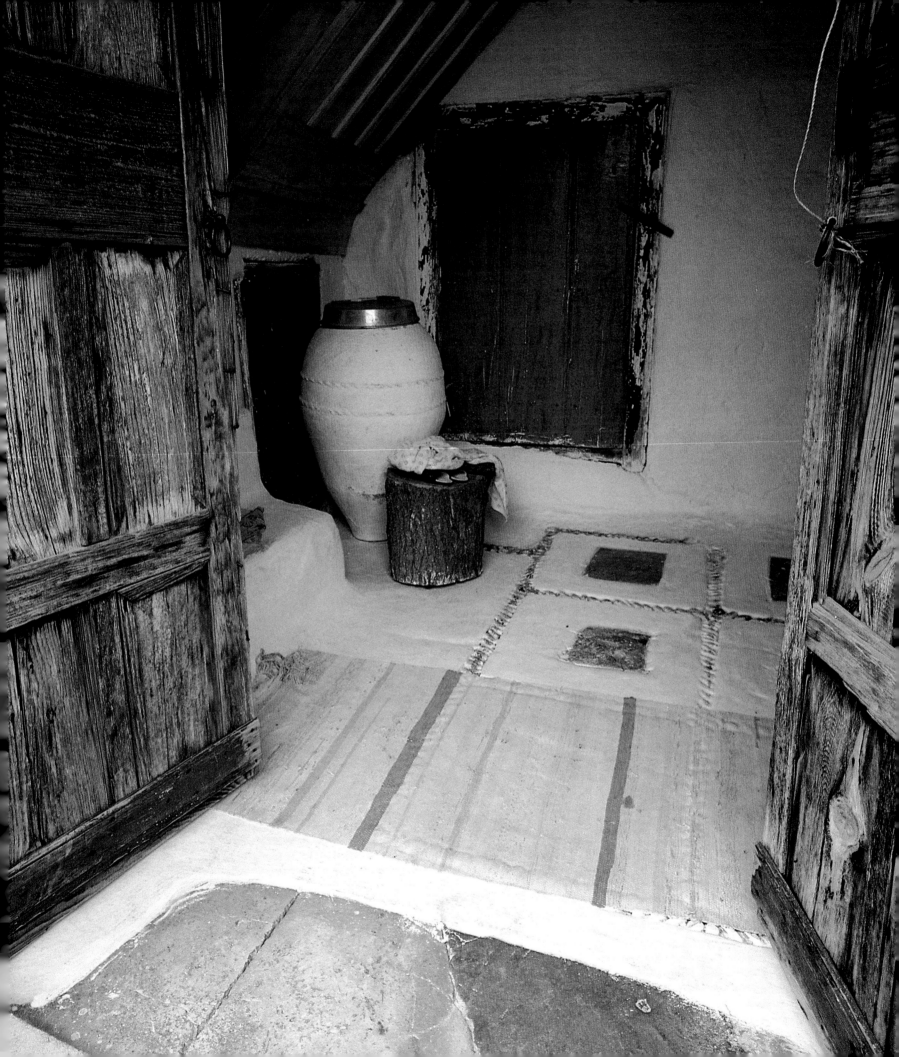

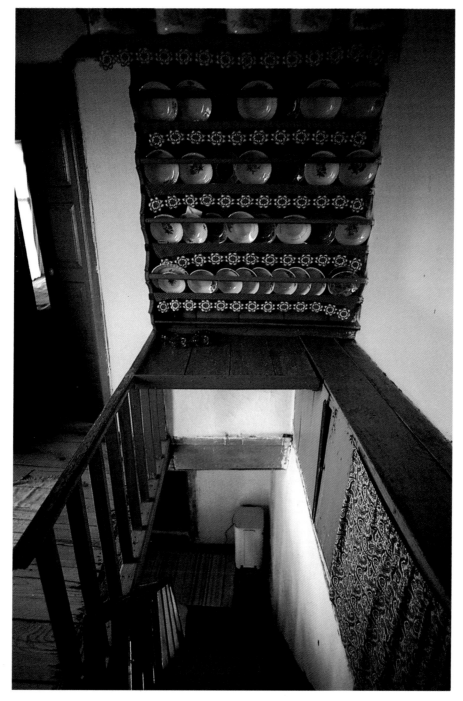

*I*n the Anatolian

house, the main floor

above – the floor where

the family live – is gained

by a flight of rudimentary

stairs that feeds into

a hayat, *a sort of veranda*

giving onto the

courtyard. This is the

scene of everyday life

and one that provides

access to the whole

ensemble of rooms on

the floor. With its

progression of windows,

its complete openness

to the elements, and its

encirclement by rooms,

the Anatolian hayat

probably gave rise

to the sofa *of the*

Istanbul house.

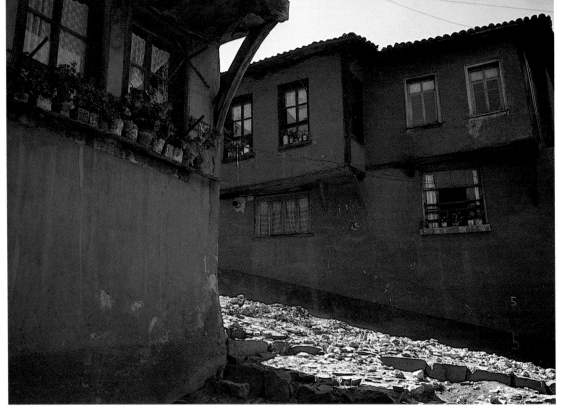

A distinctive feature of the traditional street is the sequence of overhanging structures called çikma. *These evidently provided a means to gain space, but also to regularize the surface, often made up of irregular fragments. Thus, while rooms may be haphazardly arranged on the ground floor, reserved for service, the* çikma, *by virtue of their being allowed every sort of departure from the walls below, provide living rooms of great regularity.*

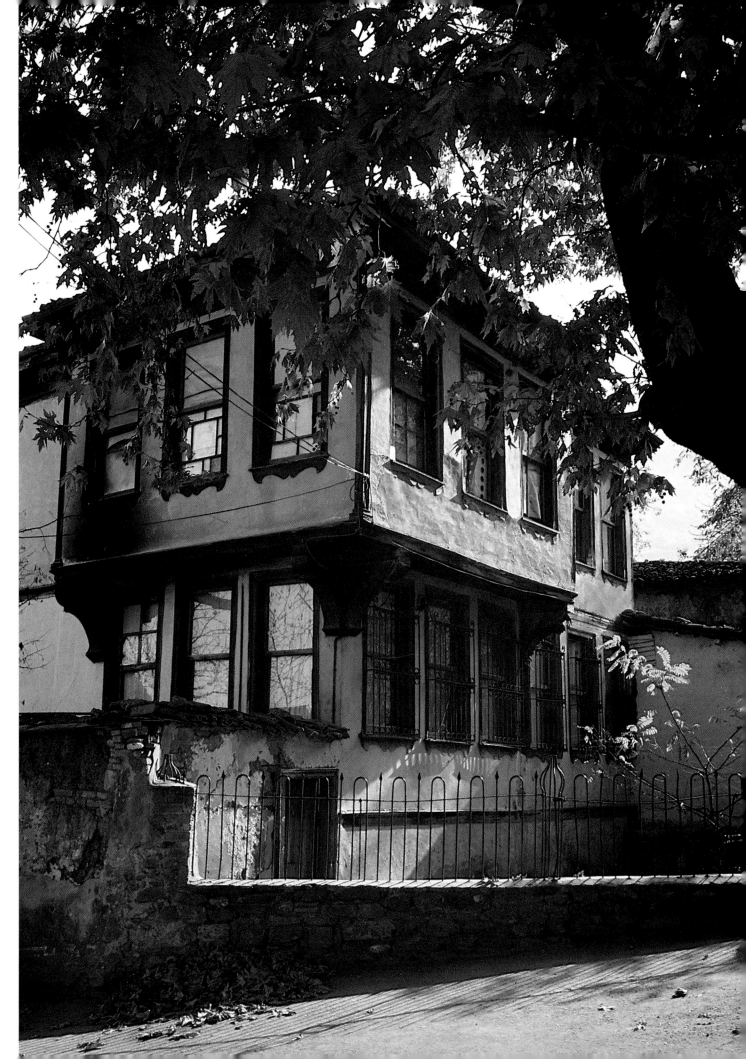

The two-sided overhang (çikma) of the main floor signifies the principal room (başoda), a large square space illuminated by two sets of three windows each, as well as, no doubt, by a side window on the right, under which runs the sedir. In this way, the person seated in the prime corner place – the mistress or master of the house, depending on the time of day – can see without rising who knocks at the door in the courtyard wall.

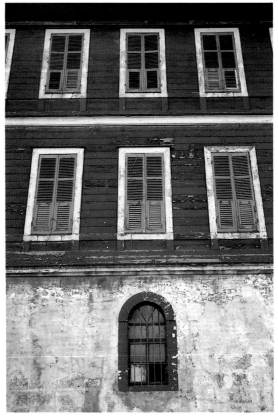

The traditional "guillotine" or sash window opens from the top, often with a counter-weight allowing the frame to be stopped halfway down. This avoids windows opening inwards, which would discommode those seated on the sedir, or outwards, which would make it impossible to view through the kafes or shutters. The replacement of the old guillotines by windows opening sideways is in itself an index of how the style of Turkish life has changed.

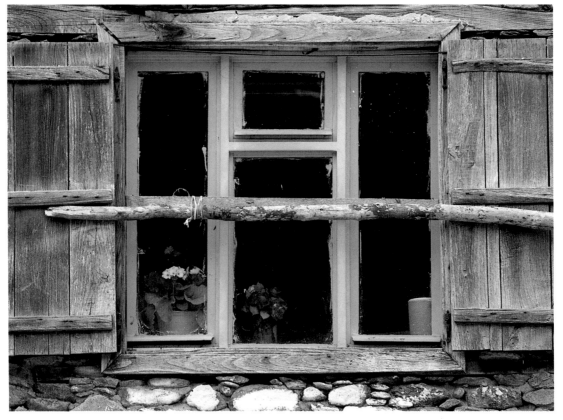

*H*ere, the

monumentality

of the steps and portal,

reinforced by the

perspective effect of their

position in depth,

leaves no doubt about

the importance of

the occupant. If this

transforms the visitor into

a supplicant, so does

the marble enframement,

helped by painted colors

and axial placement

within a recess between

two overhanging çikma.

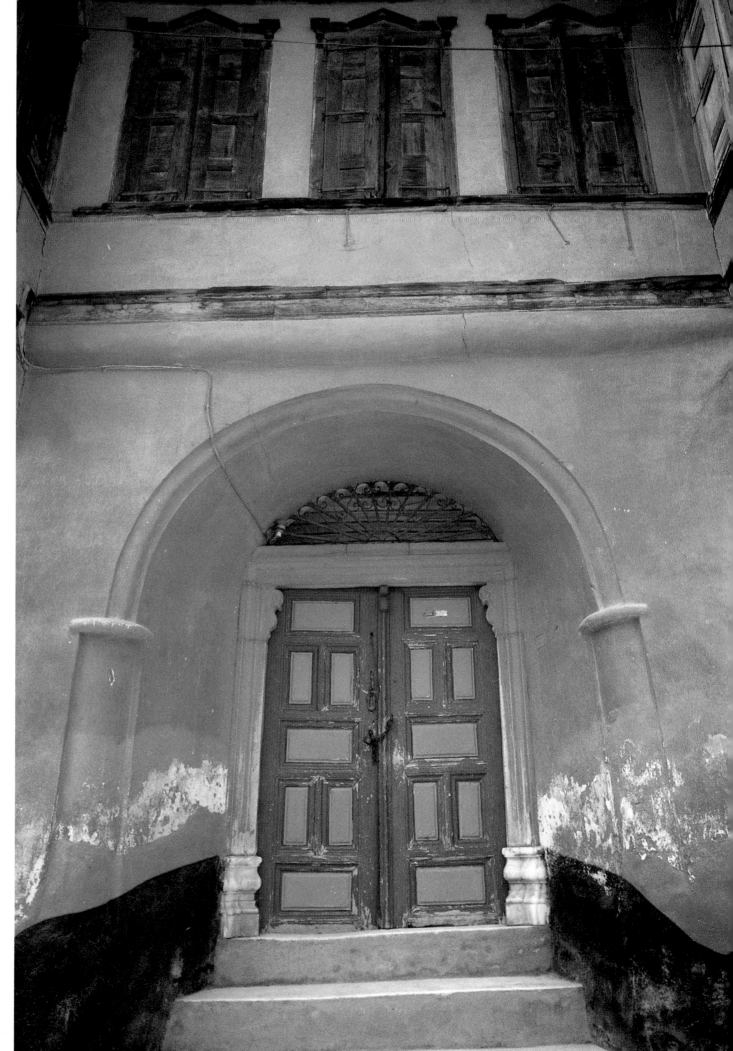

A play

of apertures and lights:

Above an entrance door,

a window that

illuminates an

antechamber giving onto

a blind façade;

a ventilator filtering light

into a service area

on the ground floor;

a grille that allows

occupants to lean

forward in order to see

who knocks at the door,

or permits a child to play

without danger;

and, finally, a fantasy

palace applied to

a façade and destined

to become a nest

for sparrows.

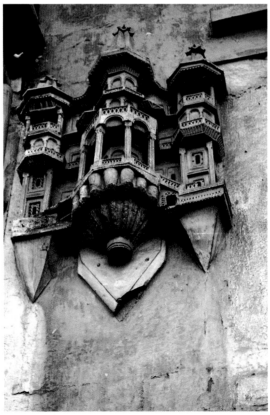

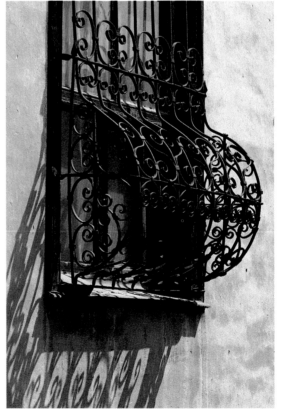

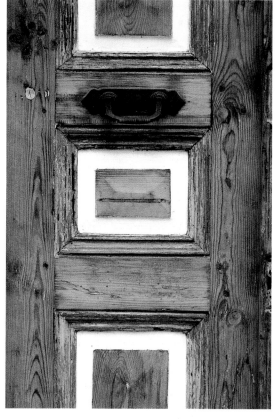

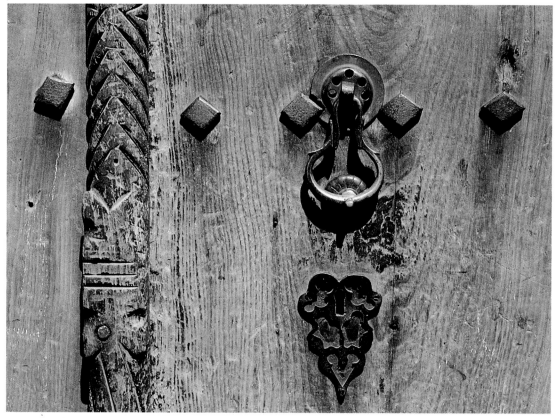

*A play

of closure and color:

the ambiguous desire

to make welcome difficult

yet also to honor guests,

while simultaneously

impressing them with the

importance of the host.

The infinite subtleties

of civilization, where

thresholds are to be

crossed but never violated.

Here, for instance,

two door-knockers differ

in both size and material,

because one is for male

and the other for female

visitors; consequently,

by their very sound,

they announce to

the occupants the sex

of their callers.*

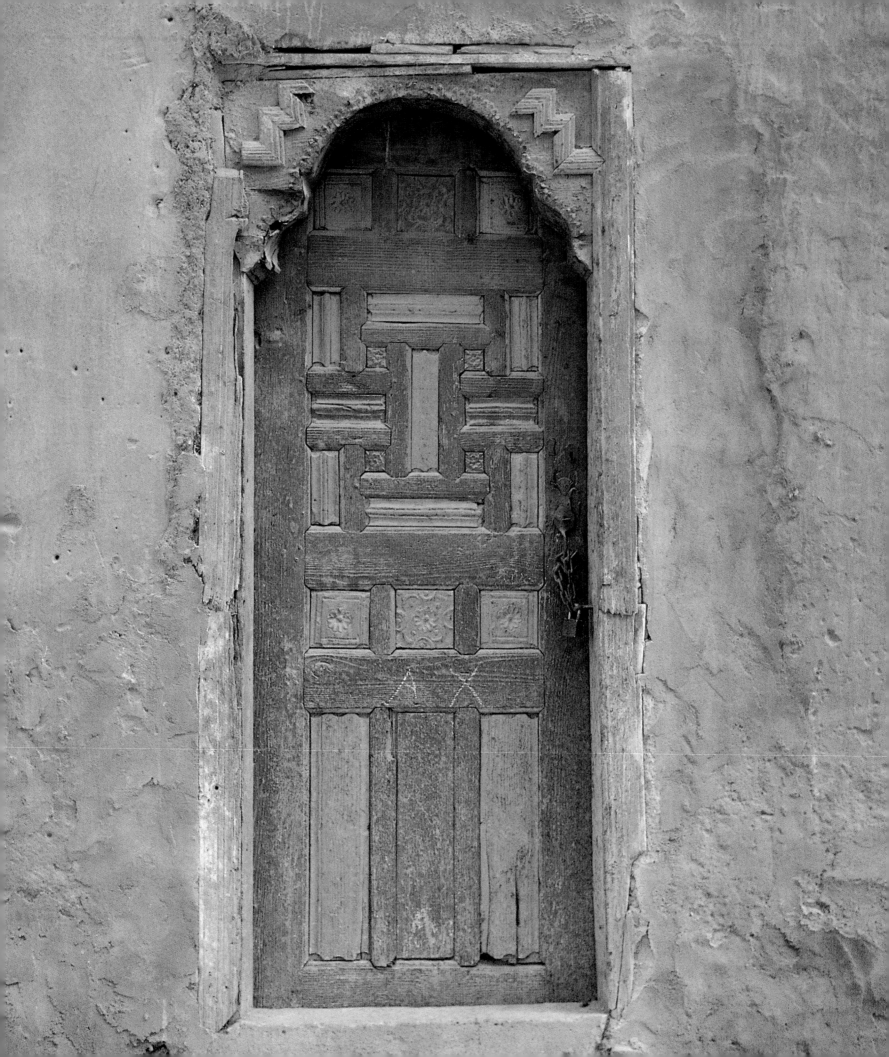

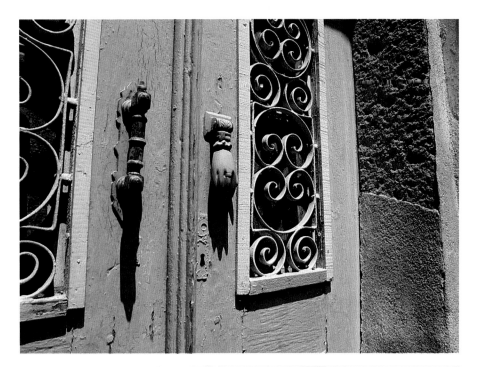

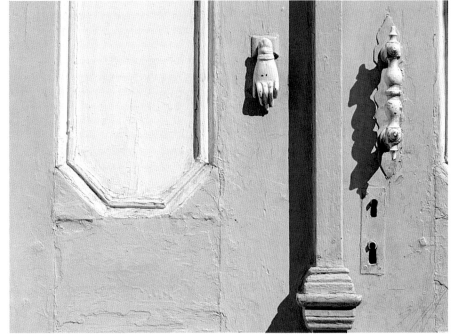

In Greek houses on the Aegean coast – here at Ayvalik – the door-knockers are shaped like women's hands. One left hand wears a ring on the engagement finger, in the traditional Greek way for a fiancée. A visitor grasping this hand in his own becomes a suitor.

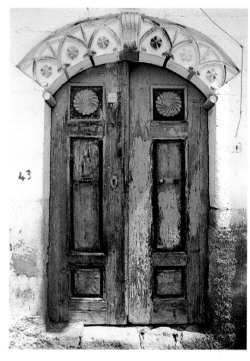

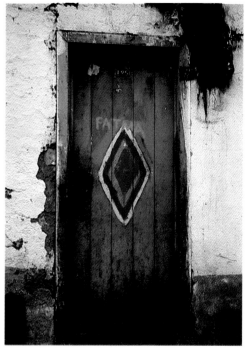

\mathcal{W}alls are either whitewashed or painted in natural colors — red, ochre, indigo. This kind of painting, which is renewed every year, does not lend itself to figurative work, and only rarely, as here, does one find simple images, which nonetheless seem never to lose their freshness.

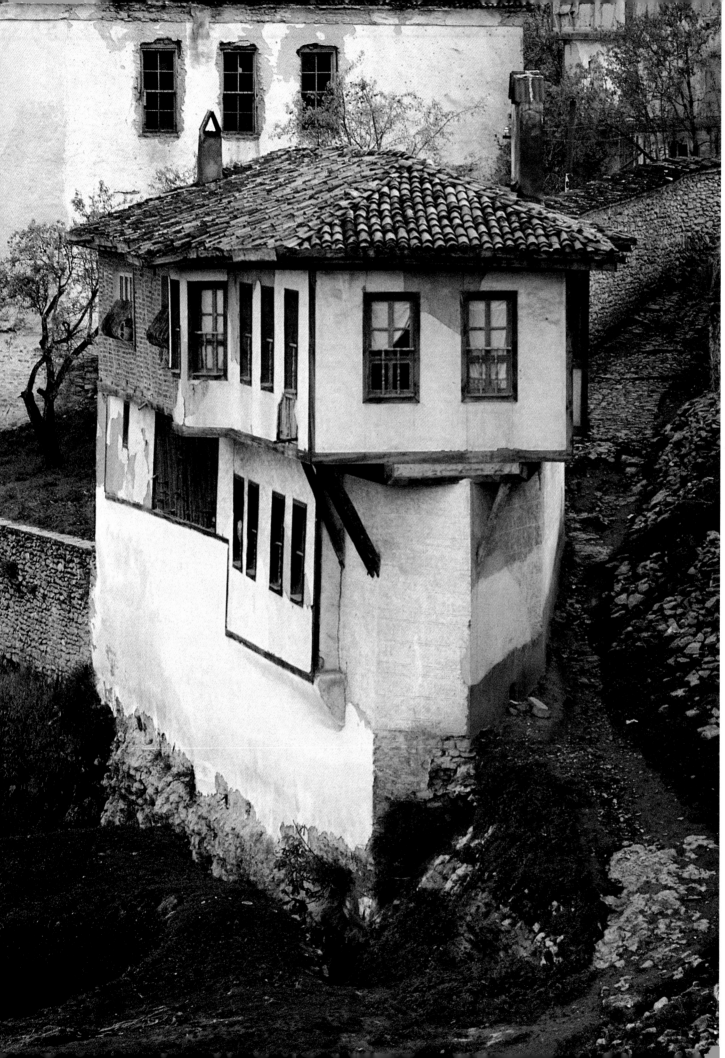

A corner house, by the various possibilities for orienting it, offers distinct advantages, but also a challenge, especially when the angle is as acute as this one. The master mason surpassed himself and succeeded, by means of a combination of supporting struts and corbels, in creating a rectangular başoda *on the main floor.*

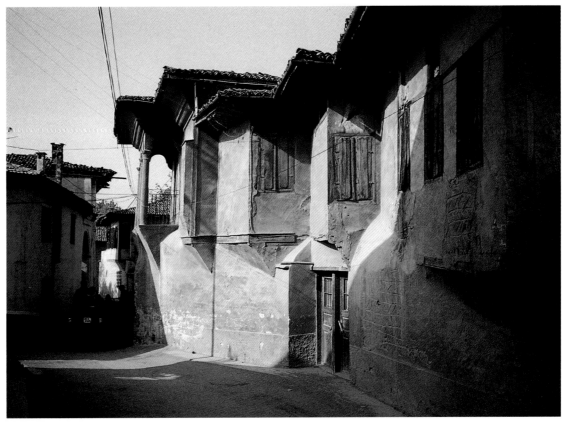

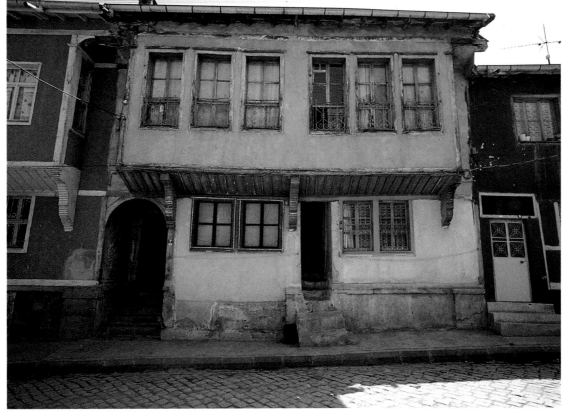

Houses deployed along curving streets often present an abundance of çikma, crowned by massive cornices and intended to compensate for the grade-level wall with a multitude of pyramidal forms. In a straight street the çikma are more soberly aligned, which creates a certain community of interest among owners and thus the feasibility of side windows.

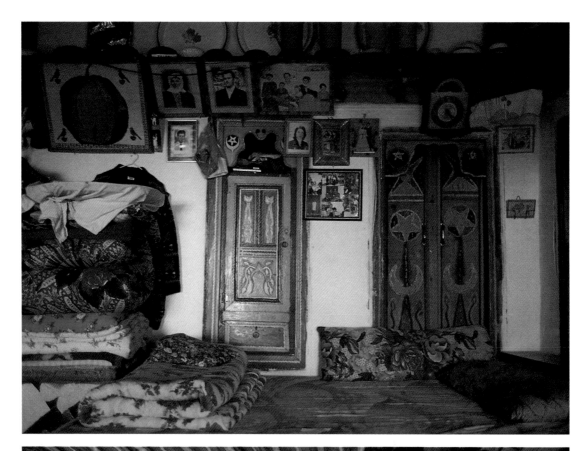

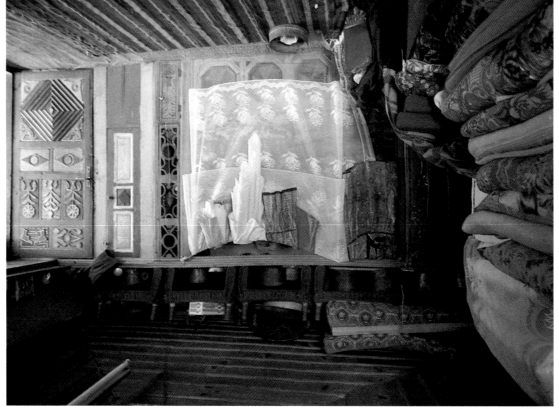

Ordinary rooms

for everyday use.

Bedding, consisting

of cotton- or wool-filled

quilted blankets with

sheets tacked onto them

are neatly folded and

ready for the night.

The sergen *– a simple*

overhead shelf running

the length of the wall –

is heaped with objects.

Modernity asserts itself

in family photographs

and the naïve painting

of a watermelon.

The kitchen is a room rarely seen in traditional Turkish houses, since cooking was done in the courtyard. Located on the ground floor, it is often combined with facilities for daily tasks, which accounts for the name işevi. *Preparation, like the consumption of the meal, is done on a cloth, a piece of leather, or a decorative copper tray* (sini) *placed on the floor. Sometimes vessels are laid out on a low folding table called* sofra.

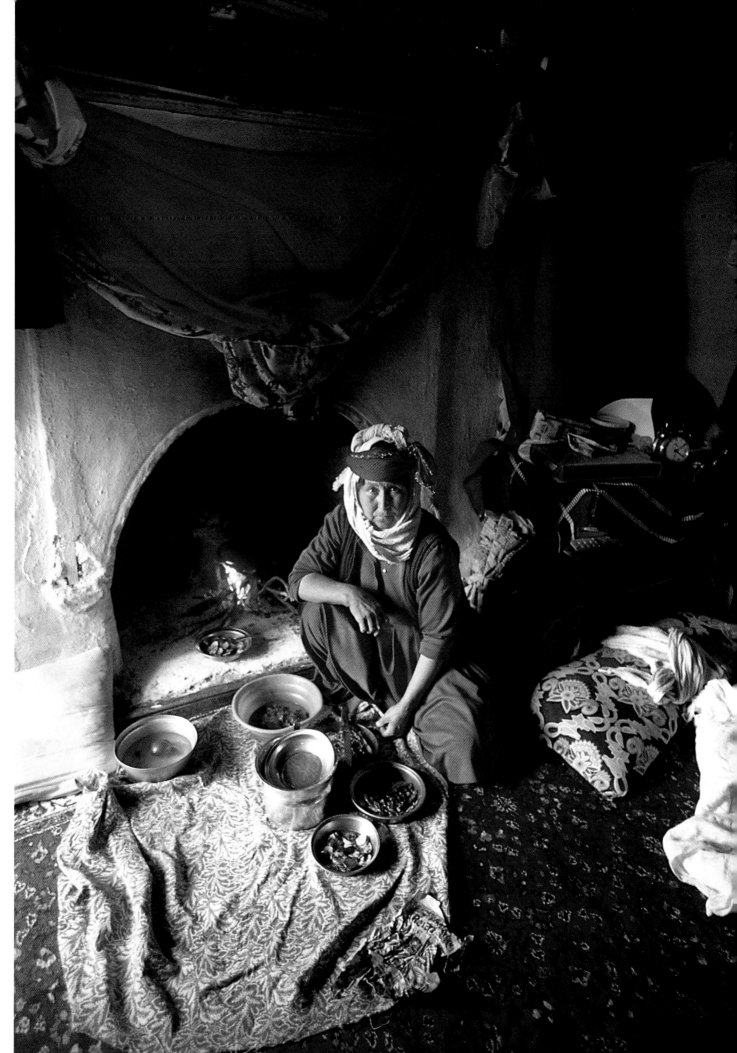

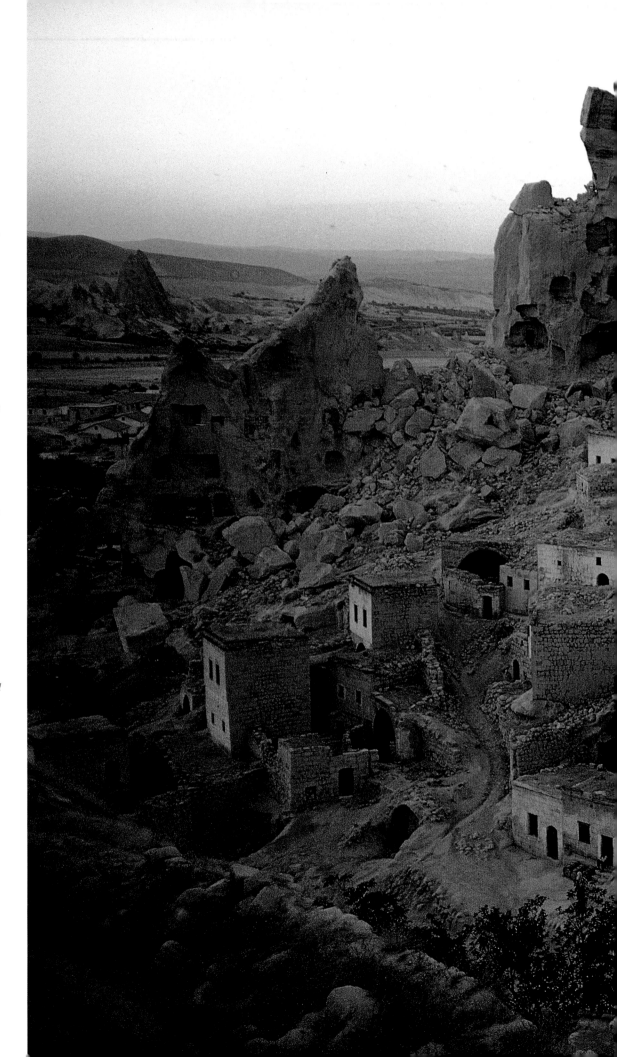

The village of Çavuşin in Cappadocia. Under a cliff pitted with excavation sites, which still shelter proto-Byzantine churches, are houses built of stone quarried from the surrounding rock, with the result that only by their whitewash can they be distinguished from the mineral environment. Moreover, their rooms often extend deep into troglodyte cavities.

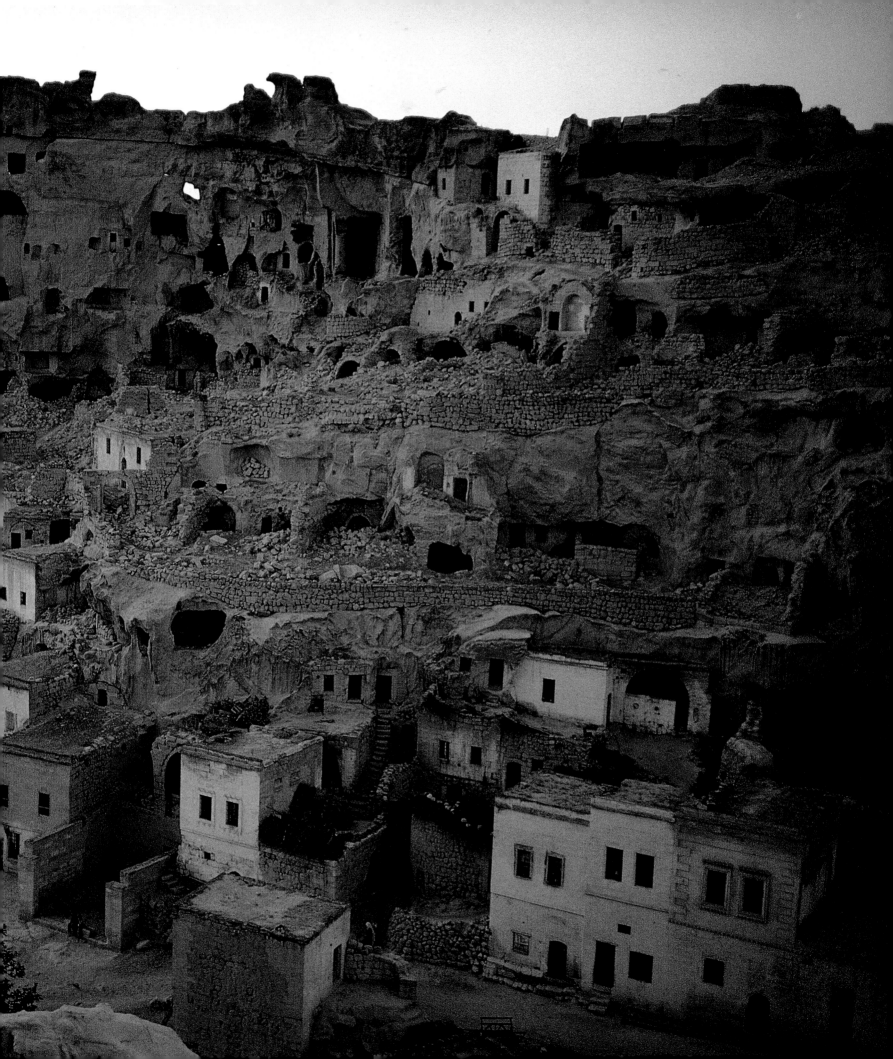

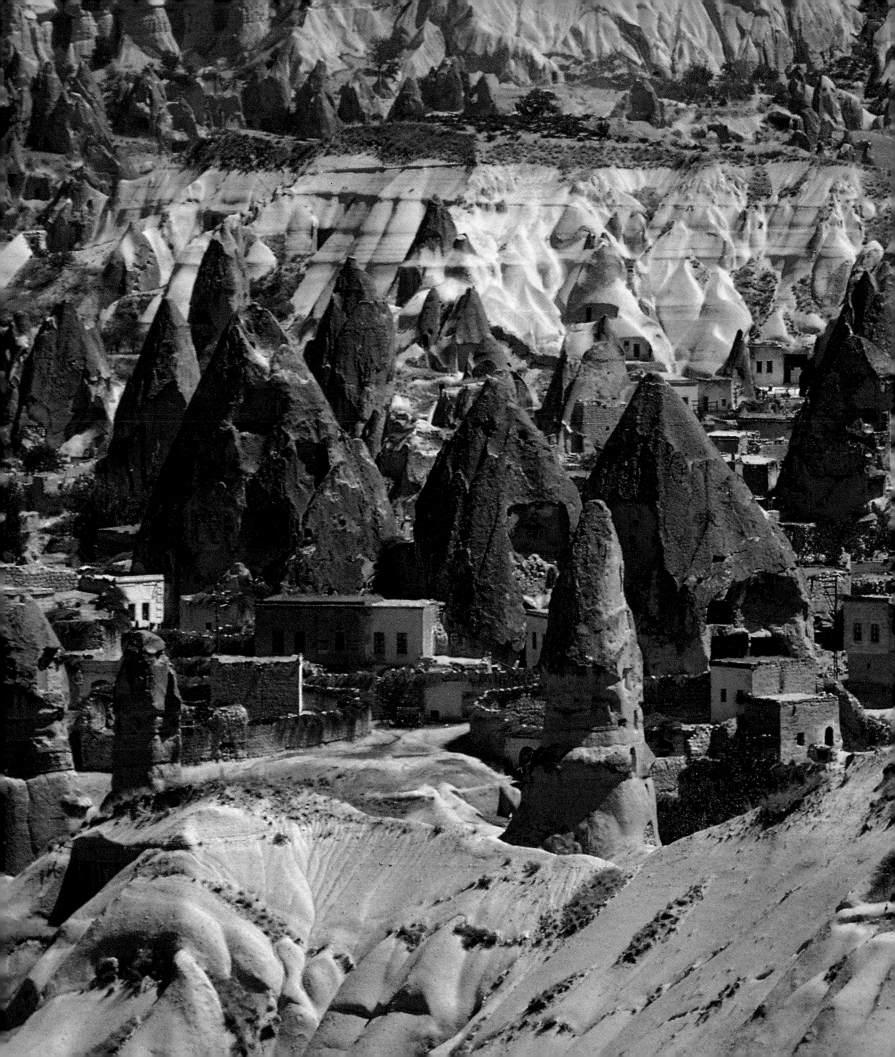

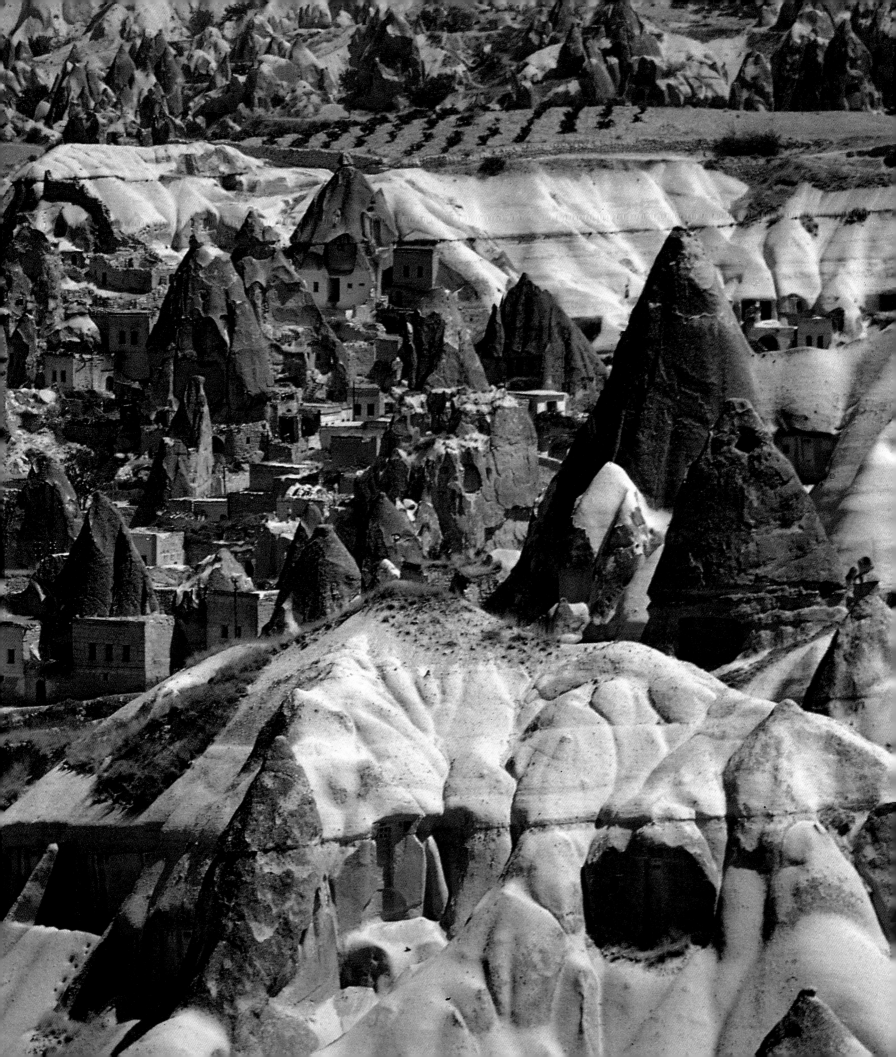

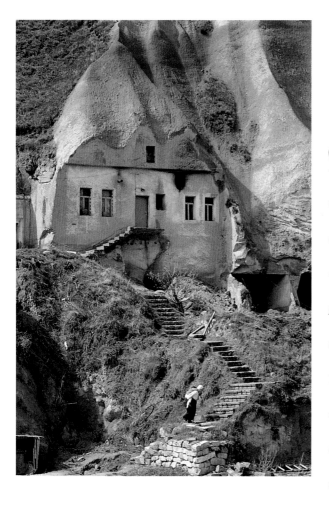

The villages of

Cappadocia, where cubic

houses alternate with

conical formations and

peaceful villagers live in

the very cradle of history.

The onetime tombs

of anchorites now serve

as goat mangers,

old column shafts pack

together for roofs

of beaten earth, and

shepherds sleep under

frescoes of cherubim in

chapels excavated at the

heart of the mountain.

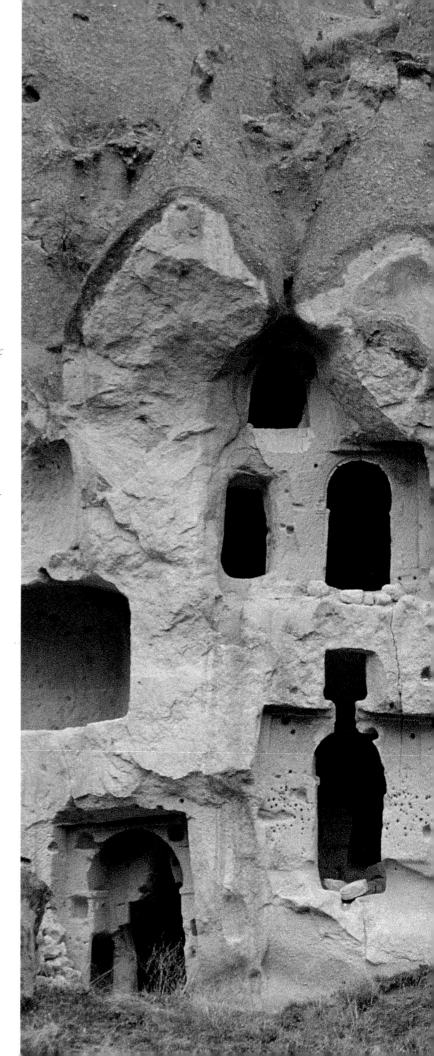

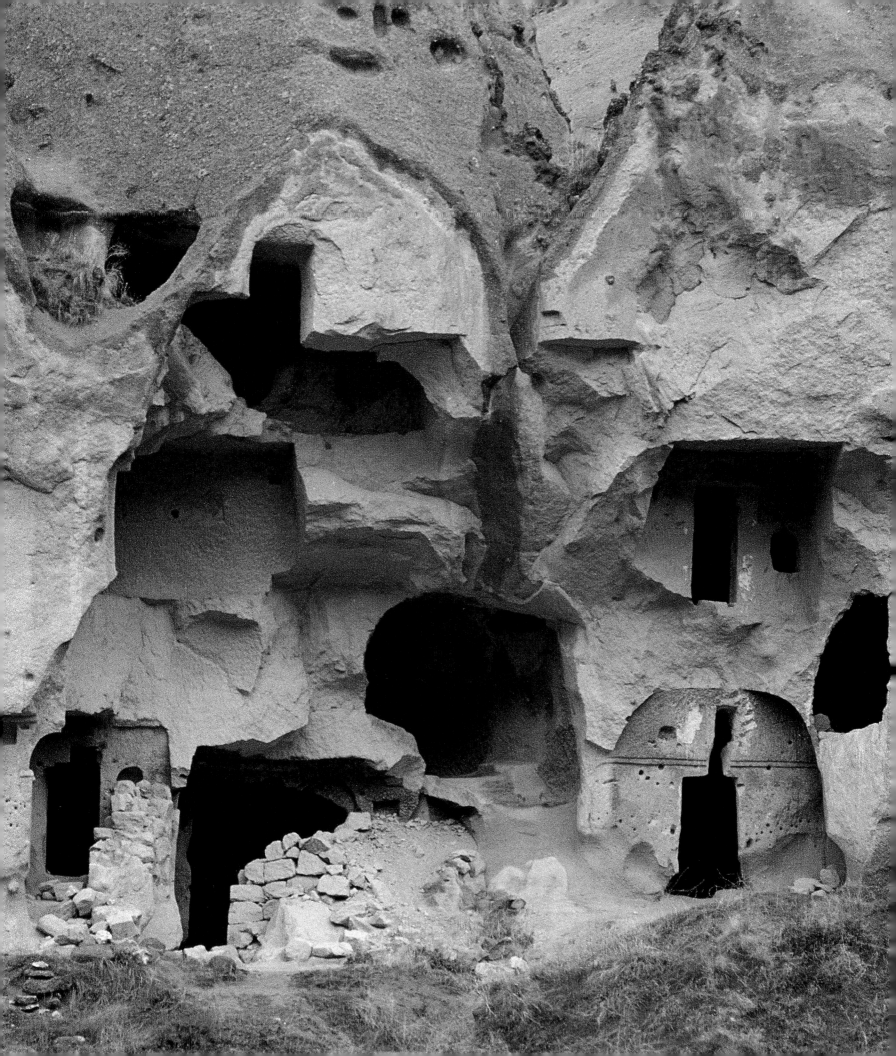

The houses

of Cappadocia, owing to

their stone construction,

stand somewhat apart

from the traditional

Ottoman house. Indeed,

they are more like the

houses of southeastern

Turkey, a region subject

to Arab influence. Still,

even here, one finds

dispositions similar

to the large floor-through

sofa flanked on all sides

by living spaces.

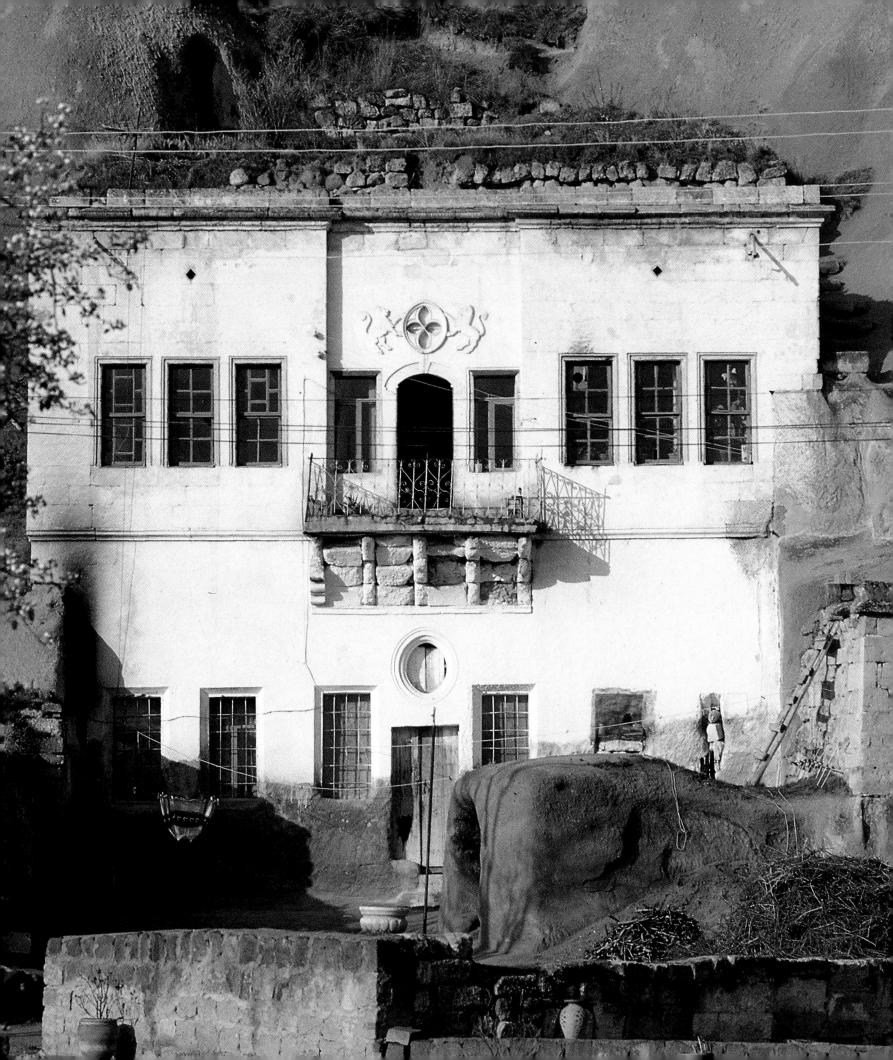

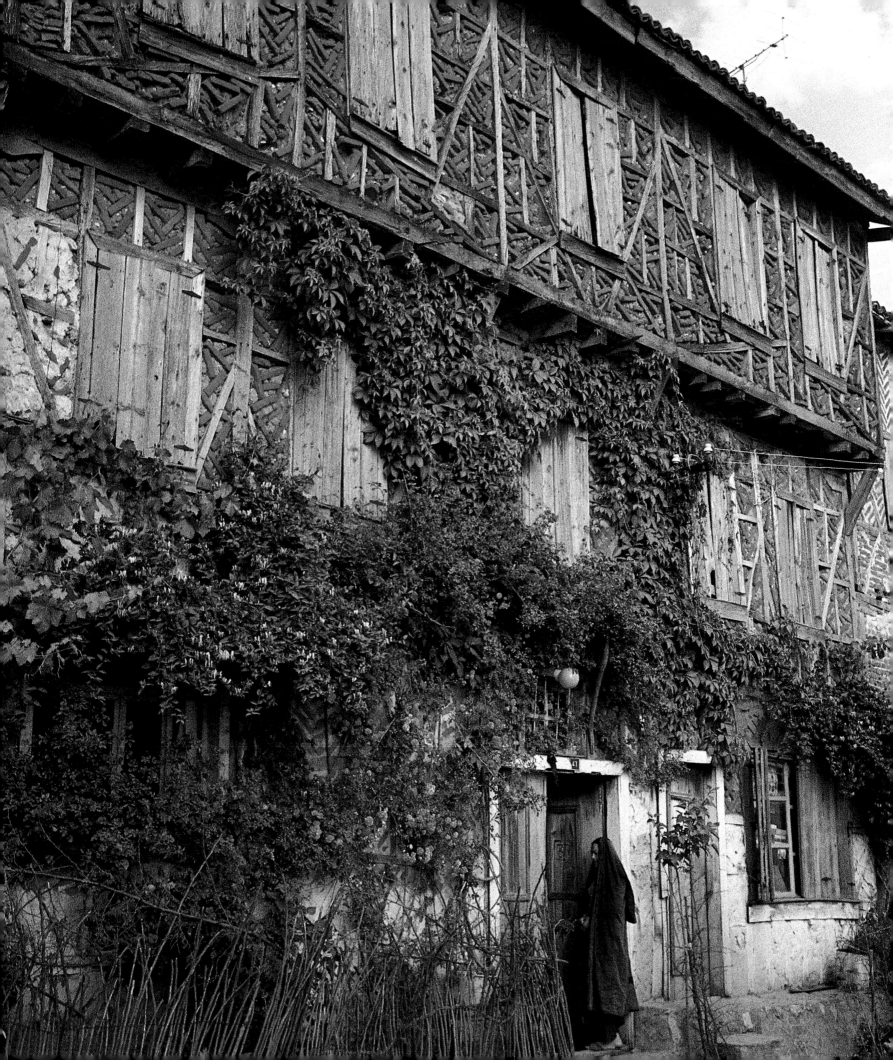

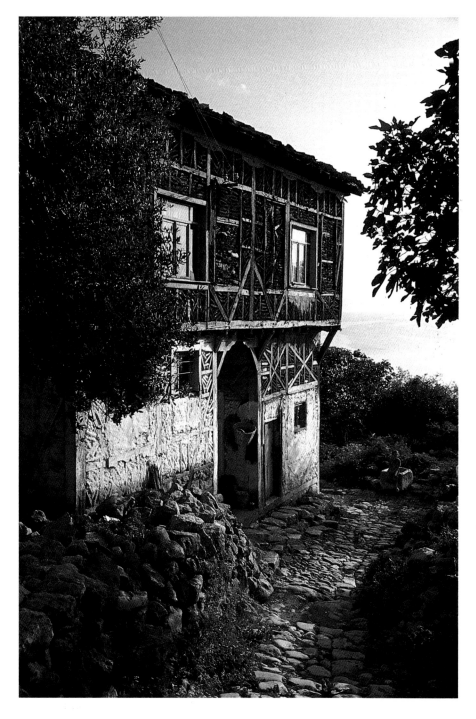

The basic structure of the Ottoman house is a timber skeleton, constructed in several days and quickly roofed over, with the interstices then stuffed with bits of brick, dob, stones, or whatever salvage happens to be available. An in-fill of relatively noble and permanent materials, such as the brick seen here in houses on the shore of Lake Manyas in western Anatolia, allows the structure to remain exposed; otherwise, it would be plastered and whitewashed.

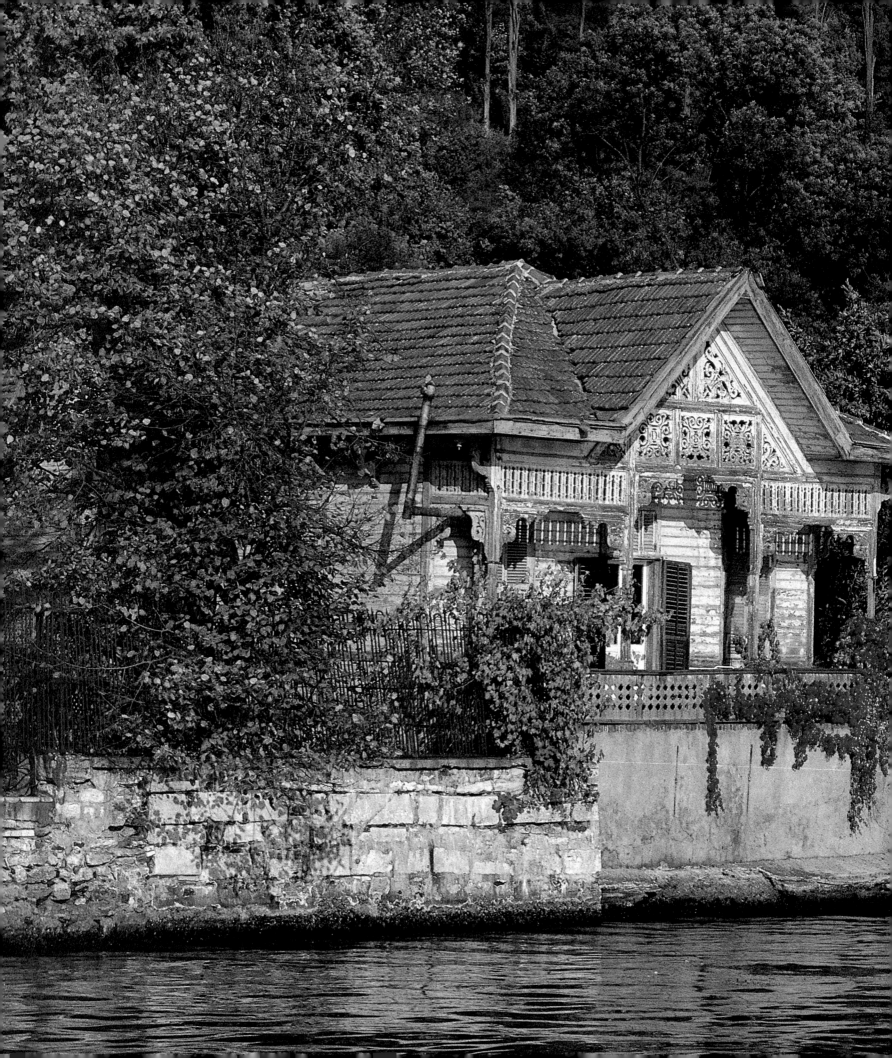

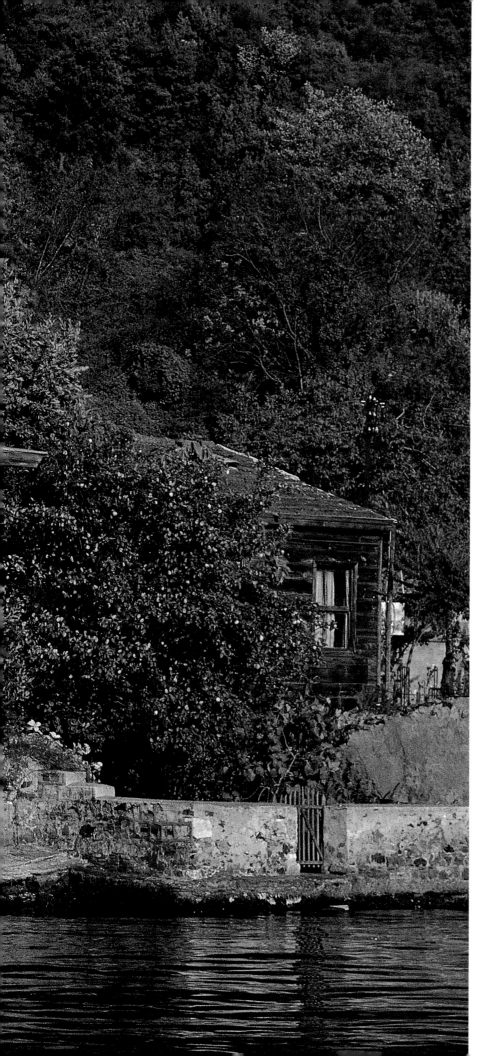

The status of wood, as the material of choice for the Ottoman house, becomes ever more evident the higher one climbs in the hierarchy of Turkish buildings. After the dob-built houses of the Anatolian villages and the filled-in, whitewashed timber frames of the townships come the houses of Istanbul, in which wood tends to be integral, whether brightly painted, as in ordinary houses, or elaborated and painted white in more refined dwellings.

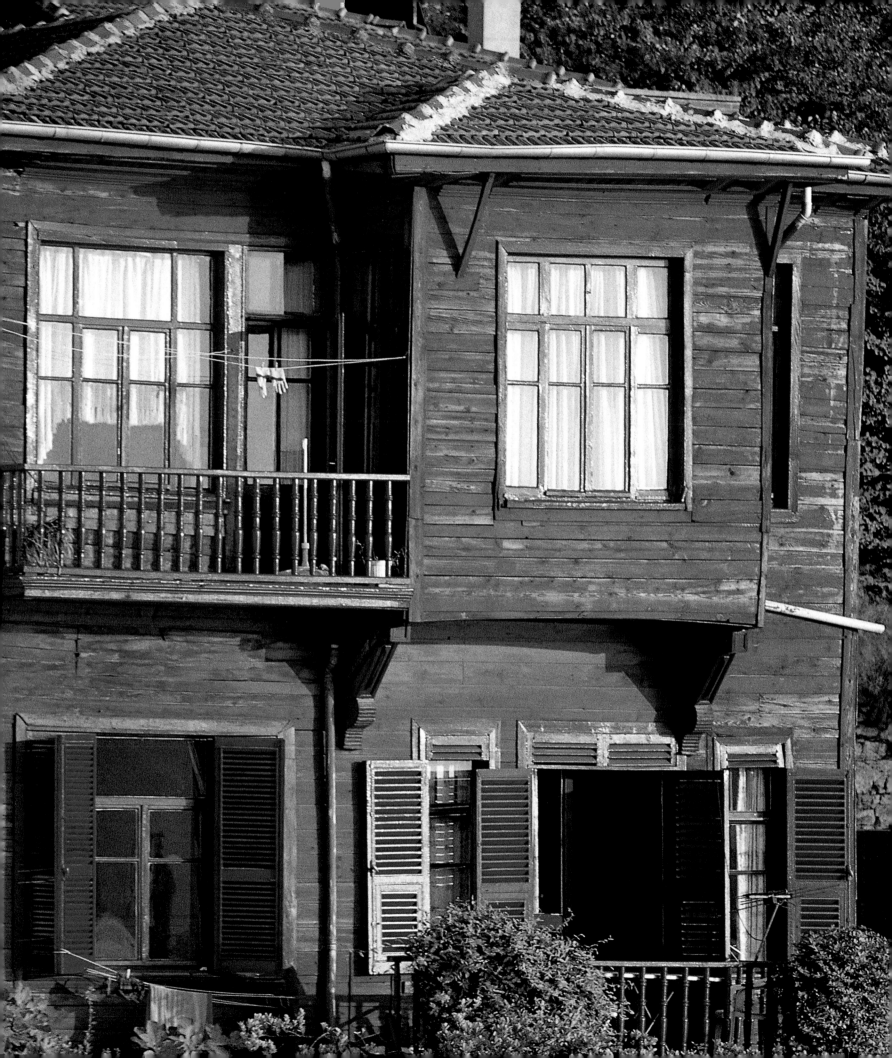

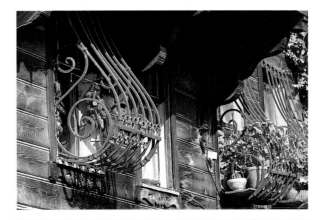

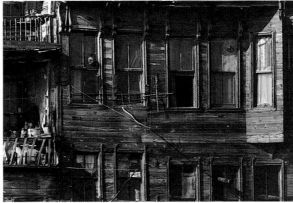

*I*stanbul houses,

where wood reigns

supreme, despite the

presence of modernity

in certain features,

such as balconies and

roofs of flat rather than

rounded, Roman tiles.

Abandoned,

commandeered by

impoverished

immigrants, occupied

by old Stamboul folk

of modest means,

or rehabilitated by upper-

class families, they

proudly bear witness to

a bygone era.

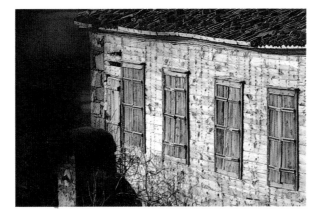

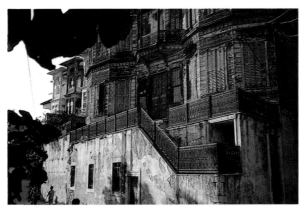

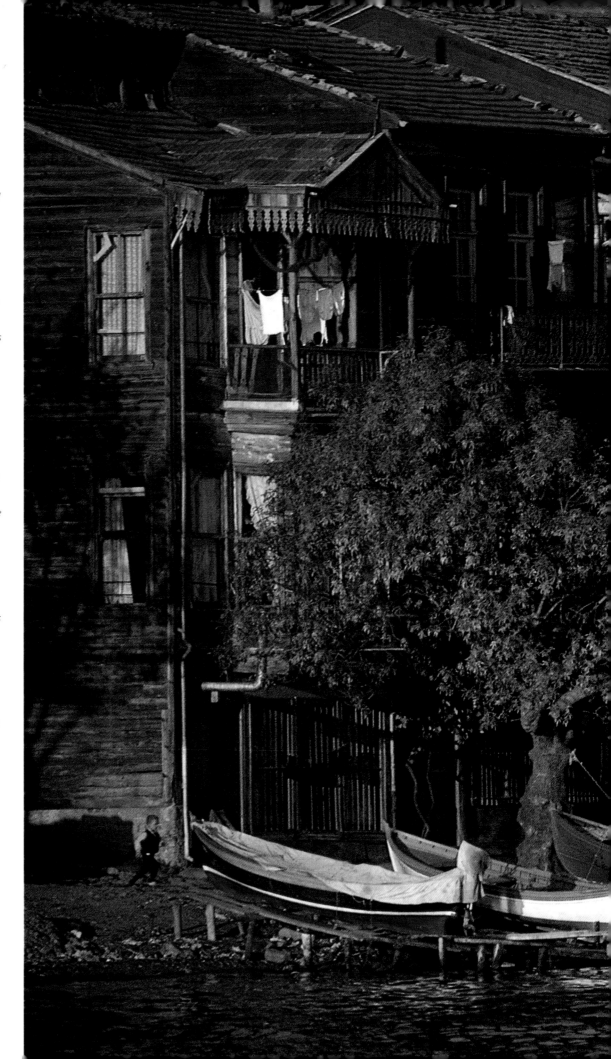

Another Istanbul characteristic: joint ownership, made necessary by the densely populated city. It renders intimacy altogether relative and causes the house, which here can be day-lit from only two sides, to depart quite radically from the traditional order of things. The sofa becomes a dark passage, while rooms pile one on top of the other in buildings that stretch higher and higher.

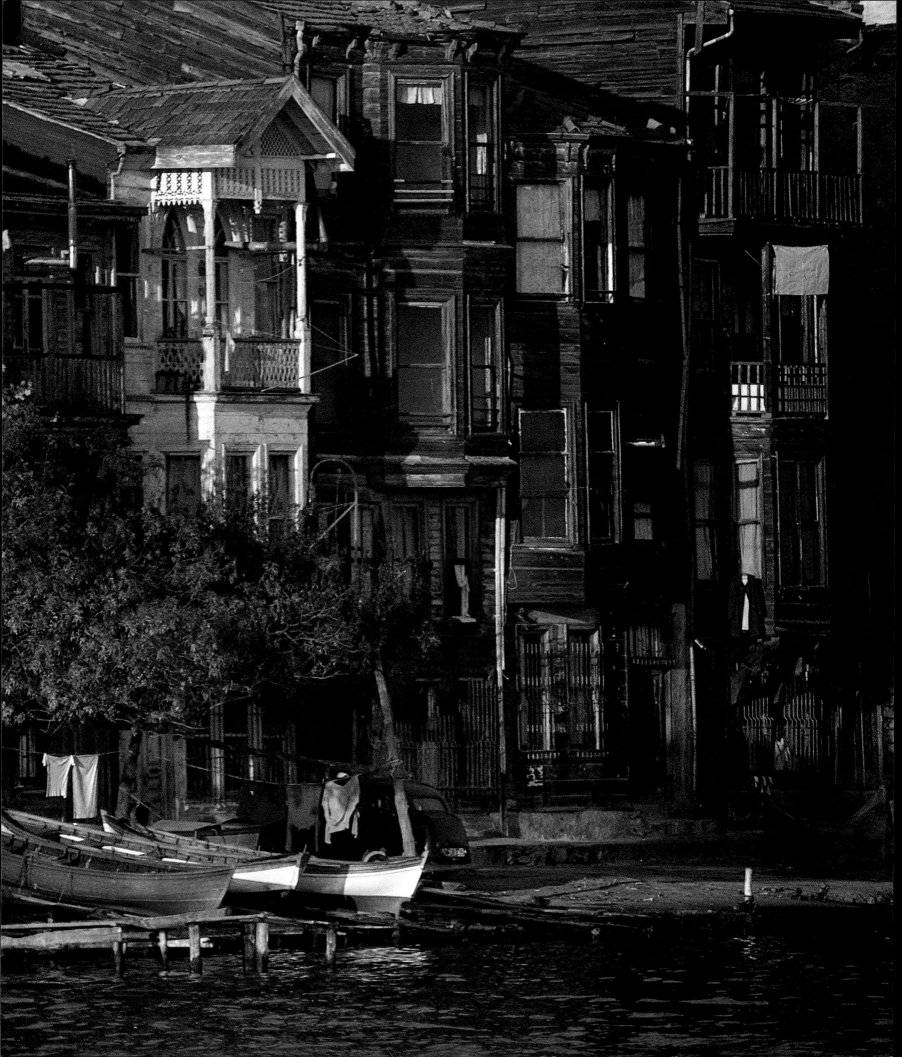

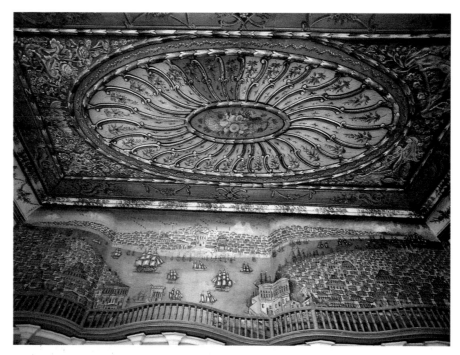

The 18th-century house of Çakir Ağa, a notable of the small town of Birigi in the Aegan hinterland. Here (*OPPOSITE*) the oda is divided into two parts: the entrance where the dolap are found, and the sitting area with its low step or platform (seki) and a balustrade. The fireplace and the trompe-l'oeil draperies indicate Occidental influence, while the landscape murals offer idealized views of Istanbul (*ABOVE*) and Izmir.

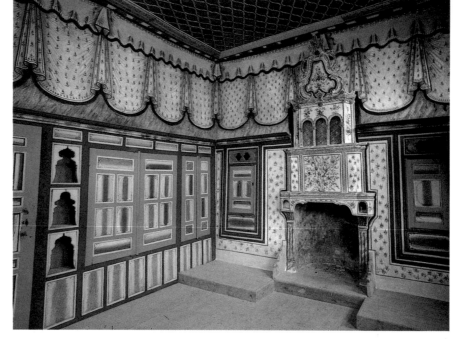

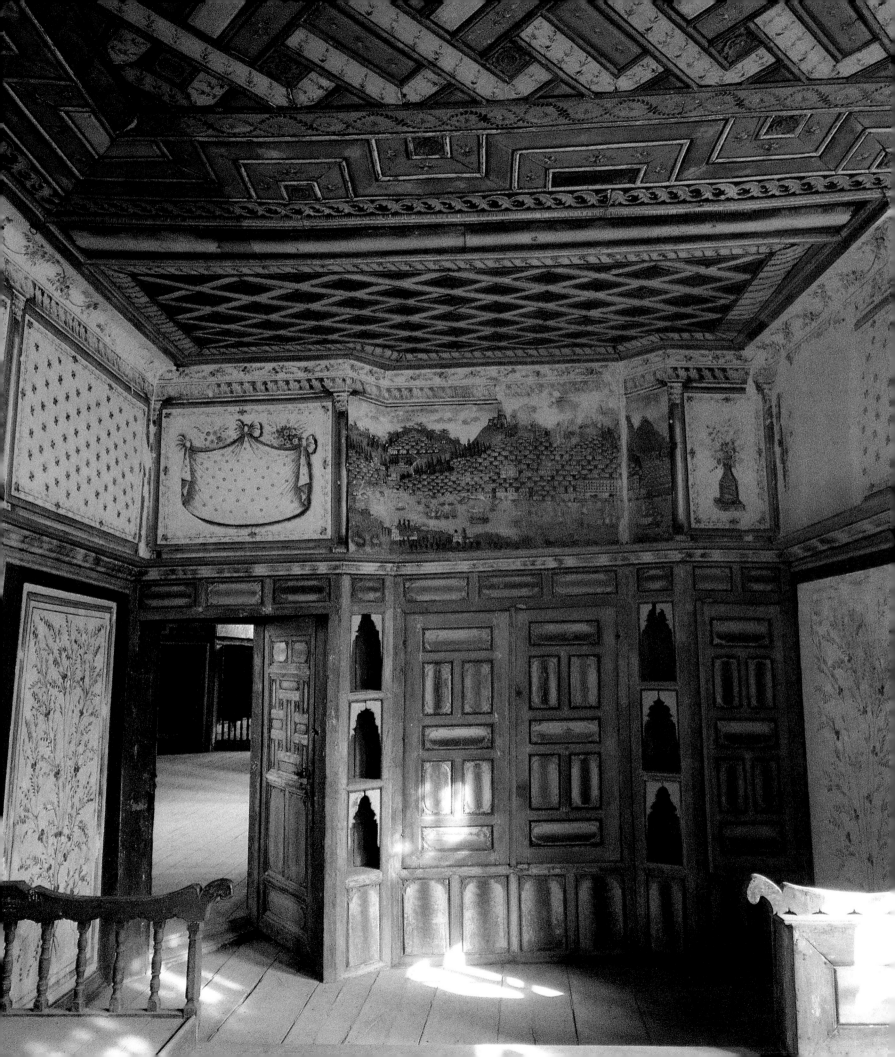

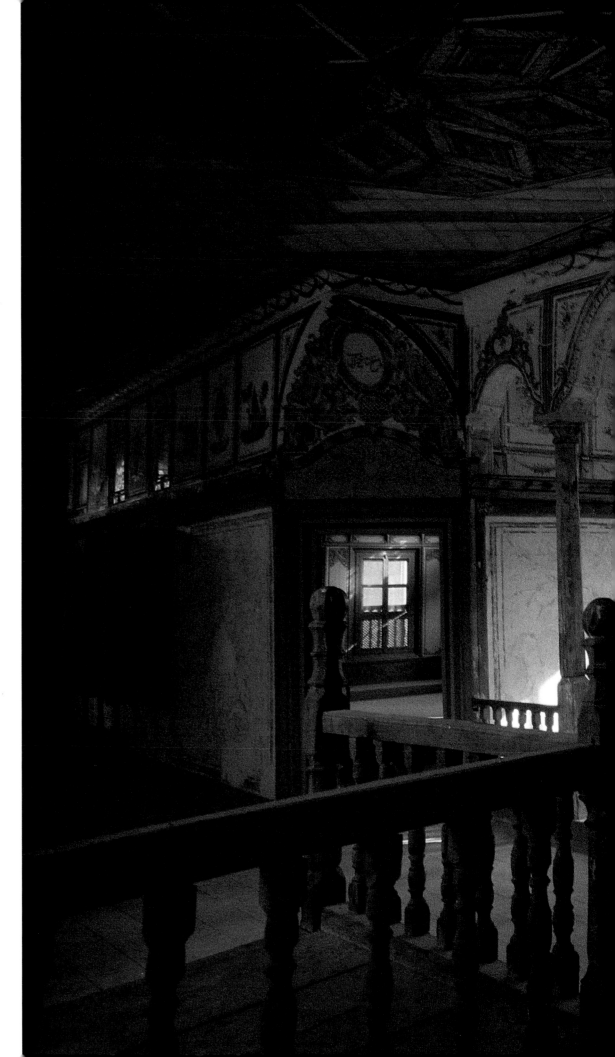

The hayat *in the house of Çakir Ağa, windowed on the garden side and extended on the street side by an* eyvan. *The latter, where one may also sit, is separated from the* hayat *by a* seki *and a balustrade terminating in a pair of columns, a normal arrangement and often found as well in the* oda. *As usual, the doors leading into the* oda *are so placed as to form cut-off corners.*

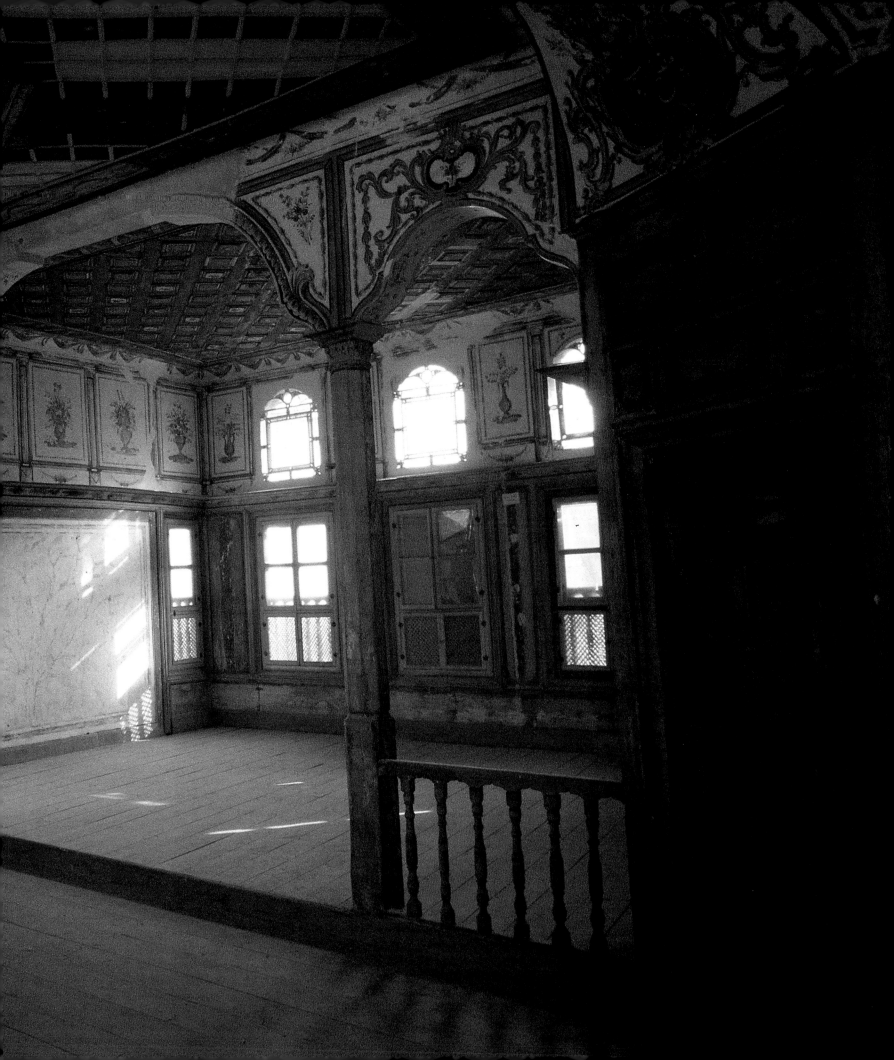

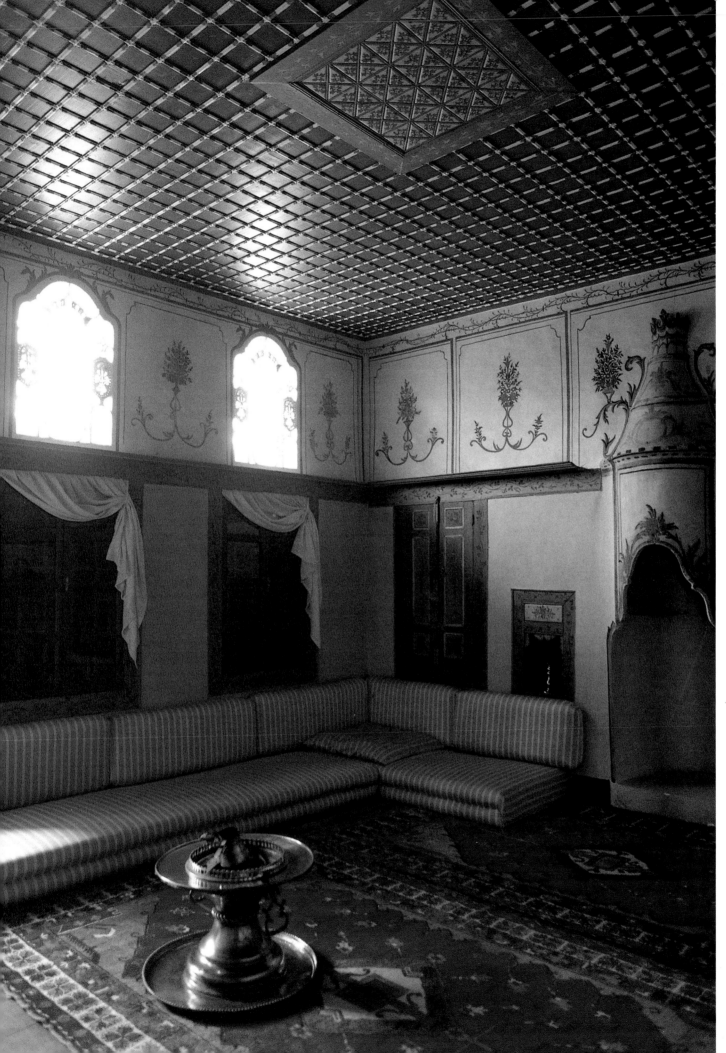

The Şemaki family, who immigrated in the 18th century from the Persian city of Chemakha, established themselves at Yenişehir near Bursa. Their house, restored by the Turkish Ministry of Culture, has been turned into a museum. All the rooms possess stacked pairs of windows, the ones above equipped with fixed stained glass and those on the bottom with exterior shutters (the inward-swinging mullioned panels were added later). The brazier (mangal) at the center is for preparing coffee.

*D*olap,

or cupboards, and niches

in the house of the

Şemaki. The floral décor

on the wood paneling,

as well as the ceiling

with its moldings,

is characteristic of the

classic Ottoman style and

must date from periods

older than the house

itself. On the other hand,

the little perspective views

evince the first symptoms

of Westernization, which

commenced around

the beginning of

the 18th century.

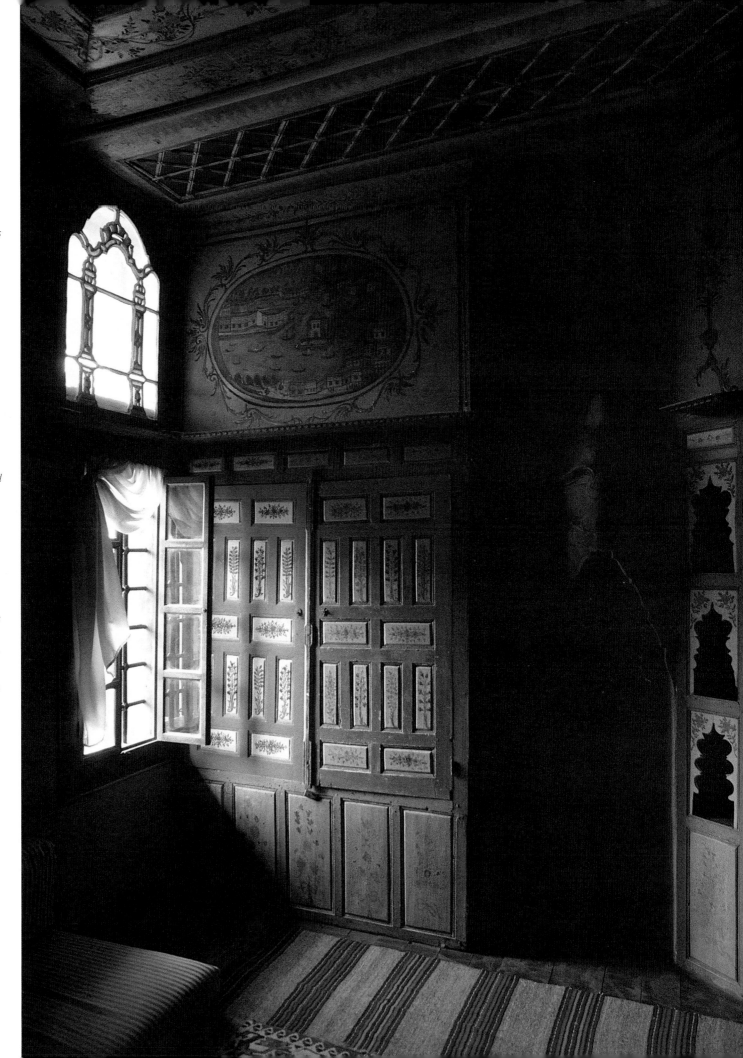

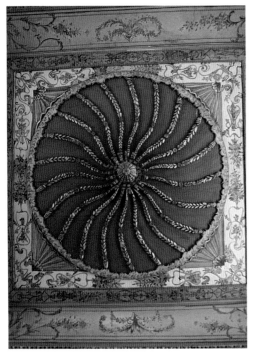

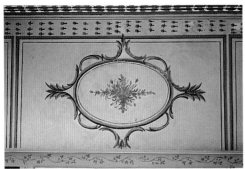

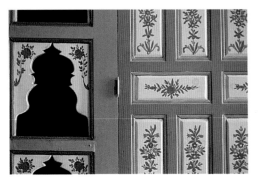

The principal room in the house of the Şemaki, where the décor fully reflects what has come to be called "Turkish baroque." The most representative elements are the fireplace and the ceiling. The brazier at the center was for winter evenings.

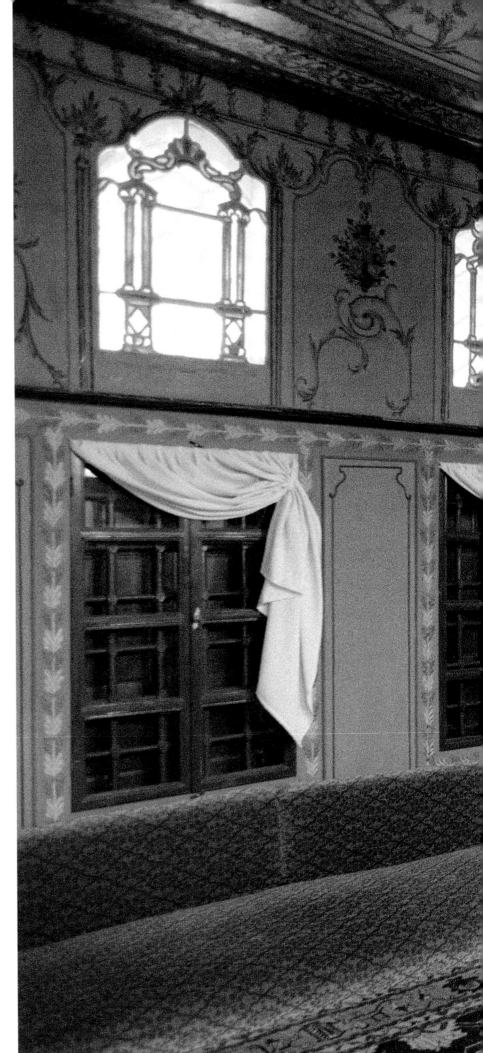

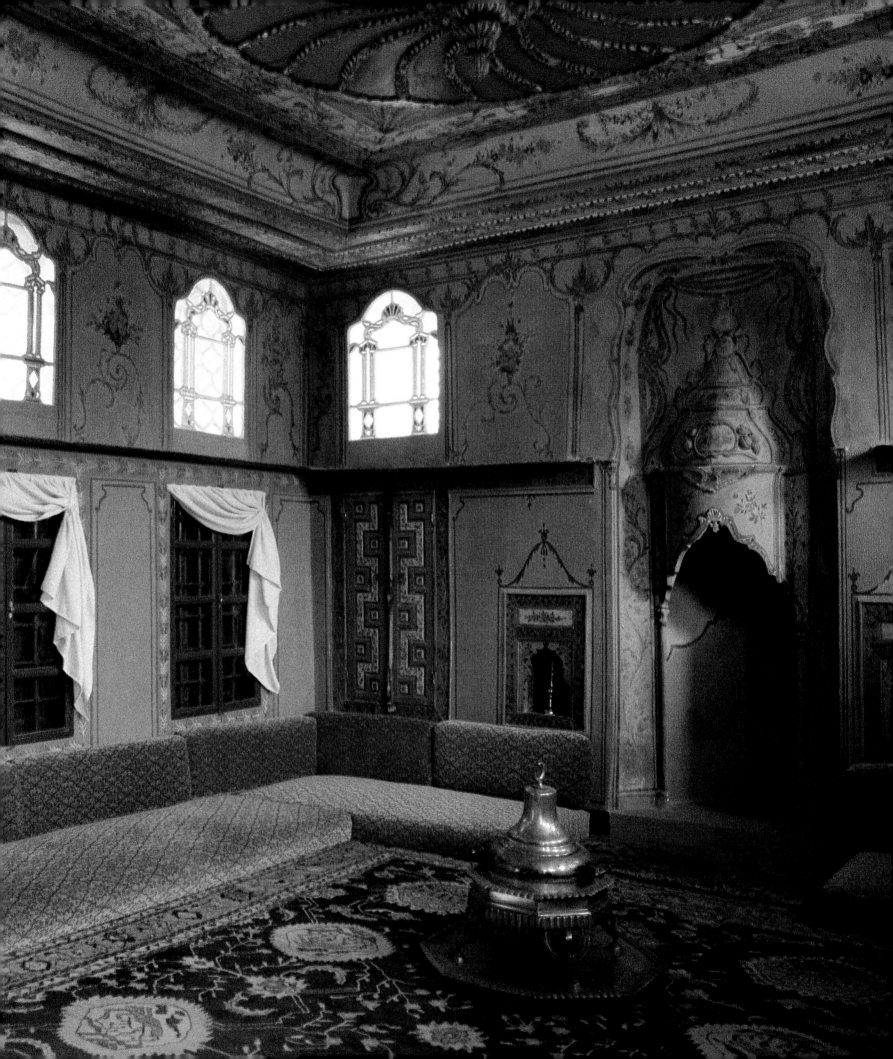

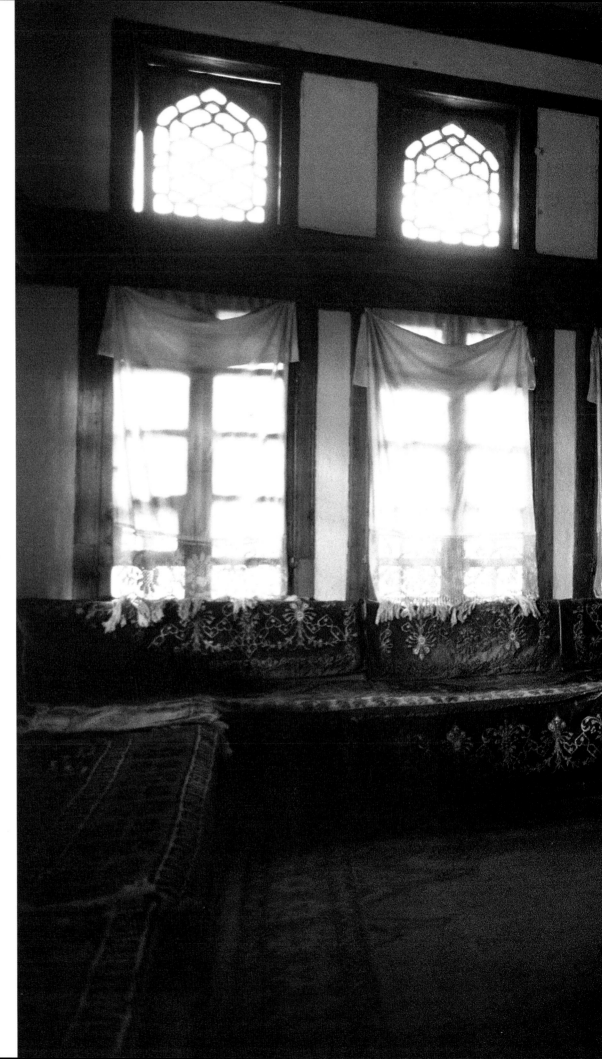

*L*ajos Kossuth, hero of the Hungarian revolution of 1848, took refuge in Turkey after his cause collapsed under the weight of Austrian might. During several years of supervised residence at Kütahya, he had assigned to him the house of a leading citizen. Thanks to this bit of mediating history, the building was saved from destruction and transformed into a museum. A dwelling with a hayat, or courtyard veranda, it is a good example of an important provincial residence from the beginning of the 19th century.

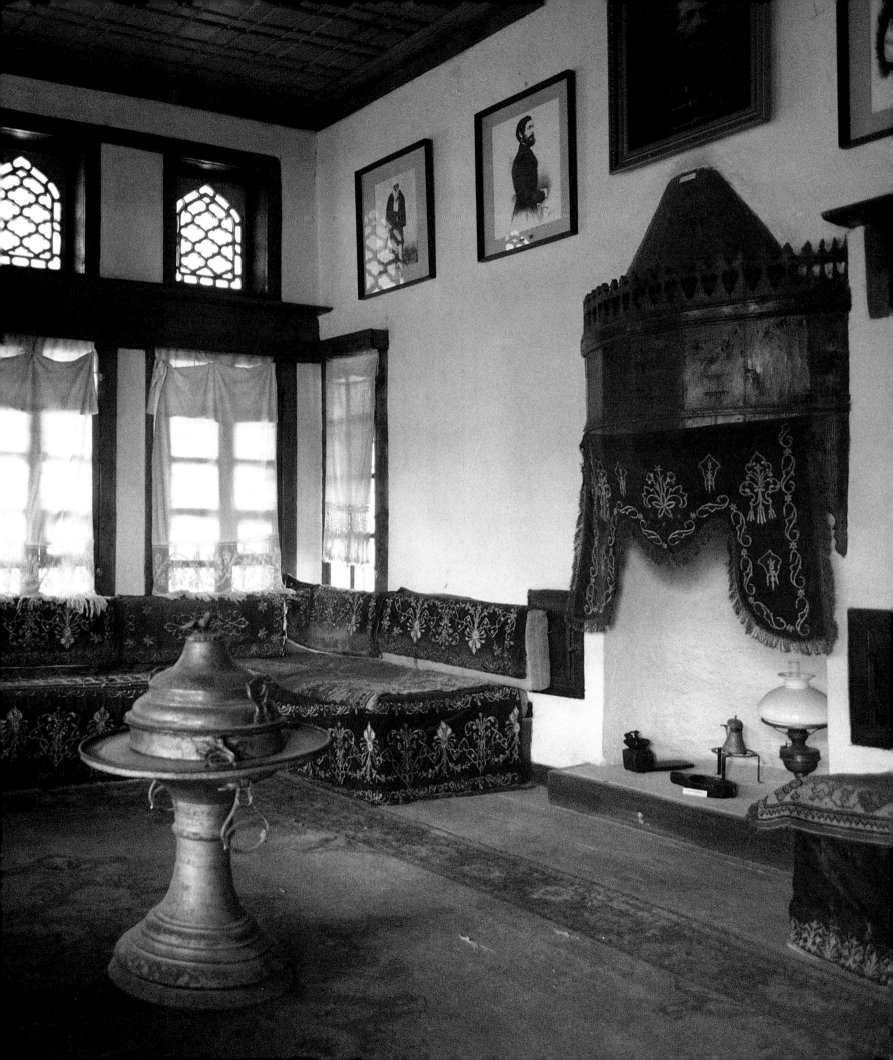

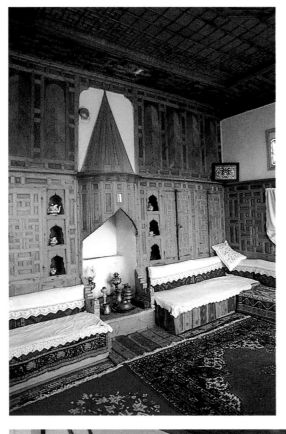

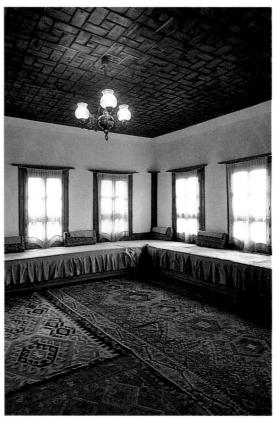

A fireplace in a house built of wood presents difficulties, beginning with technique, inasmuch as walls measuring no more than 20cm (c. 8") deep must be reinforced, usually on the exterior. Even so, there is always the danger of fire. As a consequence, only winter rooms in relatively important residences have fireplaces; elsewhere, a brazier suffices.

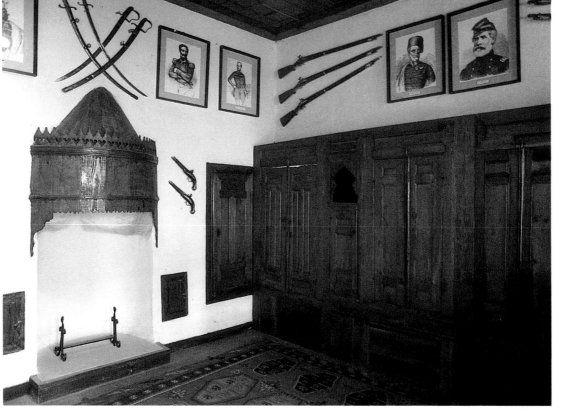

A house—no doubt from the beginning of the 20th century—at Safranbolu, a small city that today offers the best ensemble of well-preserved traditional houses. The great interest of this building—whose windows have recently been changed—resides in the huge basin fountain, which in turn brought to an upstairs room a scale quite out of the ordinary.

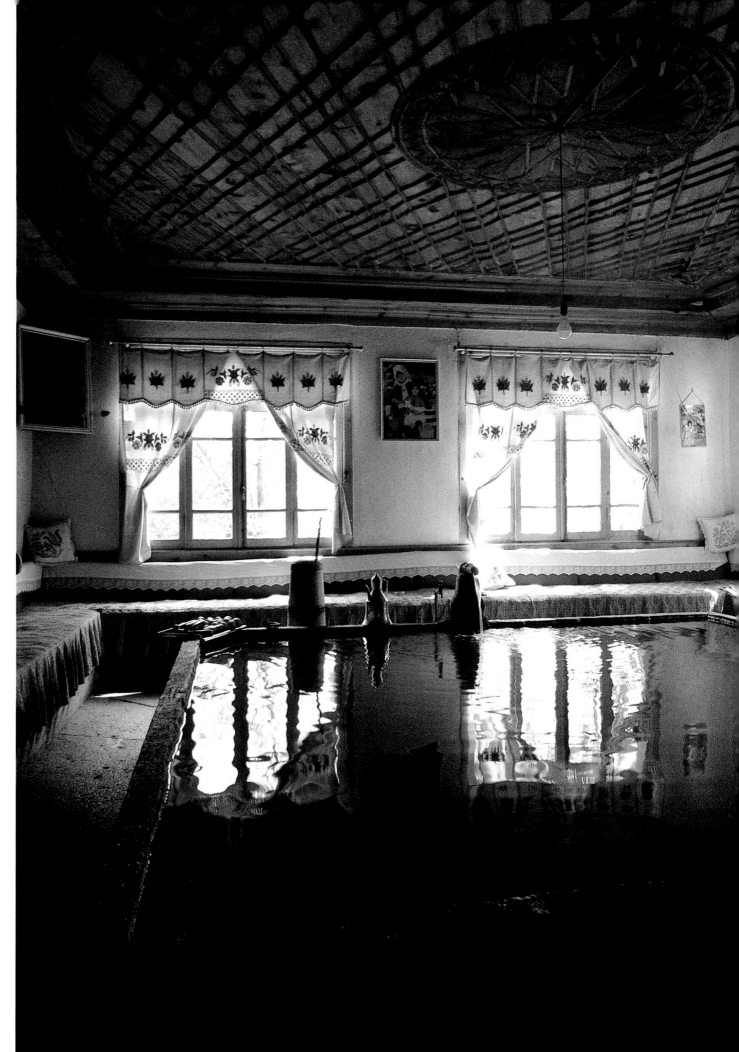

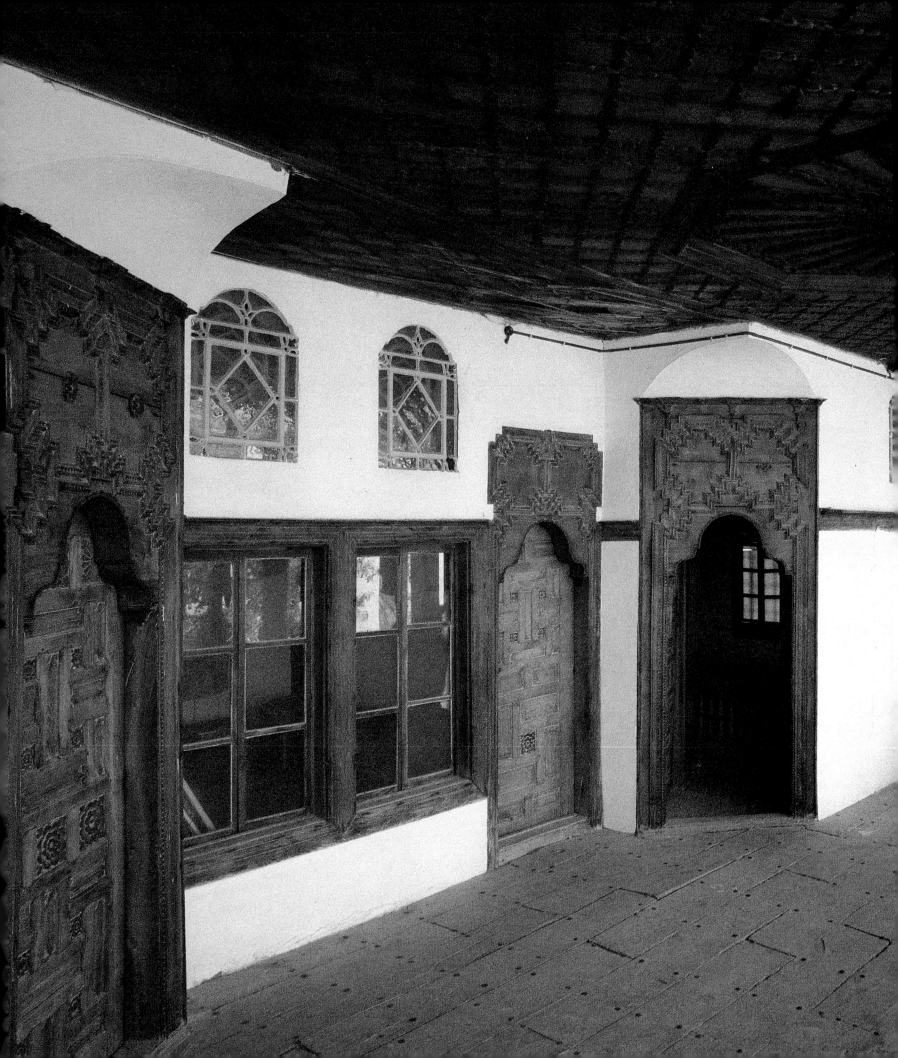

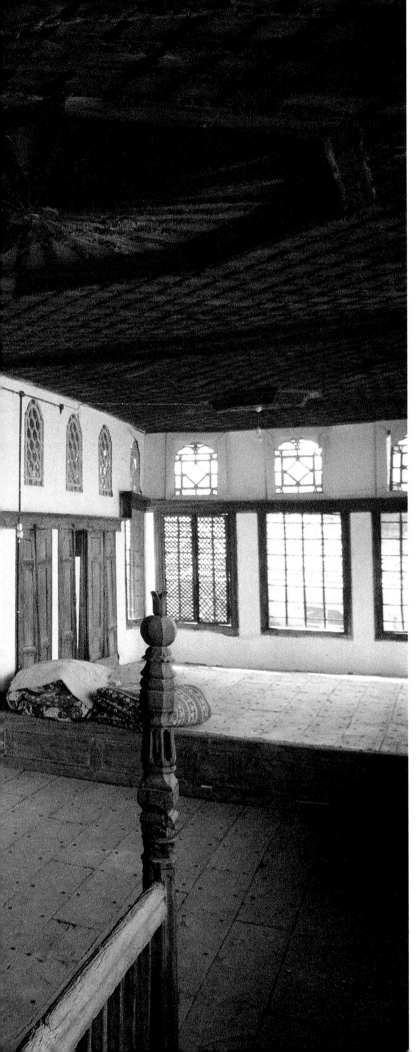

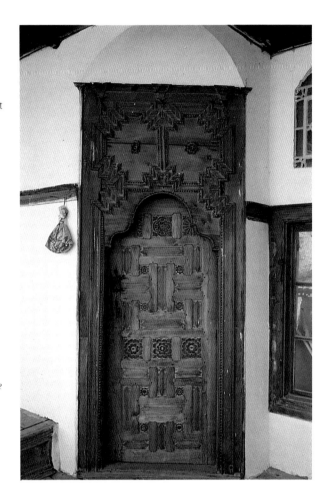

A house with hayat *at Kula, a town in the Aegean region that has survived with its architectural patrimony intact. The* hayat *is separate from its* eyvan, *which becomes an independent room (left); it is also closed to the exterior by a wall with tiered windows. This fenestrated closure, which makes it unnecessary to illuminate spaces once removed from the* hayat, *constitutes the first step in the latter's transformation into a* sofa.

CONTEMPORARY RESIDENCES

Contemporary architecture in Turkey continues under the enchantment of the Ottoman house. Quite apart from the restoration or rehabilitation of old dwellings, there is an eagerness to adapt new materials and functions to the interplay of volume, light, and color such as prevailed in Ottoman times. This ranges from a recovery of the traditional manner of organizing important spaces – realized with the habitual material, wood – to efforts designed to evoke them in similar situations using modern materials. Décor oscillates evenly between fidelity to the ancient, drawing generously on a still vigorous world of crafts, and "quotations," the prominent display of emblematic objects from Ottoman residences: paneling, ceramics, copperware, and carpets.

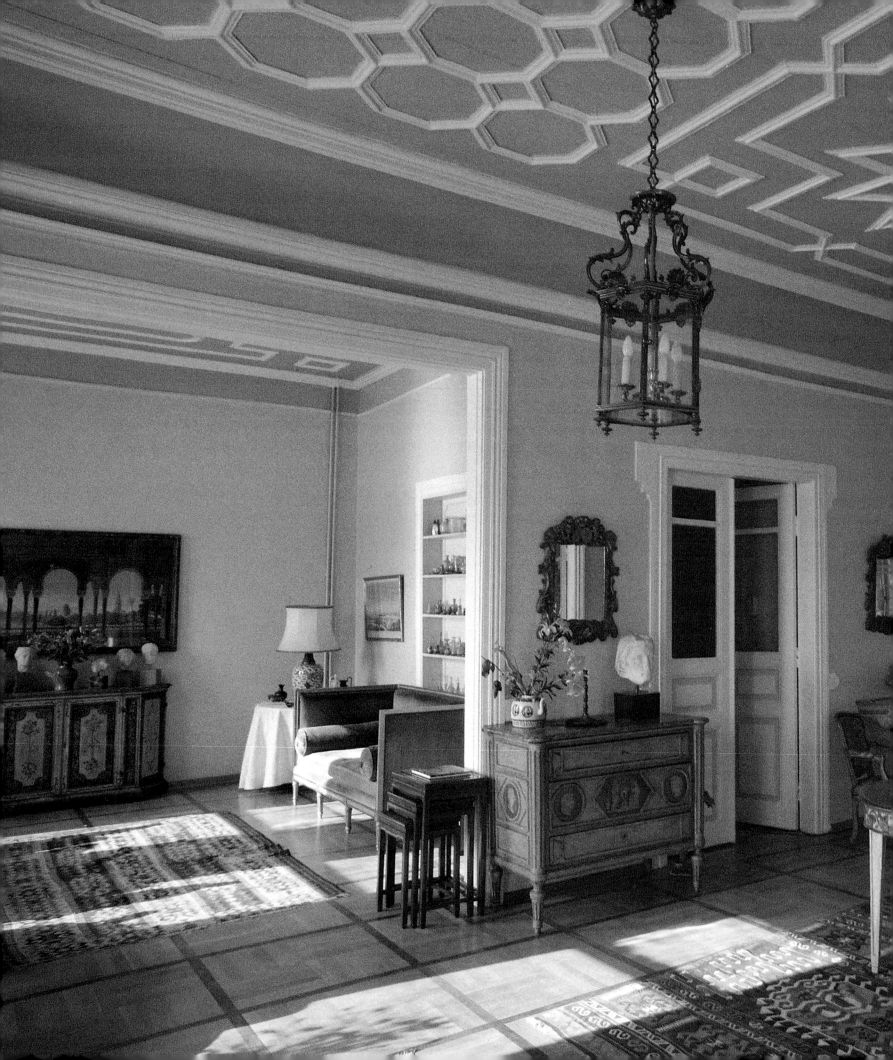

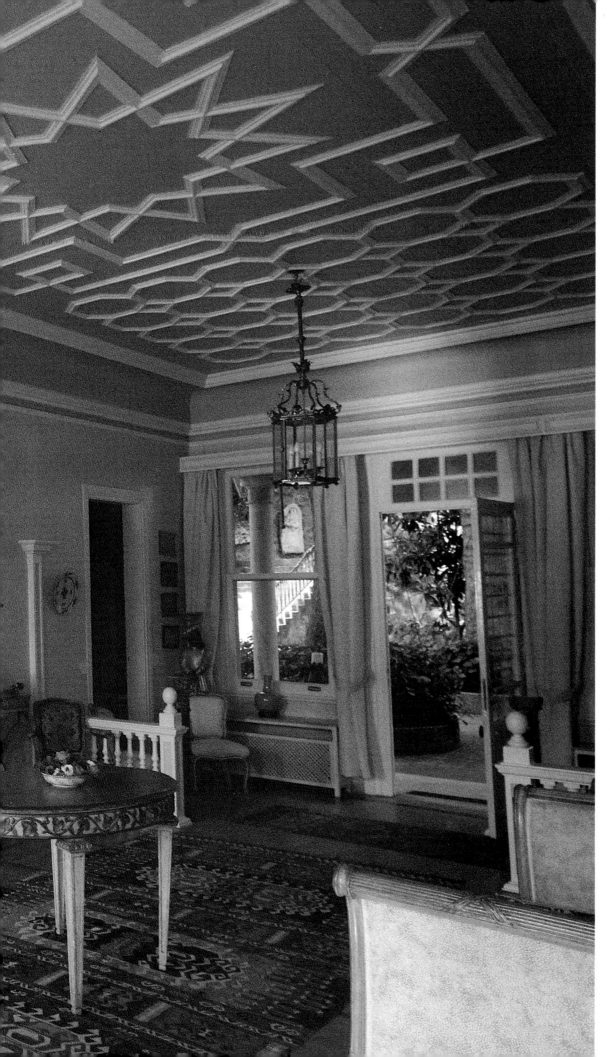

The contemporary Turkish house is a balanced mixture of tradition and modernity. Indeed, the architecture oscillates between solutions resolutely modern — where old elements persist in the form of "appropriations," quotations, or "citations" (explicit references to the past) — and adaptations, more or less forced, of traditional spaces to present needs and tastes.

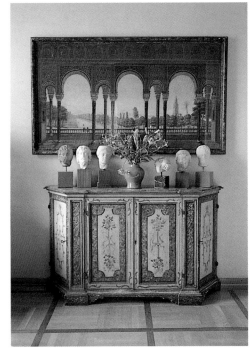

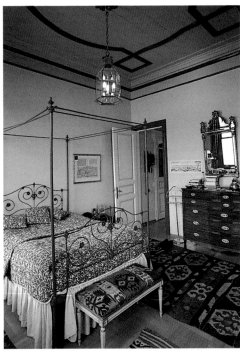

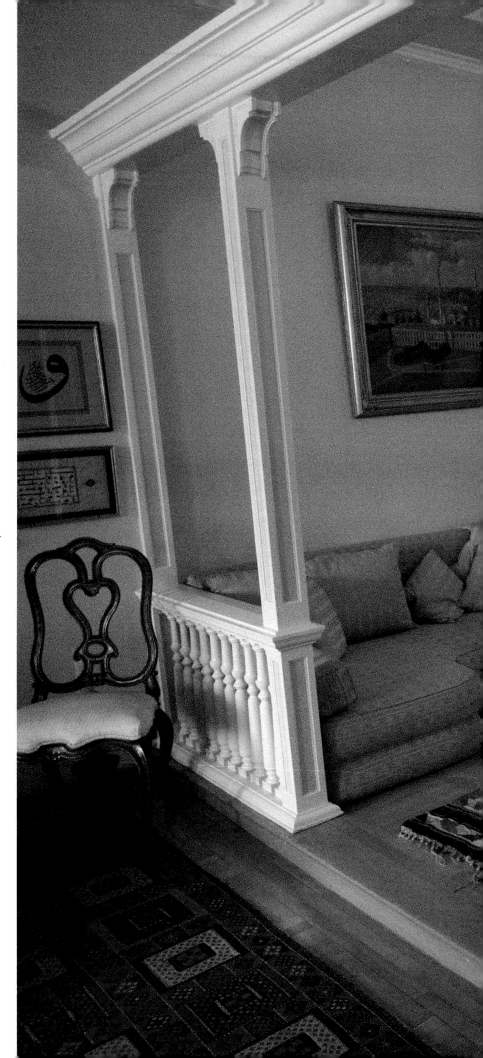

The residence of the
industrialist Rahmi Koç
provides an example
of the first stages
in the transition from the
ancient to the modern.
It retains the warmth of
the old wood houses and
the cool, shadowy interior
of the big sofa. The latter
even extends into an
eyvan complete with all
the classic attributes:
seki, balustrade, and
colonnade. The sedir,
barely transformed into
a canapé, defines this
space, even though
contradicted by
the presence of a door
onto the terrace.

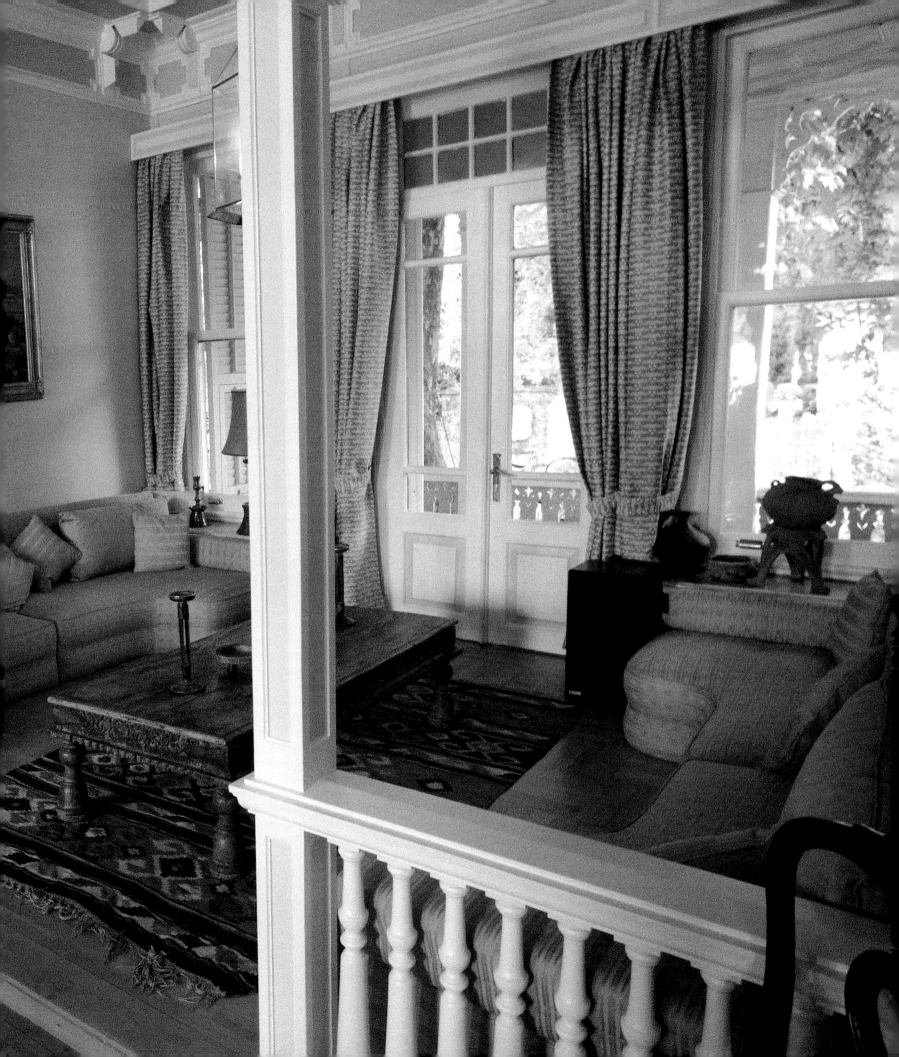

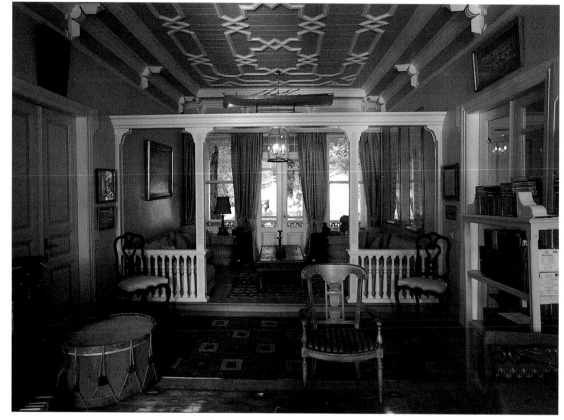

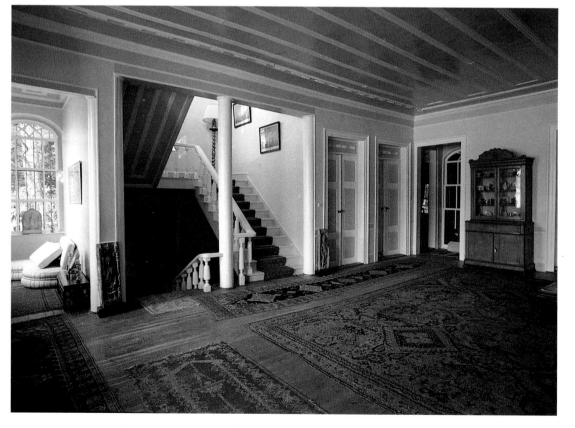

*I*n the house
of Rahmi Koç, the sofa
on the ground floor
extends right across
the building, whereas
the one on the upper story
receives the stairs and
gives access to the other
rooms. Thus, the
traditional arrangement
has been essentially
preserved. Here, it is
primarily the furnishings
that are modern, at the
same time that decorative
motifs have been
reinterpreted in blended
colors of an entirely
new sort.

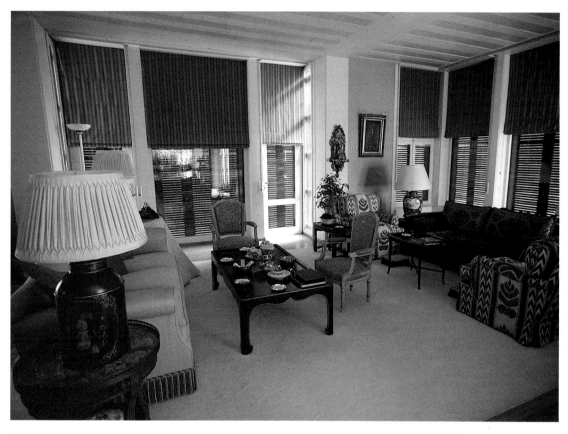

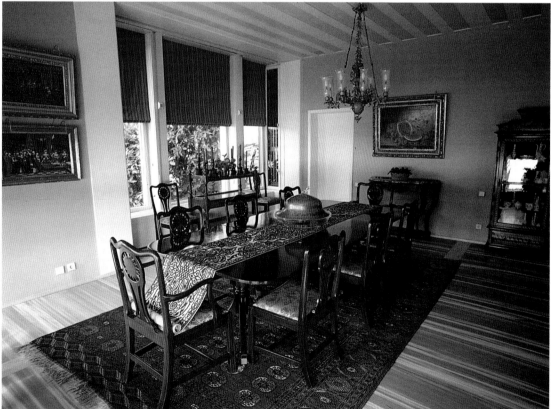

*H*ere the
suppleness of wood
gives way to the rigor
of concrete. The
arrangement of
the furniture is equally
turned about.
Nonetheless, the space
retains something of
the ambience of the large
sofa, *thanks to the*
disposition of windows
and, above all,
the filtering of light.

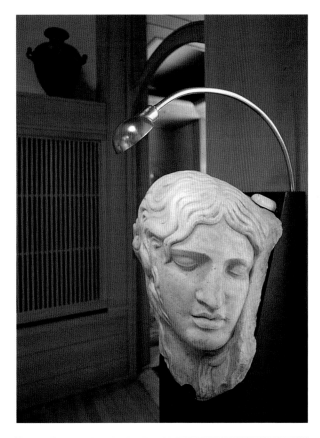

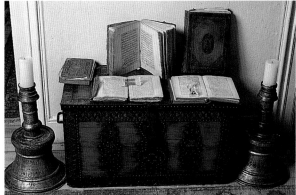

The modern Turkish house tends to be eclectic. Open to Western influence, it views itself as a repository of not only the Islamic patrimony but also the legacy of other civilizations that have come and gone on Anatolian soil. Here, combined under the same roof, are Hellenistic and Roman bas-reliefs, Arabic calligraphy, Latin incunabula, Ottoman candlesticks, and a popular view of Istanbul painted on a serving tray.

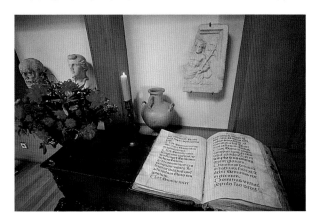

171

Mischievously, jealously, coolly — the traditional Turkish house allows the outside world to filter within. The modern Turkish dwelling, on the other hand, abandons the old game of reticence and ostensibly turns eagerly towards the exterior. Windows, doors, bays, and terraces project life-styles into the open air, directly confronting nature and the countryside.

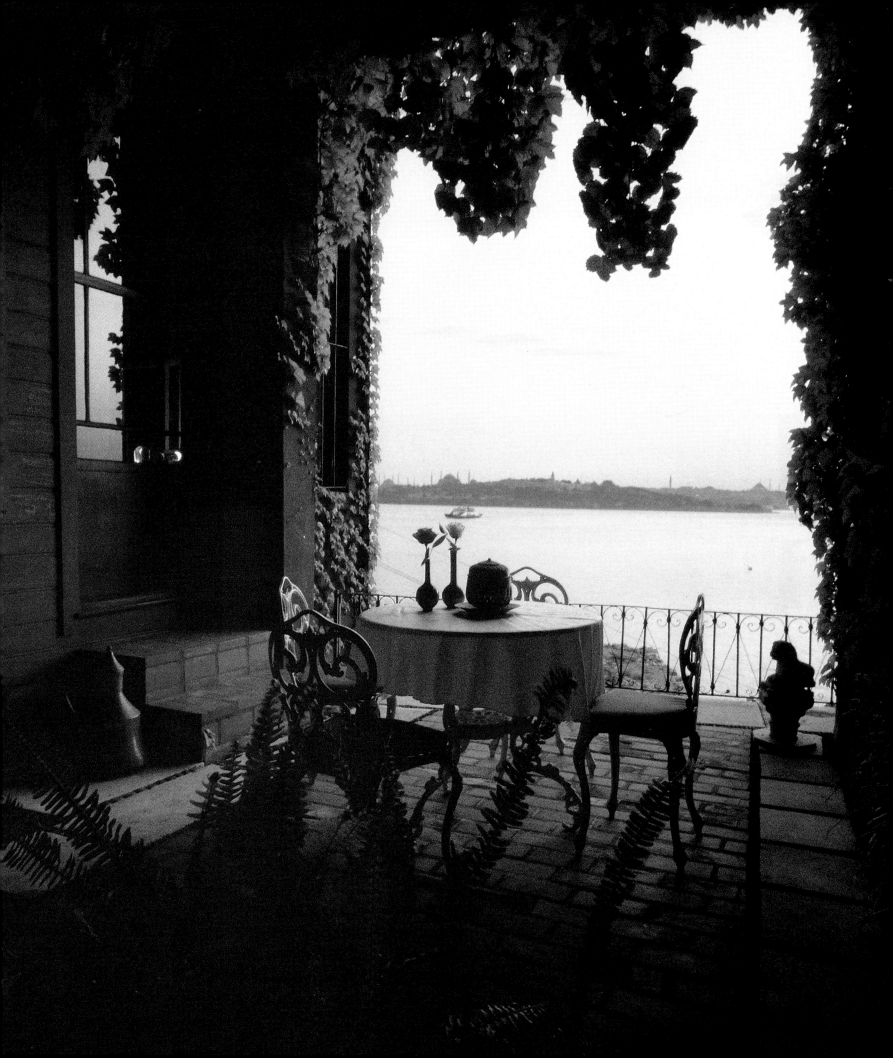

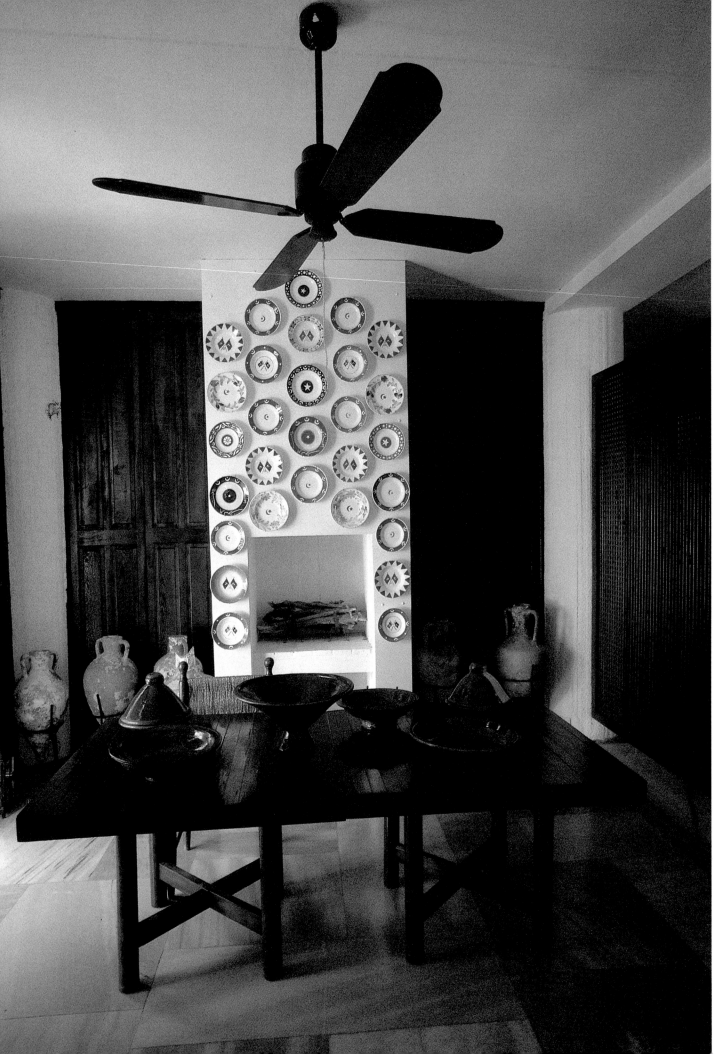

*S*ole reminders

of the past — the whiteness

of the fireplace and its

placement at the center

of the wall. And all about

the hearth, a variety

of fired pieces — Greek

amphorae recovered from

the sea, Turkish plates

displaying flags and

crescents, and vessels

in terra-cotta.

Here, the gifts of tradition have more or less disappeared. Even the flower pattern in the carpet is Western, and the motifs of the kilim, the lone Oriental touch, hang in a deck chair. The house simply basks in the Mediterranean sun, aided by the whiteness of its walls, its railings and marble pavement.

175

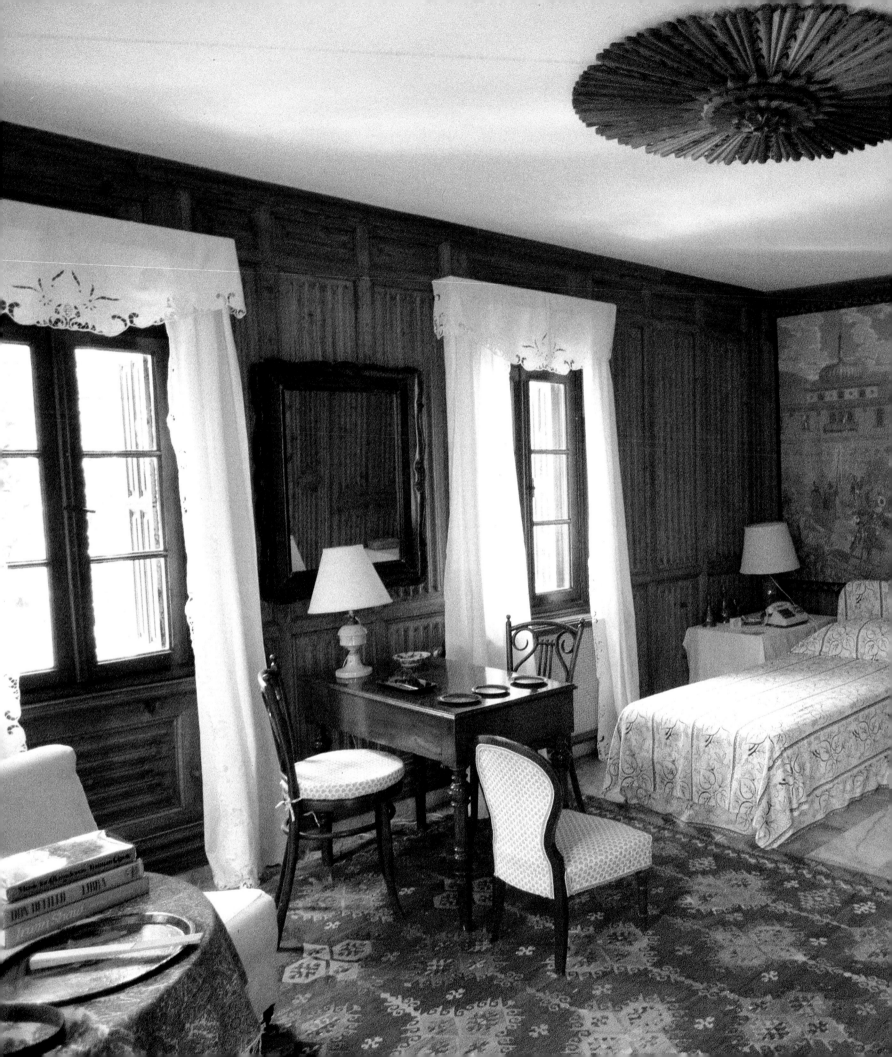

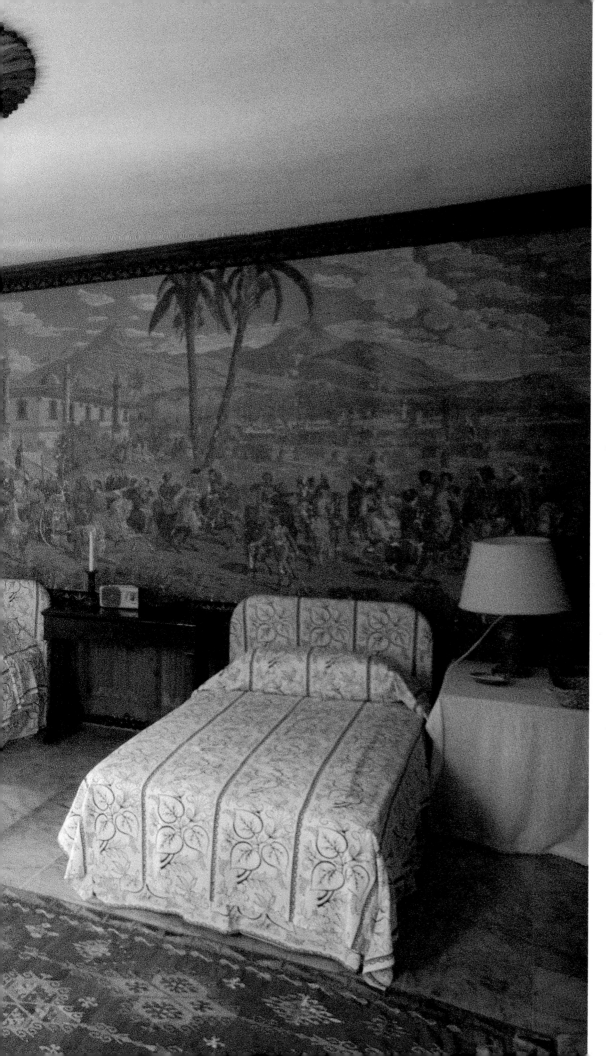

\mathcal{H}ere, in this
beautiful room, the wall
paneling, the windows,
and the curtains
are distinctly northern
in their origin, but the
ceiling rose, salvaged
from some başoda,
continues to mark
and hold the center.
Nevertheless,
it would be difficult
to imagine a bedroom
in a traditional Turkish
house, which never
possessed such a thing.

177

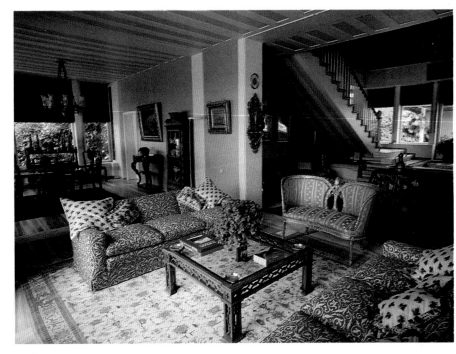

*C*eramics,

copperware, and carpets

are things that transcend

time and space with

the least difficulty.

Objects already as much

decorative as utilitarian

can partially retain their

function without losing

anything of their visual

quality. Here, the corner

of a salon with ceramics,

mainly from Kütahya,

displayed on shelves,

a ewer with basin,

both of late production,

and a rug.

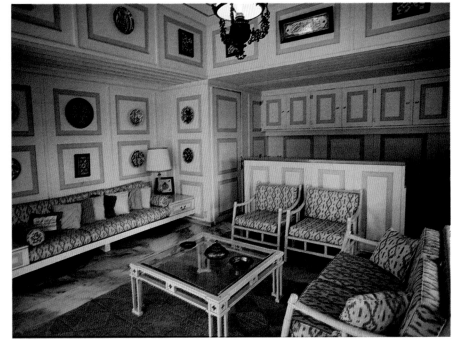

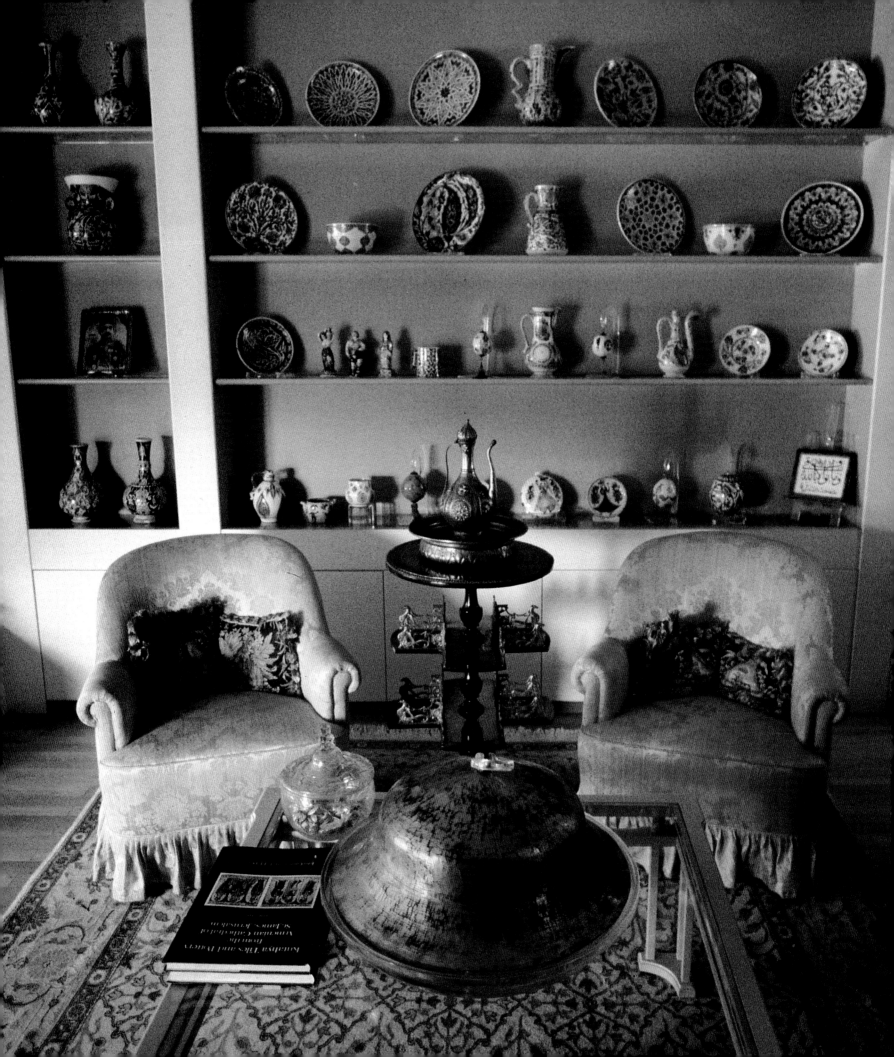

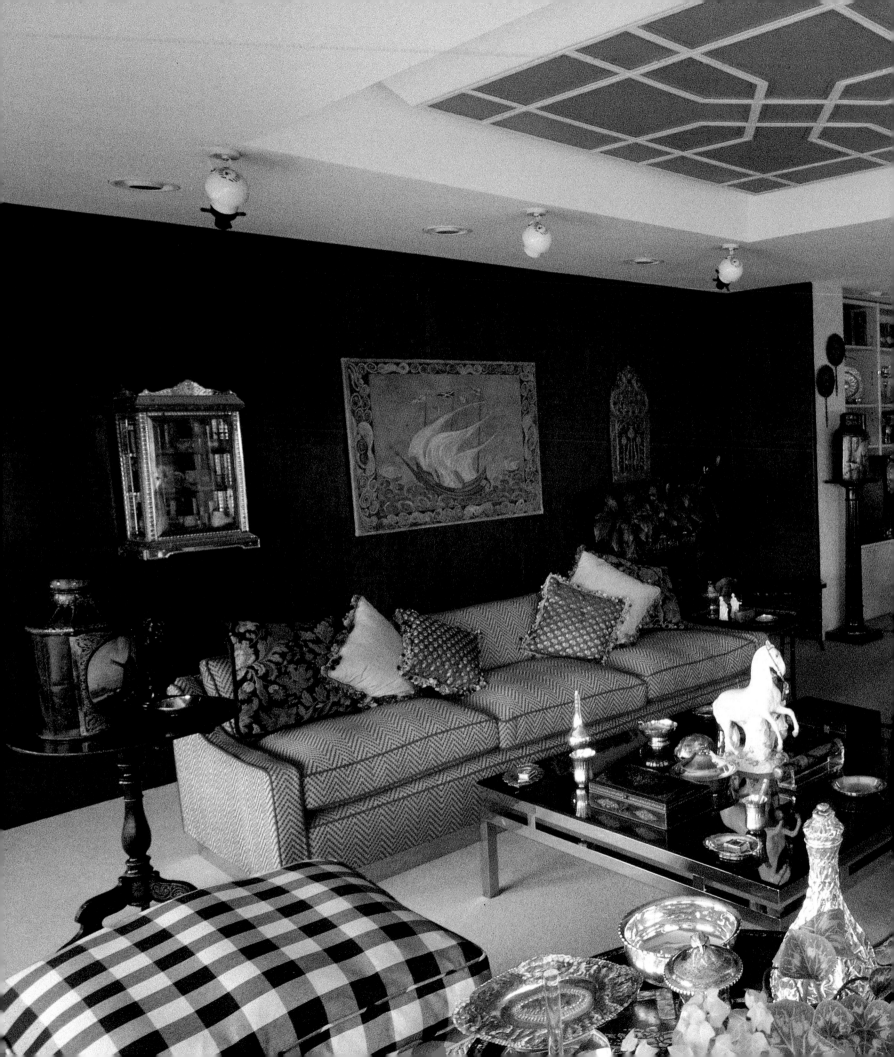

In the traditional dwelling, furniture — rare to begin with — aligned against the walls. The custom continues even today, in the ordinary Turkish house where chairs and couches replace the sedir, *just as cabinets and buffets — the successors to niches and* dolap — *back up to walls, leaving the central space empty. In large houses, on the other hand, the furniture pulls away from walls to come together in a square grouped about low tables.*

The classic Turkish house is always covered by a pitched, four-part roof, while the interior has flat ceilings. The peaks are never occupied, and attics as well as mansard roofs do not exist. The contemporary house, by bringing the roof inside, added a diagonal, which shatters the quietude of the old volumes.

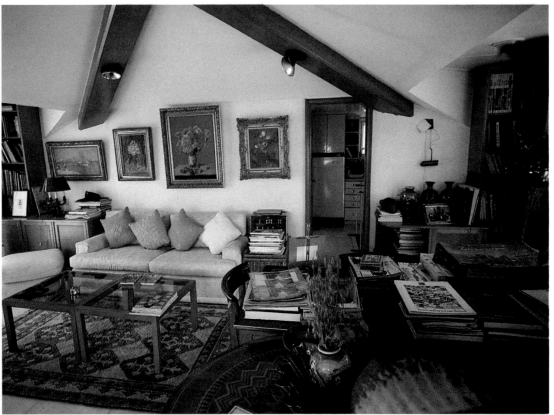

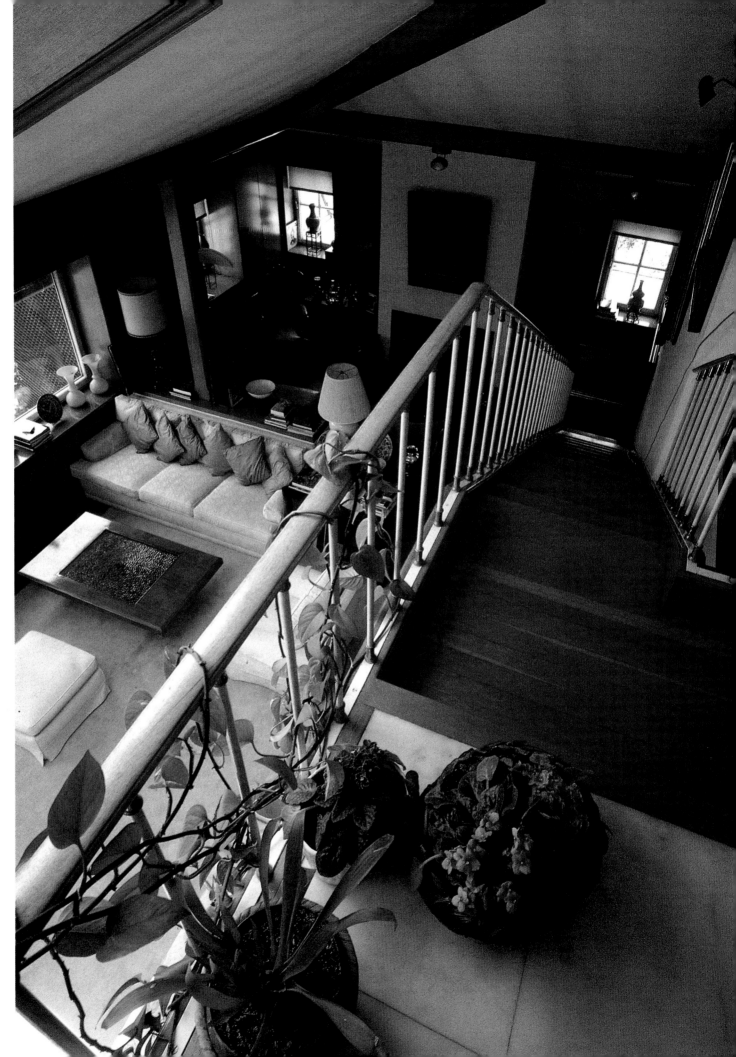

*D*uplex volumes,
with their projection
of stairs into the living
area, multiply the
diagonals, which further
activate the spatial
dynamic, whose effect
is the exact opposite of the
calm, ordered succession
of Oriental spaces.

*The return
to horizontality,
accompanied by a
sidelining of the
furniture, which leaves
the central area free,
could be seen as
a renewal of tradition.
This is hardly the case,
however, for in place of
the finite, circumscribed,
delimited volume of the
traditional room has
come a space without
precise limits, where
the eye is beckoned from
every direction,
generating, underneath
the appearance of calm
and majesty, the same
disquietude.*

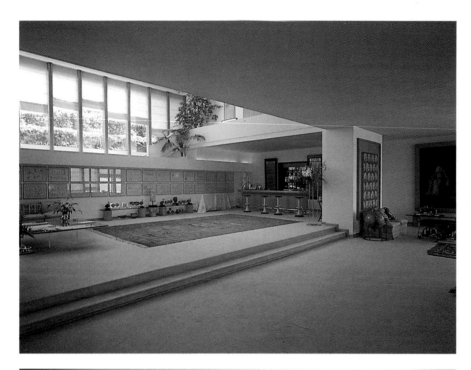

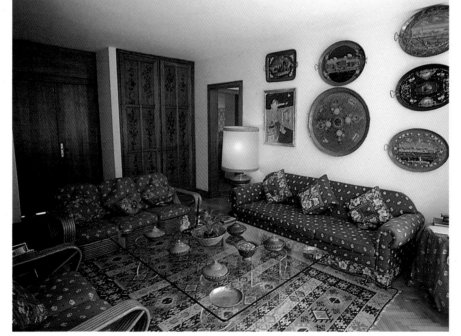

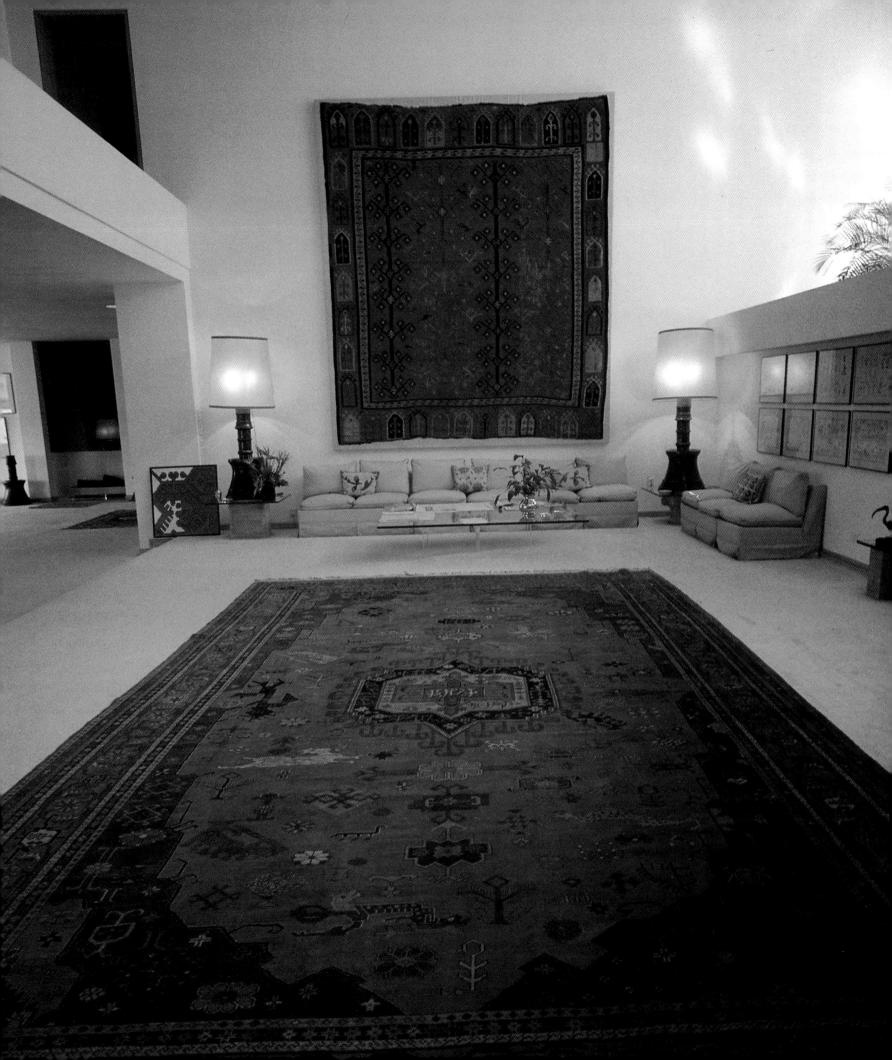

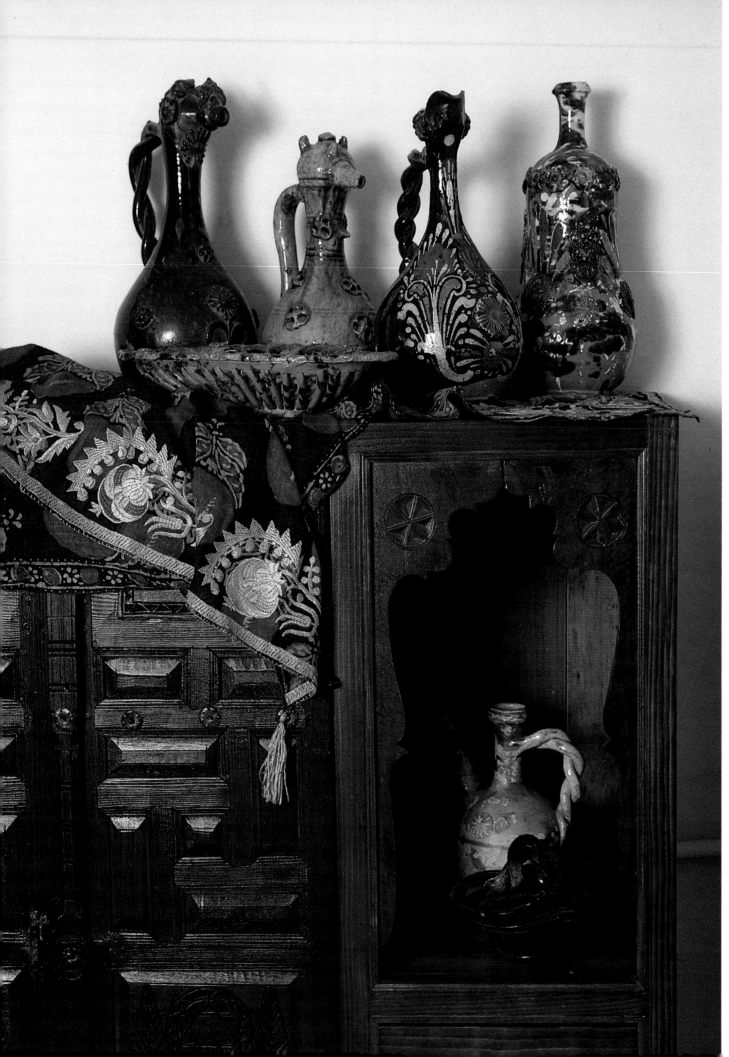

The contemporary Turkish house seems inclined to compensate for its withdrawal from tradition by assuming a museological function, which simply widens the gap further, given the rarity of furniture and objects in the old Ottoman house. Here, modern pieces of furniture, bearing ancient motifs, are surmounted by pottery of the Çanakkale type.

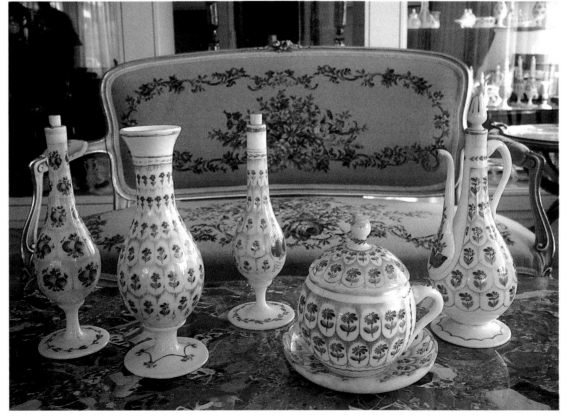

*T*he Ottoman court always had a taste for porcelain. Originally, the ceramics were imported from China, examples of which can now be admired in Topkapı Palace. Beginning in the 18th century, the favorite source was Europe, but in the manner of European courts, the Turks soon organized their own workshops, which succeeded in achieving a good synthesis of forms and techniques from both East and West. Now, their products are the delight of collectors everywhere.

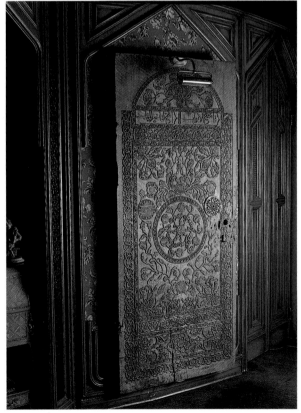

Work in wood and marquetry, where geometric compositions of an extreme complexity abound, was much prized by the Ottomans, especially for the knowledge of geometry that such craft implied. Consequently, architects, such as the builder of the Blue Mosque, became skilled marquetrists. Products of the craft — doors, cupboards, low tables, and Koran cases — are now in great demand.

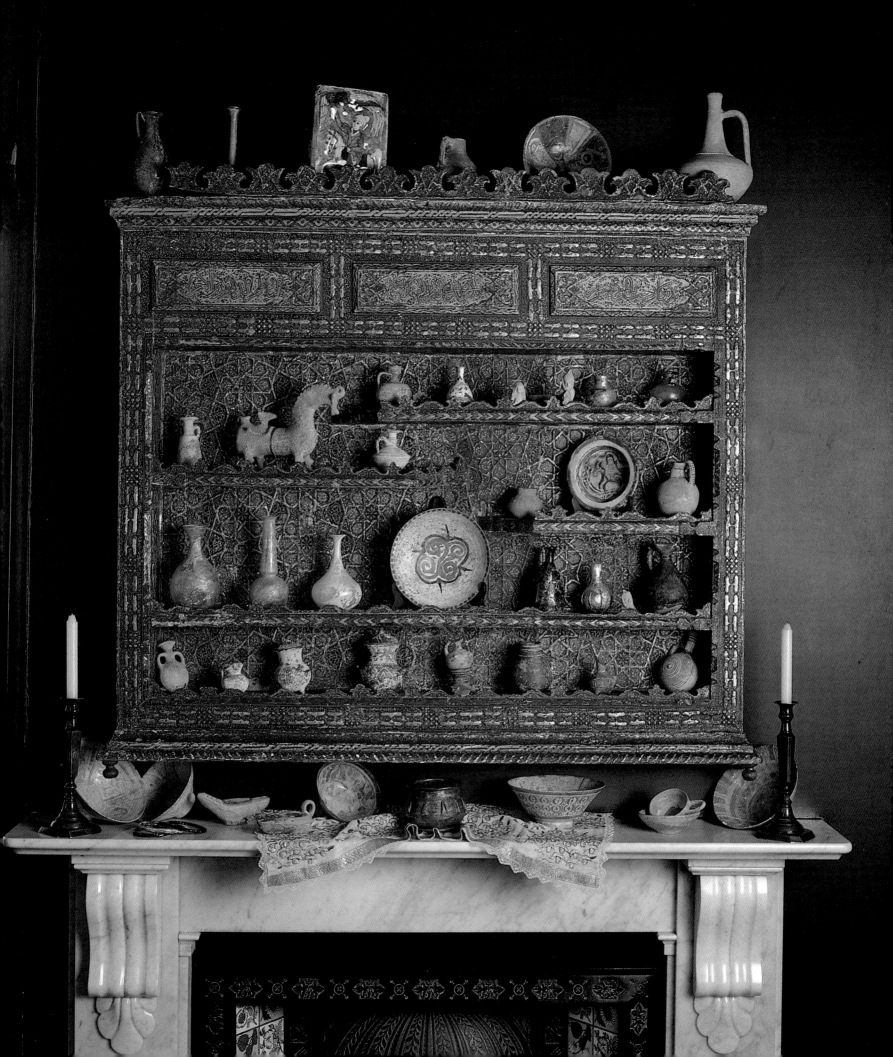

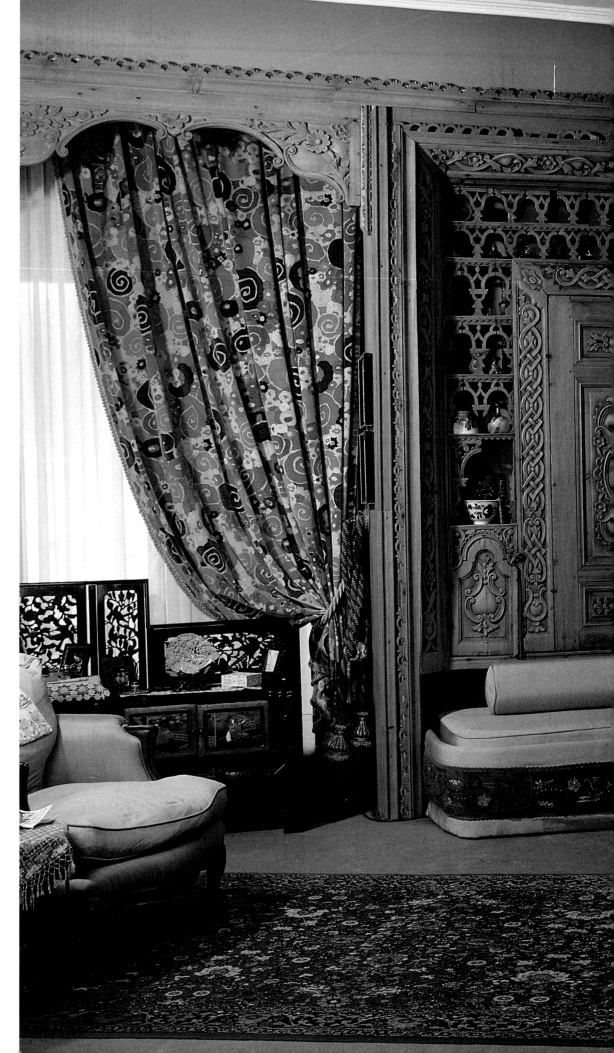

*C*arved wood paneling is rarely found in Anatolia or even in Istanbul, but it existed in the former Balkan provinces of the Ottoman Empire, there decorating the houses of rich merchants and Greek notables or even slaves. In the room seen here, the work may be new, but it is combined with old forms and motifs.

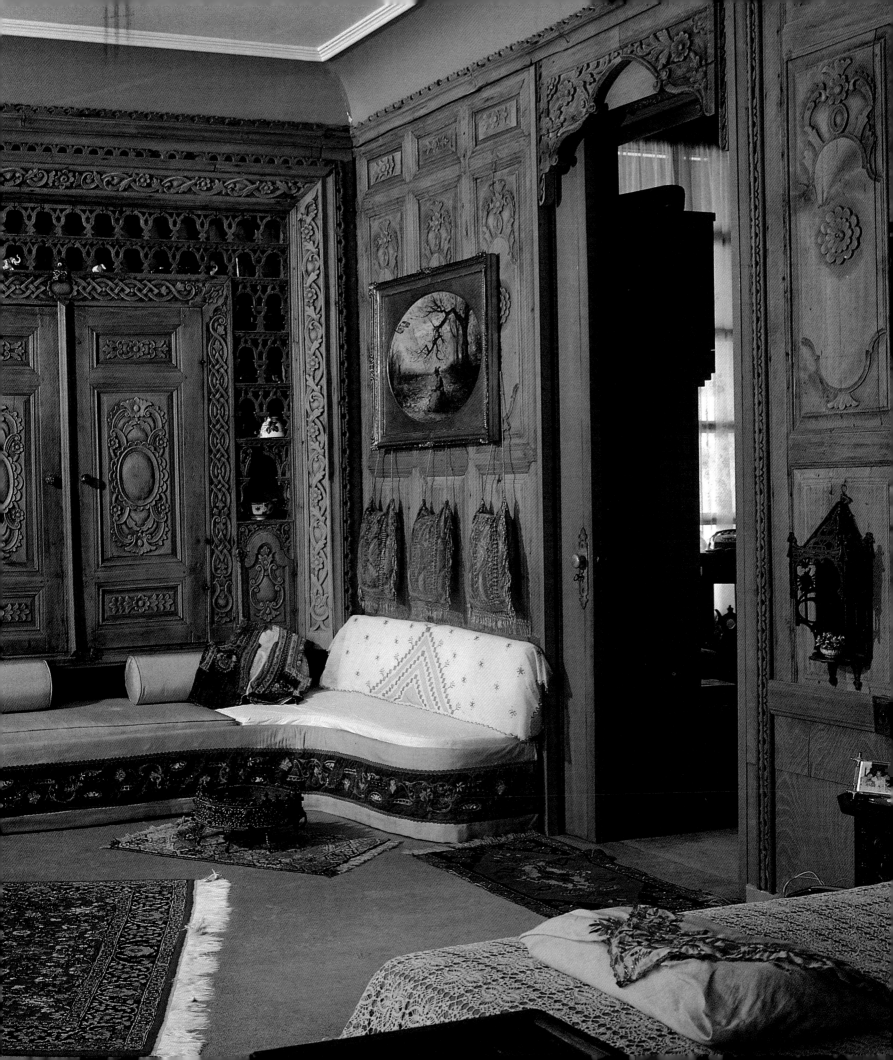

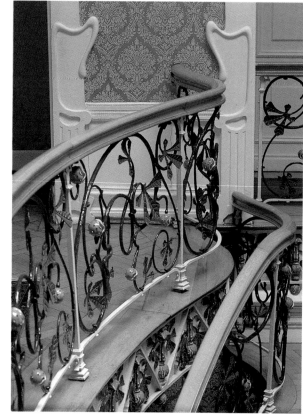

The art of balustrades did not develop in Turkey until stairways assumed importance in the 19th century, when architects of the Imperial palaces truly outdid themselves in their handling of the balustrade. The tradition continued in the residences of the late 19th (RIGHT) and early 20th centuries (ABOVE), and it is still alive in current building.

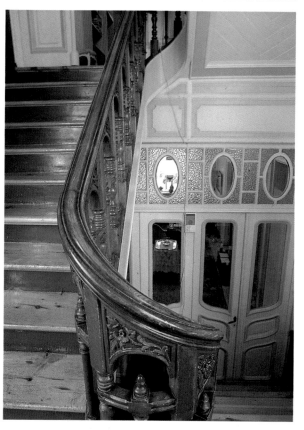

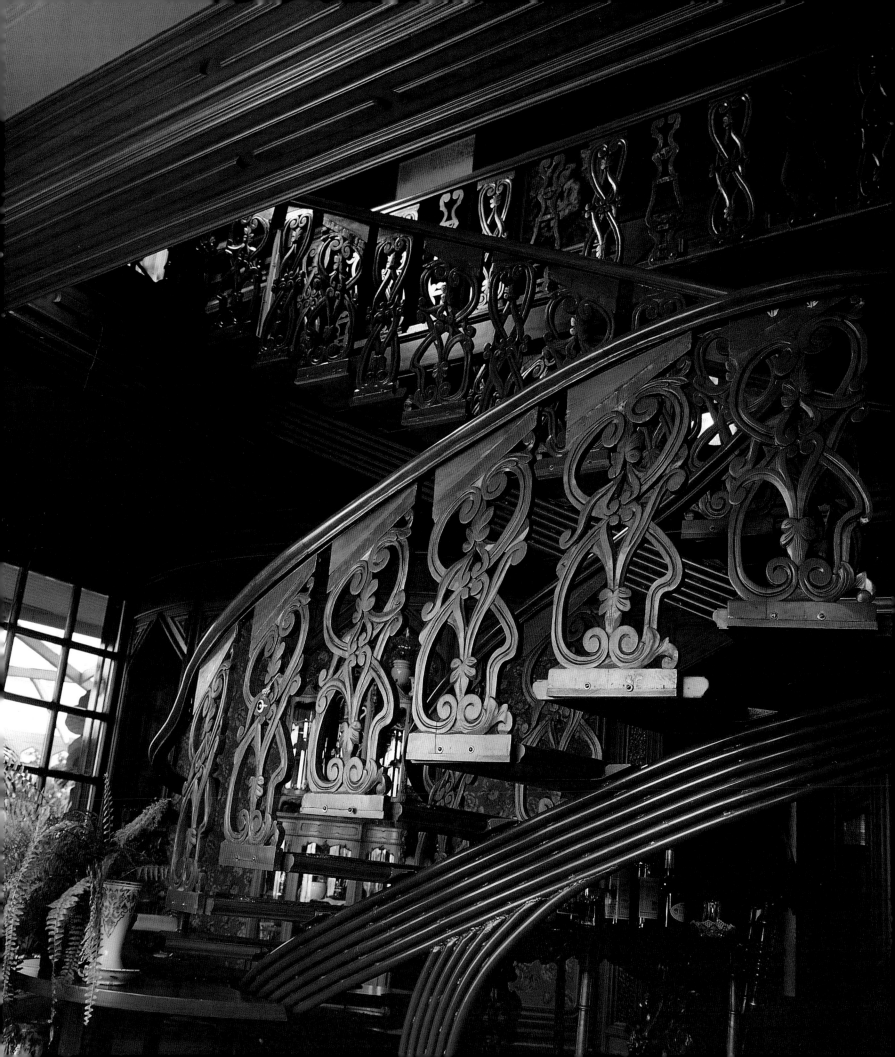

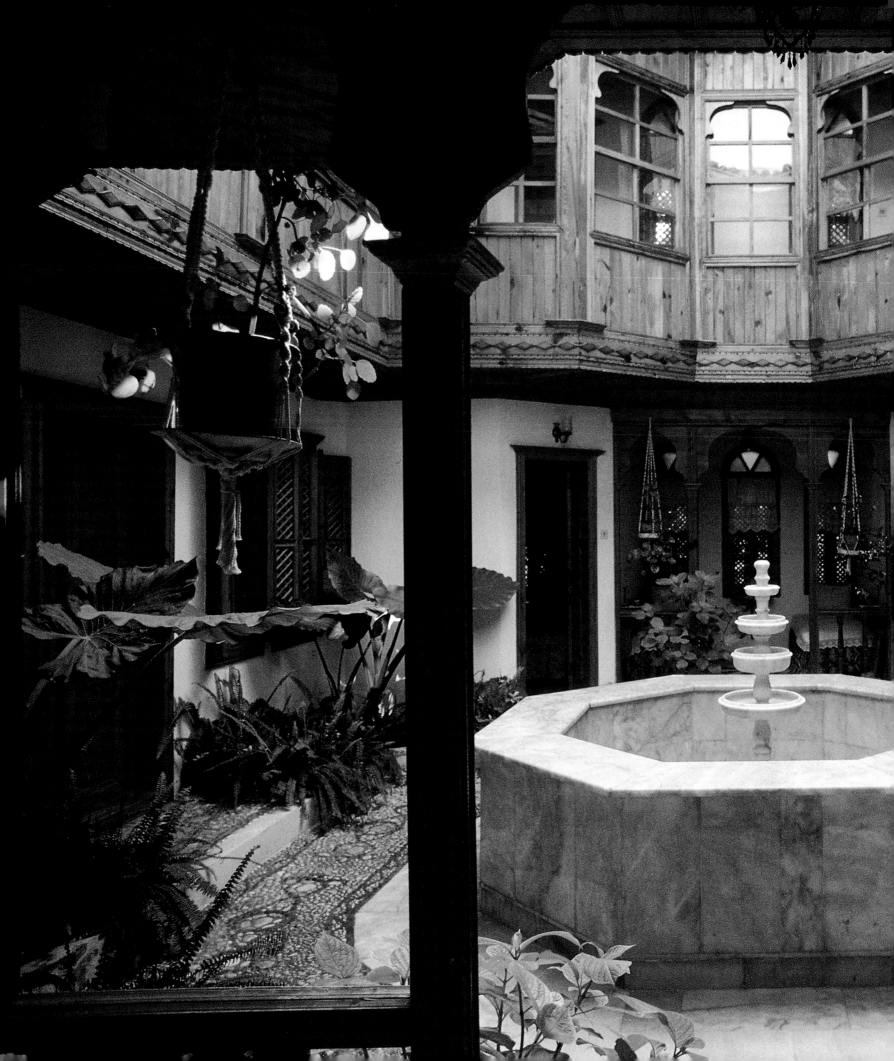

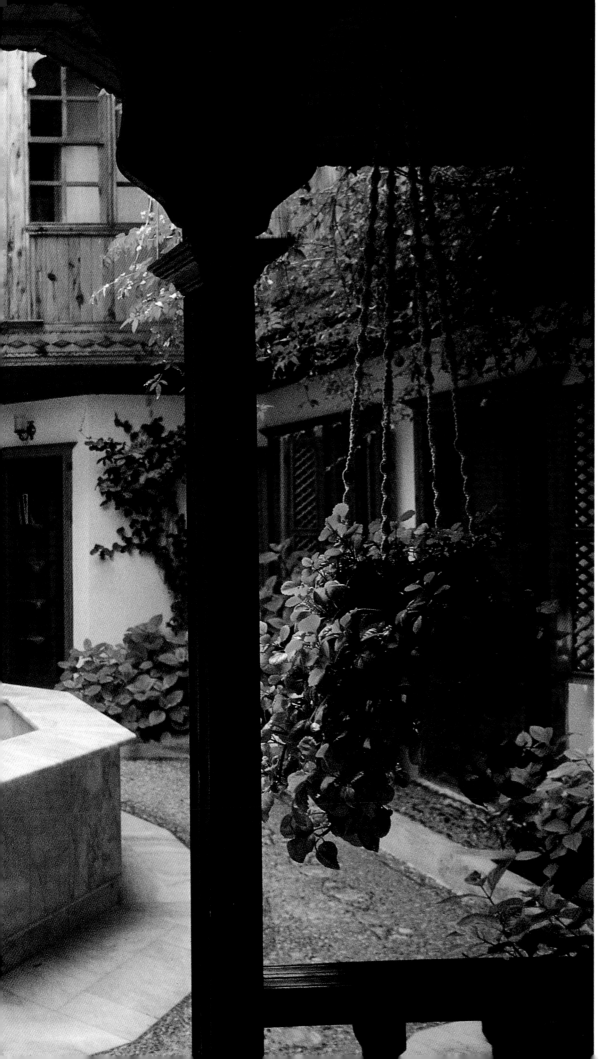

\mathcal{V}ariations on
traditional themes in a
modest house at Gökova
on the Mediterranean
coast. A windowed hayat
overhanging an interior
courtyard paved
in pebble mosaic and
embellished with a pool
fountain. Being on
the interior, even the
courtyard is not
characteristic of the old
Turkish house;
nevertheless, the ensemble
has its charms, despite
the presence of varnished
wood, for which there is
no precedent in
traditional practice.

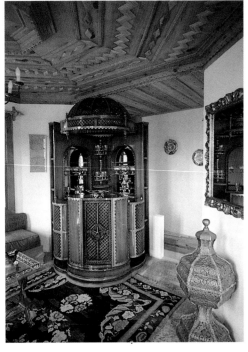

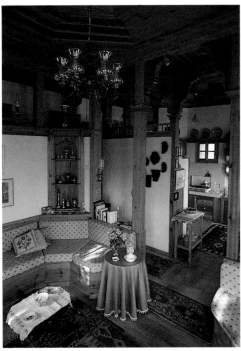

*A*gain, the love of "citations" or "quotations," this time in the Gökova house: balustrades and colonnades separating a room from the entrance and corner kitchen, a ceiling with central motif, *sergen* or high shelves running the length of the walls, sash windows, etc. Still, the disposition of the whole differs radically from the traditional Turkish house.

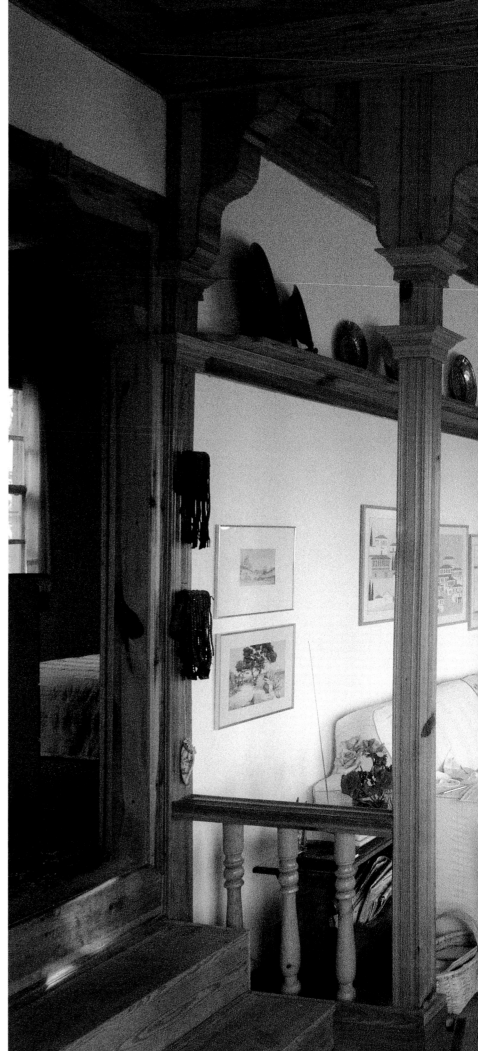

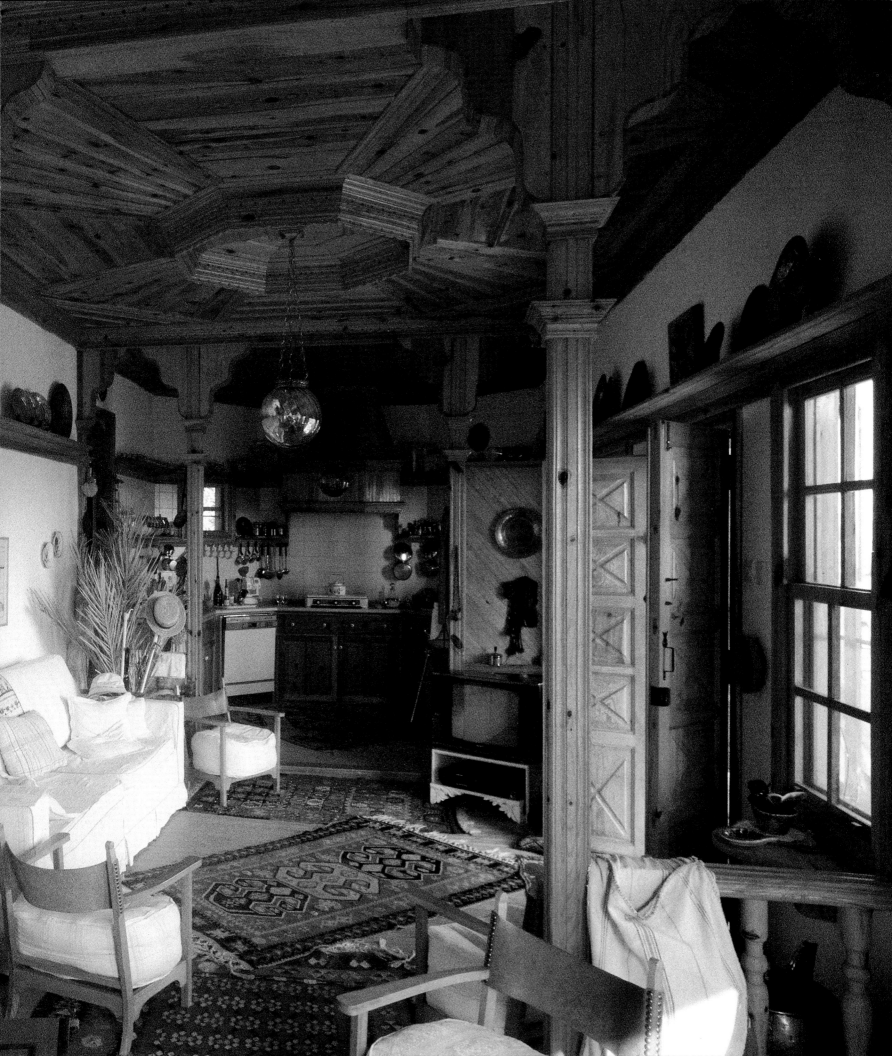

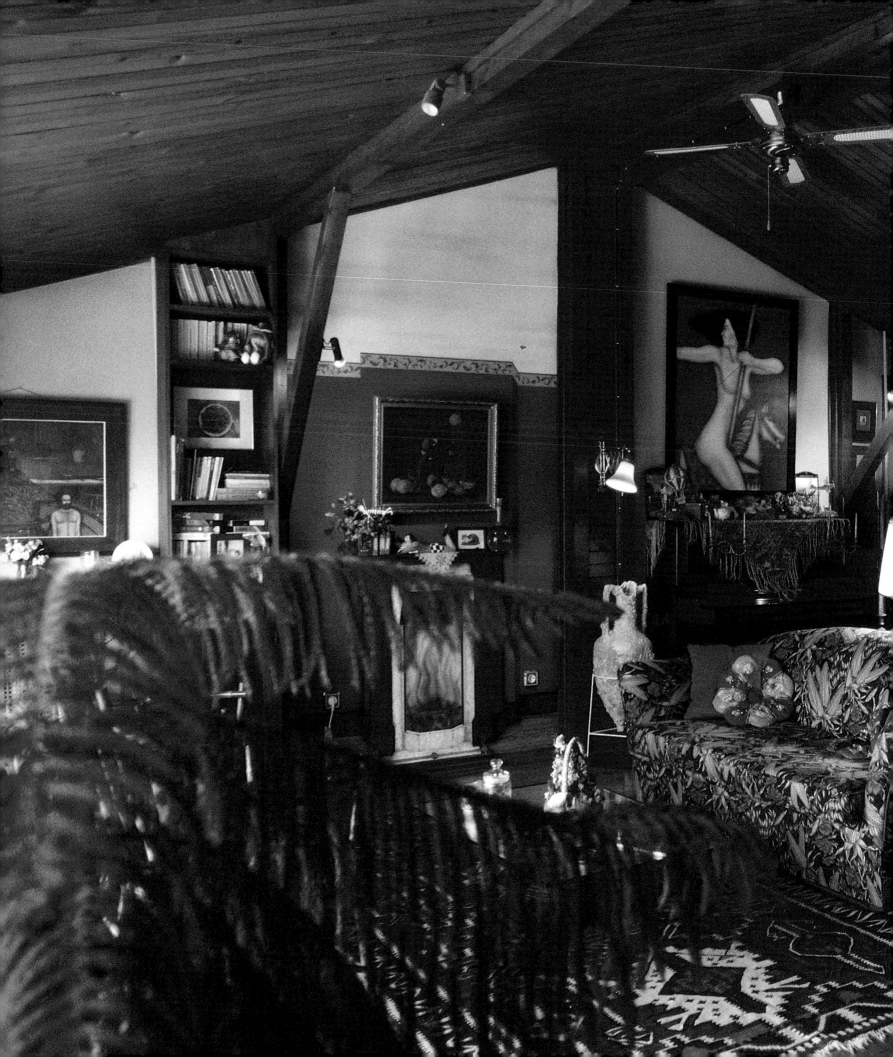

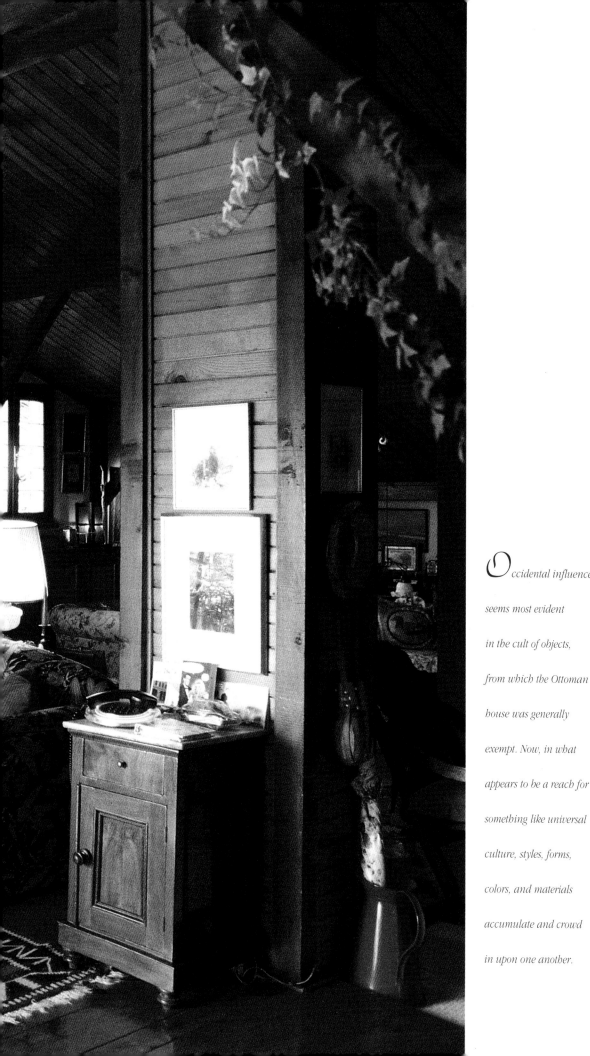

*O*ccidental influence

seems most evident

in the cult of objects,

from which the Ottoman

house was generally

exempt. Now, in what

appears to be a reach for

something like universal

culture, styles, forms,

colors, and materials

accumulate and crowd

in upon one another.

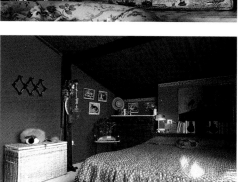

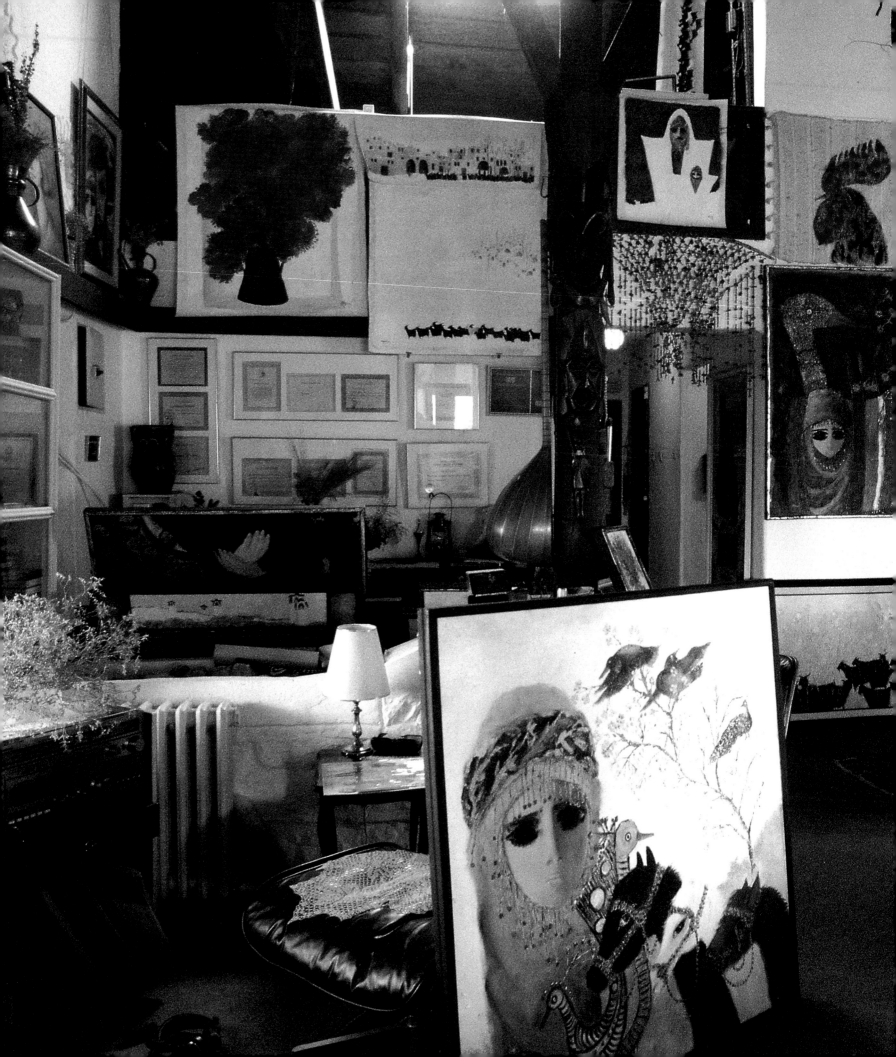

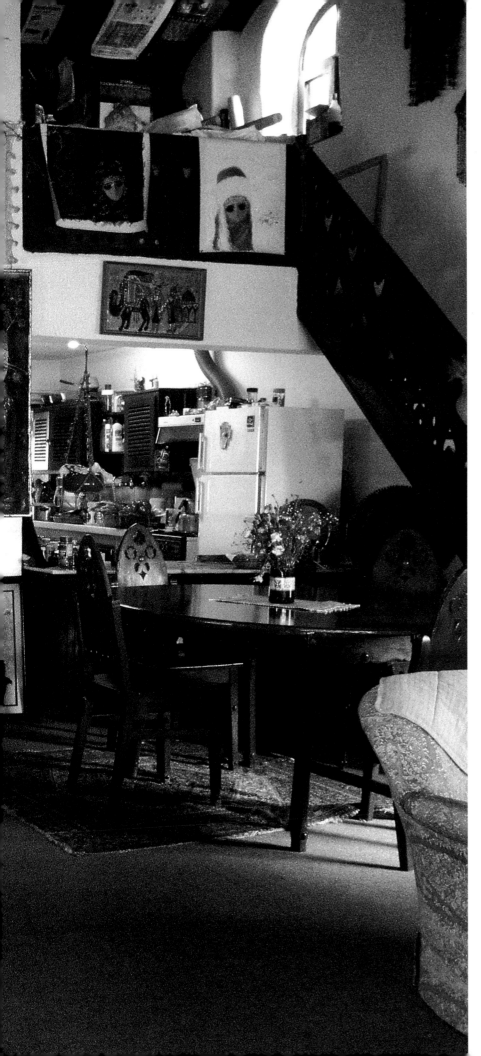

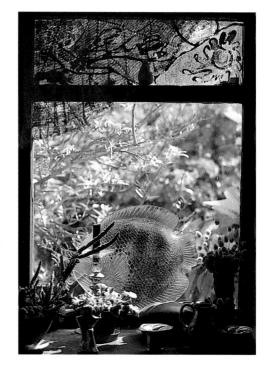

A house

belonging to the painter

and writer Fikret Otyam.

The artist's own pictures,

drawn from popular

sources, find a pendant

in the saz, an Anatolian

string instrument hung

on the wall, thus adding

to a mixed ensemble

that includes textiles

and objects by ordinary

craftsmen.

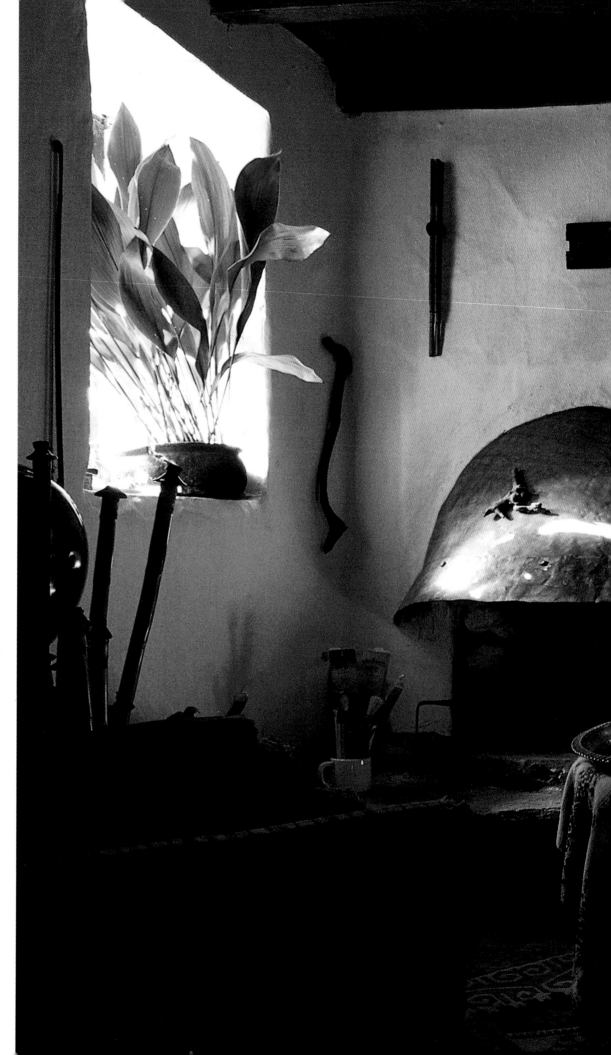

*A*n old house
of Greek peasants
on the island of Imvros
(today Gökçeada) on the
Aegean Sea. The solid
character of the house,
now owned by an actor,
has saved it from being
trapped in the "rustic."
The thickness of walls
filtering light through
openings as wide as they
are deep, the roughness
of the whitewash, and the
astonishing fireplace
hood shaped like a
German military helmet
give the room both
warmth and fascination.

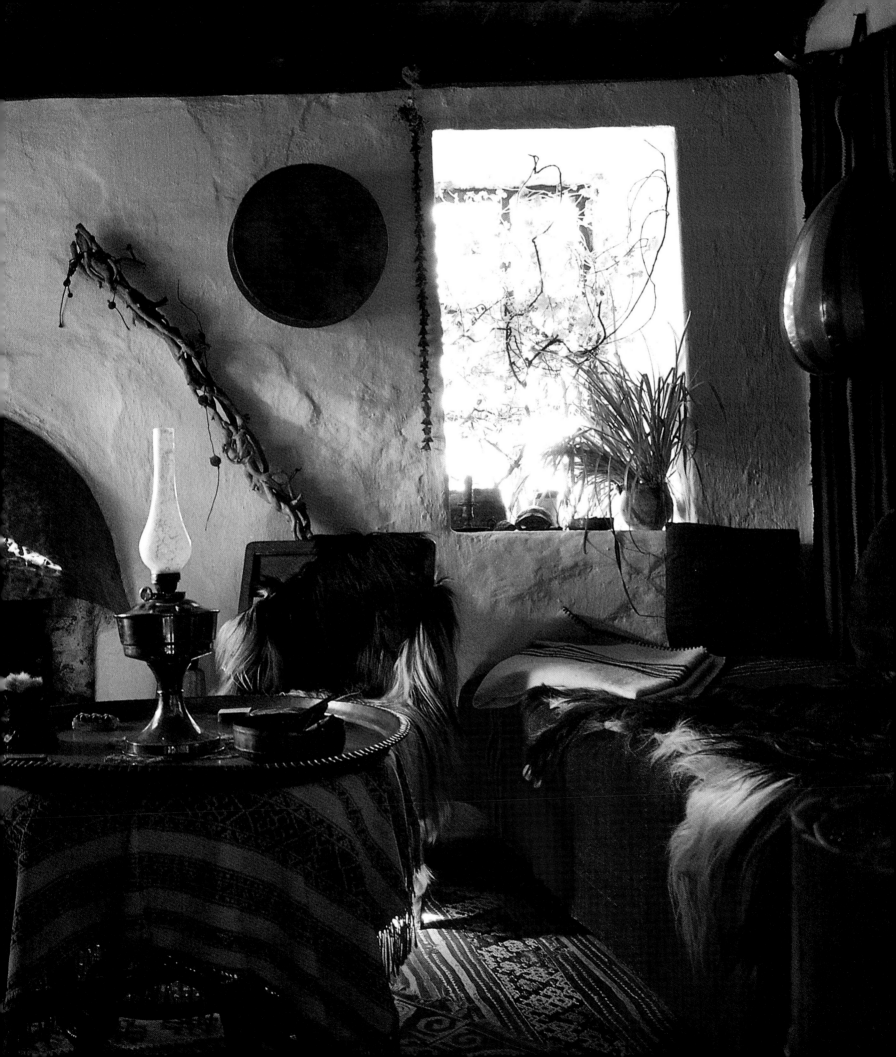

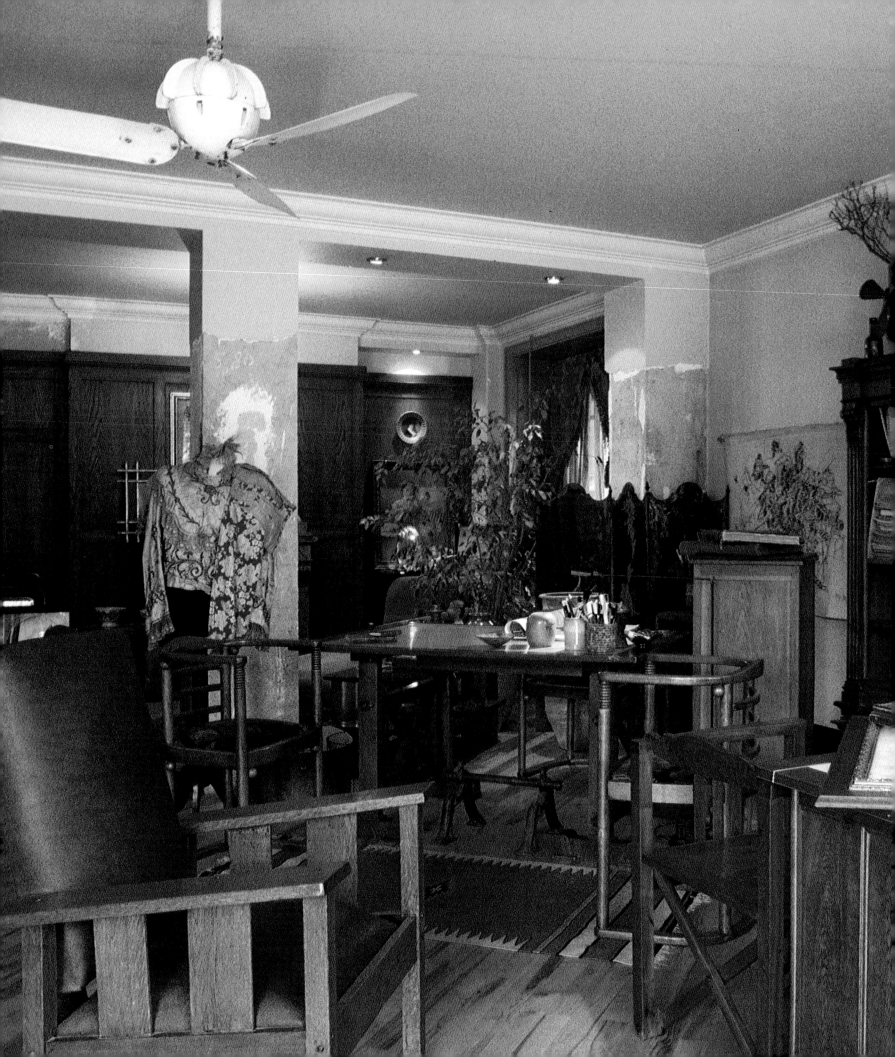

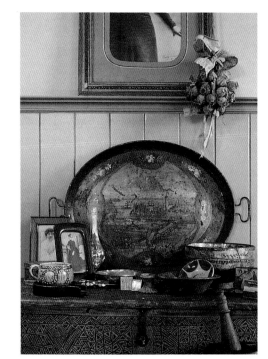

The householder sometimes proceeds like a pirate plundering old shipwrecks and hoarding booty higgledy-piggledy. Paneling from demolished houses, the abandoned possessions of dispersed families, and discarded shop-window mannequins come together with all their history to yield a glowing patina dominated by the tones of wood.

\mathcal{B}alustrades and doors from the dolap *of houses long disappeared, together with yellowed photographs of improbable ancestors, earthenware oil jars empty since the introduction of chandeliers, and Kufic inscriptions under glass, furnish the "musée imaginaire" of a freebooter of the past.*

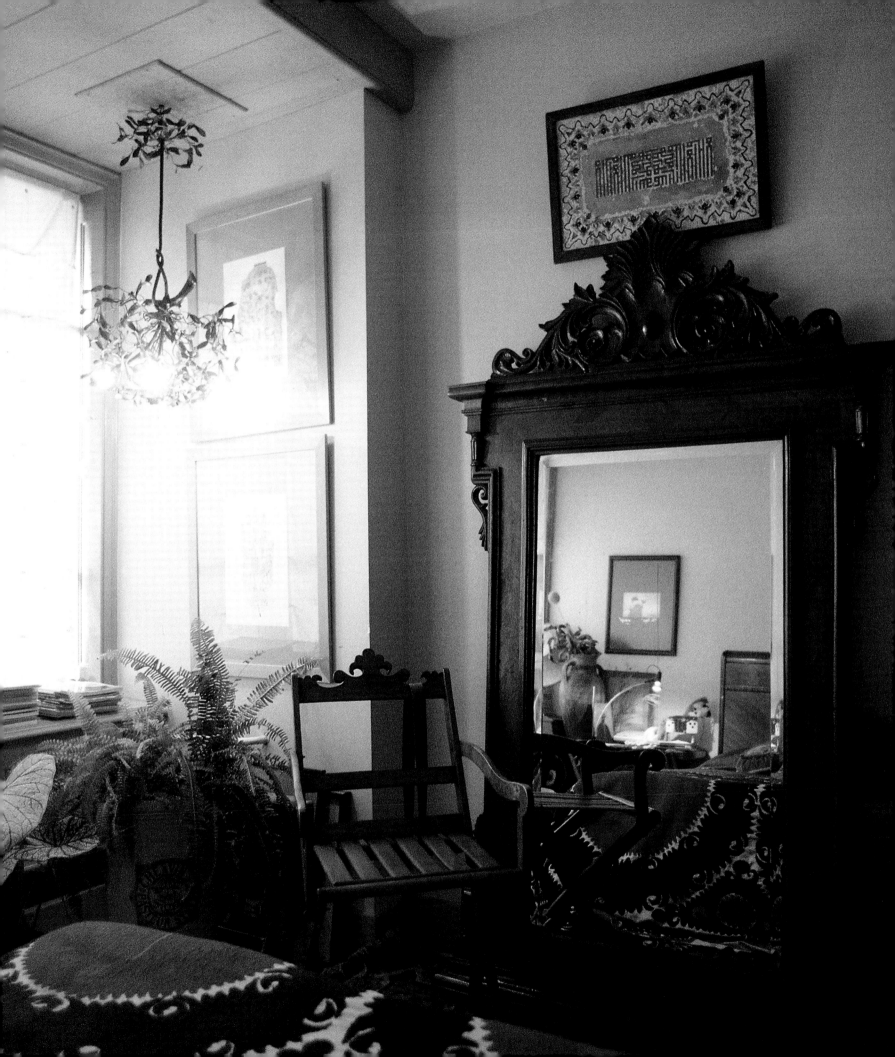

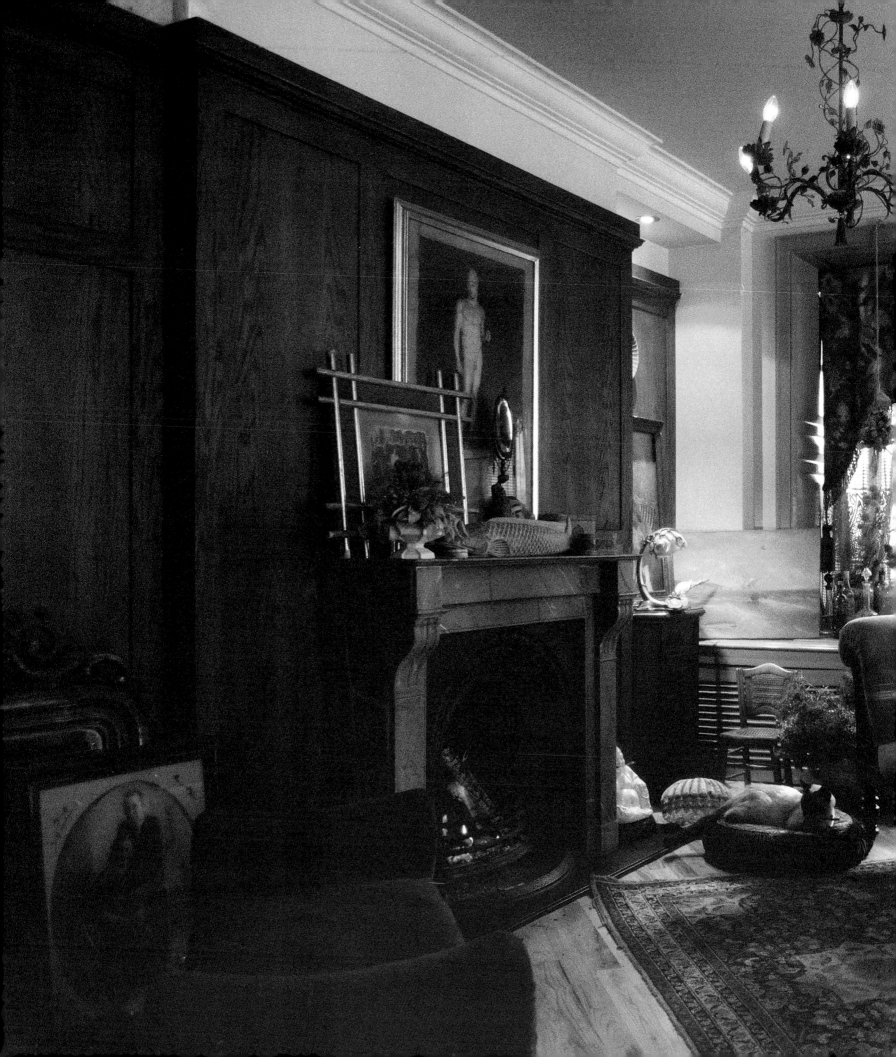

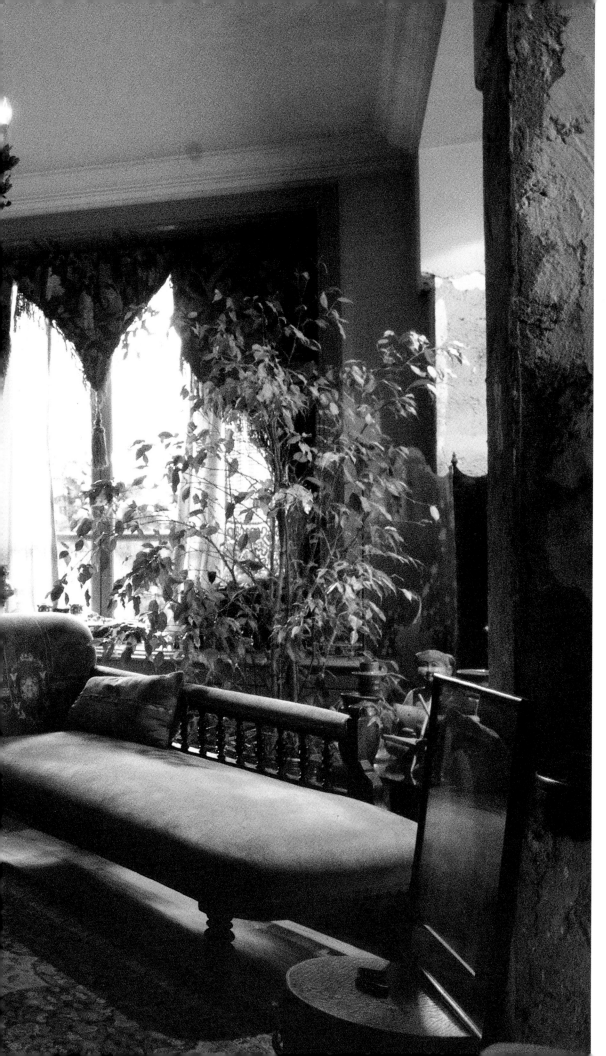

*C*ontemporaries,

anchored as they are

in the present, become

natural heirs to the past,

which makes modernity

little more than the art

of possessing and

accommodating the

remains of history,

just as humanism is

the capacity to assimilate

the works of humanity.

History ends in the curve

of an English divan,

in a Siamese cat, or in

a Chinese Buddha set

about a Turkish carpet.

APPENDICES

A house of Greek origin in the Aegean region.

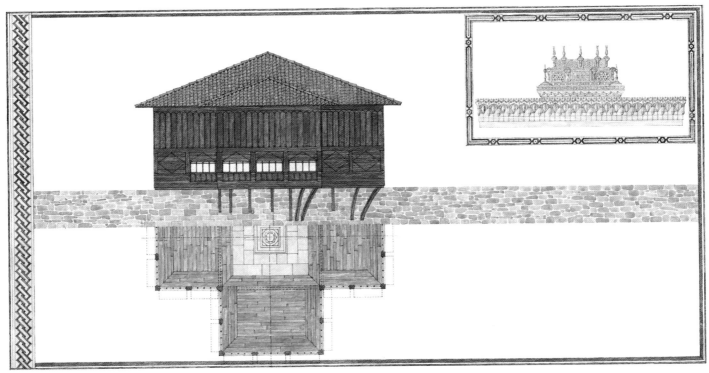

On the Bosphorus, a kiosk at the residence of Amcazade Hüseyin Paşa, Grand Vezir at the end of the 17th century.

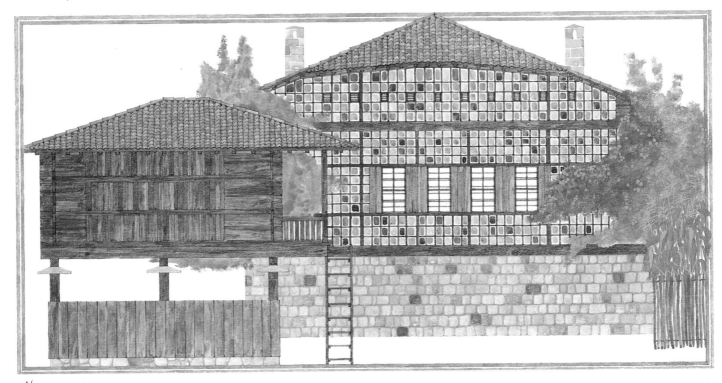

House at Rize, on the eastern shore of the Black Sea.

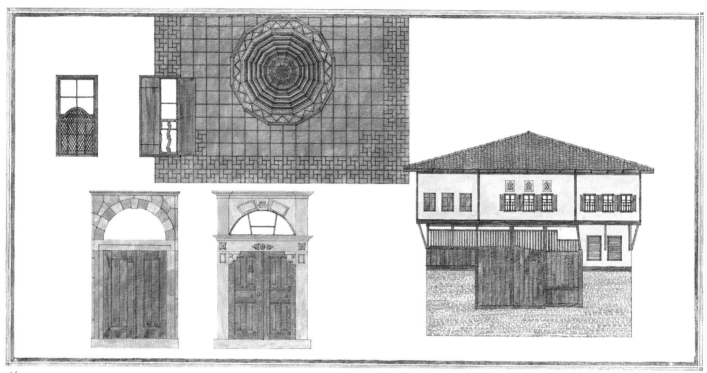

House at Safranbolu in northwest Anatolia.

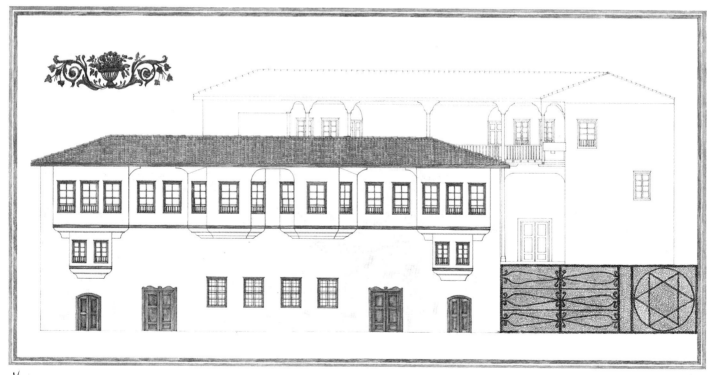

House at Antalya on the Mediterranean coast.

213

I S T A N B U L

BOOKSHOPS

Sahaflar (second-hand books).
Beyazıt (behind the Grand Bazaar).
Aslıhan. Balıkpazarı. Galatasaray.

Levant
Tünel Meydani, 8. Beyoğlu.
Tel: 244.63.33.
Old postcards, stamps, and prints.

Eren Kitapevi
Tünel Sofyali Sok, 34. Beyoğlu.
Tel: 252.05.60.
Books on the Ottoman period.

Galeri Alpha
Hacıoğlu Sok, 1/A
Çukurcuma, Beyoğlu
Tel: 251.16.72
Old postcards, books and prints related
to Istanbul.

Pera Kitapevi
Galipede cad, 22. Tünel.
Tel: 249.06.72.

ART GALLERIES

Galeri Nev
Silahane cad, 33/8. Maçka.
Tel: 231.67.63.

Tem Sanat Galerisi
Prof. Dr. Orhan Ersek sok, 44/2.
Nişantaşı.
Tel: 247.08.99.

Urart Sanat Galerisi
Abdi İpekçi cad, 18/1. Nişantaşı.
Tel: 248.73.26.

Arkeon Sanat Galerisi
İskele cad. Salhane sok, 19. Ortaköy.
Tel: 259.92.57.

Galeri BM
Akkavak sok, 1/1. Teşvikiye.
Tel: 231.10.23.

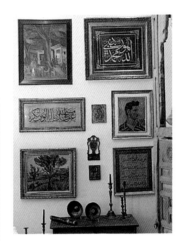

CARPETS

Bazar 54
Nurosmaniye cad, 54. Cağaloğlu.
Tel: 511.21.50.

Ayak Şirinoğlu
Nuruosmaniye cad, 63/2. Cağaloğlu.
Tel: 528.37.05.

Uyar El Halıları
Teşvikiye cad, 178/1. Nişantaşı.
Tel: 240.46.57. / 247.83.96.

Aykut Halıcılık
Nuruosmaniye cad, 100. Cağaloğlu.
Tel: 527.55.54.

ANTIQUES

Mustafa Kayabek
Tünel Geçidi, 10-12.
Beyoğlu.
Tel: 244.45.78.

Lale Antik
Antikacılar çarşısı.
Kuştepe.
Mecidiyeköy. Tel: 267.34.94.

Tombak Ahmet
Çukurcuma cami sok, 13/B. Beyoğlu.
Tel: 245.66.25.

BAZAARS

Kapalıçarşı - Grand Bazaar
Beyazıt
This colossal market, which dates from
1461, has been rebuilt on several
occasions. The last was in 1894, thanks
to the earthquake of that year, and this
reconstruction gave the bazaar its
present form. In actuality a small
mercantile city, the bazaar and its
streets offer goods and objects of the
greatest variety: carpets, old as well as
modern jewelry, traditional clothing,

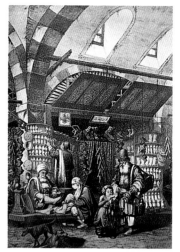

leather garments, fabrics, antiques, etc. There are estimated to be some 5,000 shops in the Grand Bazaar.

Mısır Çarşısı - Egyptian Bazaar
Eminönü.
This market once specialized in the spice trade. Although radically modernized, it still includes a few traditional shops.

𝒫 ALACES

TopkapıSultanahmet.
Hours: 9:30-16:30
Closed Tuesday
The seat of the Ottoman Sultans, this ancient palace is composed and built like a stone encampment. One may visit the apartments, the state rooms, the harem and its *hamam* or bathhouse, the kitchens and the museum. The collection includes precious objects, costumes, calligraphy, and miniatures, among other wonderful things

Dolmabahçe
Hours: 9:30-12; 13:30-15:30
Closed Monday and Thursday

Commissioned by the Sultan Abdülmeci and built by the architect Garabed Balyan, this huge palace is in an eclectic, half-Oriental, half-Occidental style. The interiors are remarkable for their luxury as well as for the hybrid character of the décor.

Beylerbey
Hours: 9:30-12; 13:30-15:30
Closed Monday and Thursday
The Sultan Abdüluziz had this magnificent palace built on the Asian side of the Bosphorus during the second half of the 19th century. It reflects the period's growing desire for Westernization of the Empire.

Yıldız
Beşiktaş.
Hours: 9:30-12;
13:30 -15:30
Closed Monday and Thursday
The last residence of the Ottoman Sultans. The palace is built like a gigantic chalet, with a superb park containing a variety of pleasure pavilions.

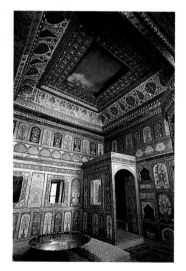

𝒞 AFÉS

Şark kahvesi
Kapalıçarşı (Grand Bazaar). Beyazıt. Small café located inside the Grand Bazaar, its tables covered in old fabrics and its walls hung with prints.

Çubuklu Ali Paşa kahvesi
Çemberlitaş.
The oldest café in Istanbul. It has a small courtyard with a fountain. Many come here to smoke the nargile.

Piyer Loti Kahvesi
(Café Pierre Loti)
Eyüp.
This small traditional café situated above the Eyüp Cemetery offers the best view of the Golden Horn. Pierre Loti visited and then brought his friends.

Malta Köşkü
Yıldız. Beşiktaş.
This antique-decorated pavilion, or kiosk, is situated in the imperial park built at the end of the Ottoman era.

Çadır köşkü
Yıldız. Beşiktaş.
Another pavilion – this one in the Yildiz park – that has been transformed into a restaurant and tea room. The café has its own garden.

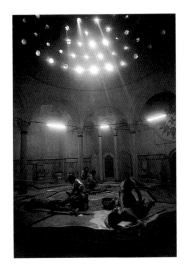

*H*AMAM - TURKISH BATHS

Galatasaray Hamamı
Near İstiklal Caddesi. Galatasaray.

Cağaloğlu Hamamı
Hilaliahmer Caddesi, 34. Cağaloğlu.

Çemberlitaş Hamamı
Vezirhan Caddesi, 8. Çemberlitaş.

*H*OTELS

Yeşil Ev (Green House)
Sultanahmet 5.
Tel: 517.67.85/6/7/8.
Superb hotel in the Ottoman style with
its façades painted green and an
enchanting garden where, in good
weather, one may dine. It is situated
between the Blue Mosque and
Hagia Sofia.

Otel Sokullu Paşa
İshakpaşa mah. Mehmetpaşa sok, 3.
Sultanahmet.
Tel: 518.17.90. - 518.17.93.
A onetime residence situated behind

the Hippodrome, this hotel is noted for
its old architecture, partly covered
garden, and traditional furnishings..

Ayasofya Pansiyon
Sultanahmet
Tel : 513.36.60.
An ensemble of small wood houses
along the wall surrounding Topkapı,
the hotel is superbly furnished as well
as situated.

Hidiv Kasrı
Çubuklu (Asian side of the
Bosphorus)
Tel: 331.26.51 - 322.40.42.
Former residence of the Khedive, or
Viceroy, of Egypt, this hotel offers
period furniture, a beautiful garden,
and an exceptional view over the
Bosphorus.

Büyük Londra Oteli
Meşrutiyet cad. Tepebaşi.
Tel: 245.06.70.
An old hotel in colonial style, complete
with faded velvets. It still preserves the
spirit of Constantinople before the
Great War.

Pera Palas
Meşrutiyet cad, 98/10.
Tepebaşı.
Tel: 251.45.60.
The best-known hotel in Istanbul.
Built for passengers arriving aboard the
Orient Express, it exudes fin-de-siècle
charm. Among its numerous
distinguished guests was Agatha
Christie.

Splendid Oteli
23 Nisan cad, 71. Büyükada
(Princes' Island)
Tel: 351.67.75. - 351.69.50.
A hotel built of wood at the turn of the
20th century in Riviera style. It retains
the character of the old *pensions*, and
was once frequented by the
intelligentsia. Elia Kazan often checked
in here.

Kariye Oteli
Edirnekapı
Tel: 534.84.14/5/6.
Constructed in the pre-revolutionary
Ottoman style, with façades made of
painted wood. Located near the great
Byzantine church kown as the Kariye.

*R*ESTAURANTS

Pandeli
Mısır Çarşısı, 1. Eminönü
Tel: 522.55.34.
Only for lunch. Famous for its
traditional cuisine.
Despite a large tourist clientele,
Pandeli remains at the height of its
reputation. Magnificent décor of
porcelain tiles.

Abdullah
Emirgan (European side of the
Bosphorus)
Tel: 263.64.09.
Cuisine in the grand tradition.
An elegant restaurant with a view over
the Bosphorus.

Rejans
İstiklal cad, Olivo Geçidi, 15.
Galatasaray
Tel: 244.16.10.

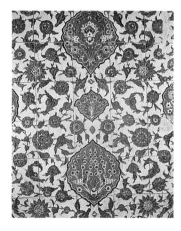

Russian restaurant once frequented by
Atatürk, as well as by many writers
and theater folk in the years following
the revolution.
Famous for its *canard aux pommes*
and its vodka.

Han
Rumelihisarı (European side of the
Bosphorus)
Seafood served in an old wood house.
An exceptional view over the
Bosphorus.

Süreyya
Arnavutköy
(European side of the Bosphorus)
A modern and generally
Western restaurant serving
mostly traditional cuisine and
Russian specialities.

Beyoğlu
A. Mesçit Sok, 5. Beyoğlu.
Tel: 251.10.46.
A small restaurant typical
of the Beyoğlu
quarter. If the décor
is a bit kitsch, the old
pictures on the wall
provide a certain charm.
Very simple cuisine.

Sultanahmet Köftecisi
Divanyolu cad. Sultanahmet
A very popular restaurant with
marble tables.
The best place to enjoy *köfte*.

Sarnıç
Sultanahmet
Installed in one of the most beautiful
of Istanbul's Byzantine cisterns.

Dört Mevsim
İstiklal cad, 509.
Galatasaray
Tel: 245.89.41.
Generally Western in
style, with an interesting if
mixed décor.

Hacı Baba
İstiklal cad. 49. Beyoğlu
A popular restaurant with an
authentically traditional
cuisine. Remarkable for its
still-life paintings hung in the
far dining room.

Kaptan
Birinci cad, 53.
Arnavutköy
Tel: 265.84.87.
A seafood
restaurant that is one
of the most
recommended of the
dining places on the European
side of the Bosphorus.

Hasır
Kalyoncukulluğu cad, 94/1.
Tarlabaşı.
Tel: 250.05.57.
A *meyhane* as popular today
as in the past. Frequented by
artists and intellectuals, who are
more likely to drink raki
than wine.

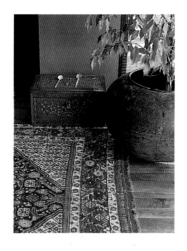

P A R I S

Antiques

Soustrel
146, bd Haussmann,
75008 Paris.
Tel: 45.62.27.75.

Crafts

Société Leyla Bilgi
33, rue de Clichy,
75009 Paris.
Tel: 42.81.24.18.

Bookshops

L'Asiathèque
6, rue Christine, 75006 Paris.
Tel: 43.25.34.57.

Librairie d'Amérique et d'Orient
11, rue Saint Sulpice, 75006 Paris
Tel: 43.26.86.35

L'Astrolabe (La Librairie du voyageur)
46, rue de Provence, 75009 Paris.
Tel: 42.85.42.95.

H Samuelian
51, rue Monsieur Le Prince, 75006 Paris.
Tel: 43.26.88.65.

Rugs & Kilims

Societé des Arts Décoratifs d'Anatolie
39, rue de l'Université, 75007 Paris.
Tel: 42.60.22.60.

Arts Décoratifs d'Anatolie
39, rue de Poitou,
75003 Paris.
Tel: 42.78.27.05.

Restaurants

Gölbasi
218, rue Saint-Maur, 75010 Paris.
Tel: 42.03.30.62

La Voie Lactée
34, rue du Cardinal Lemoine,
75005 Paris.
Tel: 46.34.02.35.

Bomonti
26, rue Lamartine, 75009 Paris.
Tel: 40.16.02.21.

Perge
16, rue des Trois-Frères, 75018 Paris.
Tel: 42.52.00.08.

Cappadoce
12, rue de Capri,
75012 Paris.
Tel: 43.46.17.20.

Pacha
9, rue du Général Leclerc,
95210 Saint-Gratien.
Tel: 34.17.19.22.

Foodstores

Fratis
10, rue Hittorf, 75010 Paris.
Tel: 42.45.68.32.

Raff
60, Avenue Paul-Doumer,
75015 Paris.
Tel: 45.03.10.90.

Taras
84, rue du Faubourg Saint-Denis,
75010 Paris.
Tel: 42.46.95.91.

Bosphore Set
5, rue de l'Échiquier,
75010 Paris.
Tel: 42.46.60.51.

Günes et ve gida Pazari
74, rue du Faubourg Saint-Denis,
75010 Paris.
Tel: 42.47.07.65.

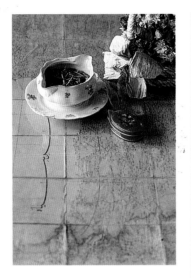

\mathscr{O}THER ADDRESSES

TURKISH EMBASSY
16, av de Lamballe,
75006 Paris.
Tel: 42.24.52.24.

TURKISH CONSULATE
184, bd Malesherbes,
75017 Paris.
Tel: 42.27.32.72.

TURKISH OFFICE OF TOURISM
102, av des Champs Elysées,
75008 Paris.
Tel: 45.62.78.68. ·

CULTURAL CENTRE OF ANATOLIA
77, rue Lafayette, 75009 Paris.
Tel: 42.80.04.74.

TURKISH AIRLINES
2, rue de l'Echelle, 75001 Paris.
Tel: 45.62.78.68.

SIPA PRESS
101, bd Murat, 75016 Paris.
Tel: 47.43.47.43.

$\mathbf{L \; O \; N \; D \; O \; N}$

\mathscr{B}OOKSHOPS

Hellenic Book Service
91 Fortess Road
London NW5 1AG
Tel: 071-267 9499

The Travel Bookshop
13 Blenheim Crescent
London W11 2EE
Tel: 071-229 5260

\mathscr{C}ARPETS

Aaron Gallery
34 Bruton Street
London W1X 7DD
Tel: 071-499 9434

Benadout & Benadout
7 Thurloe Place
London SW7 2RX
Tel: 071-409 1234

David Black Oriental Carpets
96 Portland Road
London W11 4LN
Tel: 071-727 2566

Coats Oriental Carpets
4 Kensington Church Walk
London W8 4NB
Tel: 071-937 0983

Carpet Export & Import Company
Unit 22, Imperial Studios
9 Imperial Road
London SW6 2AG
Tel: 071-404 5014

Christopher Farr Handmade Rugs
115 Regents Park Road
London NW1 8UR
Tel: 071-916 7690

Robert Stephenson
1 Elystan Street
London SW3 3NT
Tel: 071-225 2343

The Kilim and Nomadic Rug Gallery
5 Shepherds Walk
London NW3 5UL
Tel: 071-435 8972

The Kilim House
951-3 Fulham Road
London SW6 5HY
Tel: 071-731 4912

The Kilim Warehouse
28a Pickets Street
London SW12 8QB
Tel: 081-675 3122

Shaikh & Son (Oriental Rugs) Ltd
16 Brook Street
London W1Y 1AA
Tel: 071-629 3430 / 408 2369

Sussex House
63 New Kings Road
London SW6 4SE
Tel: 071-371 5455

Vigo Carpet Gallery
6a Vigo Street
London W1X 1AH
Tel: 071-439 6971

\mathcal{C}RAFTS

Turkish Craft Centre
3 Blythe Mews
Blythe Road
Brook Green
London W14 0HW
Tel: 071-371 1416 / 602 3939

\mathcal{D}EPARTMENT STORES

These mainly focus on carpets and
rugs, but some also sell jewelry and
other craft objects.

Harrods Ltd
Knightsbridge
London SW1X 7XL
Tel: 071-730 1234

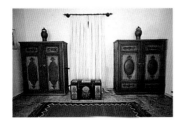

Harvey Nichols & Co. Ltd
Knightsbridge
London SW1X 7RJ
Tel: 071-235 5000

Peter Jones
Sloane Square
London SW1W 8EL
Tel: 071-730 3434

John Lewis
Oxford Street
London W1A 1EX
Tel: 071-629 7711

Liberty plc
210-220 Regent Street
London W1R 6AH
Tel: 071-734 1234

\mathcal{R}ESTAURANTS

Efes Kebab House
80 Great Titchfield Street
London W1P 7AF
Tel: 071-636 1953 / 637 5744

Efes 2
175 Great Portland Street
London W1N 5FD
Tel: 071-426 0600

Sofra Restaurant
18 Shepherd Street
London W1Y 7LN
Tel: 071-493 3320 / 491 8739

Topkapi Restaurant
25 Marylebone High Street
London W1M 3PE
Tel: 071-486 1872

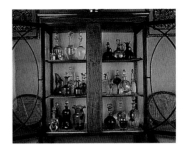

N E W Y O R K

\mathcal{B}OOKSHOPS

Turquoise
132 E 61st Street
New York, NY 10021
Tel: 759 6424

\mathcal{C}ARPETS

Istanbul Grand Bazaar
9 E. 30th Street
New York, NY 10016
Tel: 779 7662

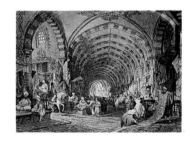

Asia Minor Carpets
801 Lexington Avenue
New York, NY 10021
Tel: 223 2288

Bergama
Center for Turkish Arts
32 East 30th Street
New York, NY 10016
Tel: 779 1444

Anadol Rugs
15 East 30th Street
New York, NY 10016
Tel: 684 7580

Durusel Carpets
Hand Made Carpet Manufacturing
and Trade Co.
34 East 29th Street
New York, 10016
Tel: 685 6733

*F*OODSTORES

Birlik Market
59-19 8th Avenue
Brooklyn, NY 11220
Tel: 436 2785

Funda Fresh Fruits
2233 86th Street
Brooklyn, NY 11214
Tel: 232 0330

Marmaris Grocery
2743 Ocean Avenue
Brooklyn, NY 11229
Tel: 891 3934

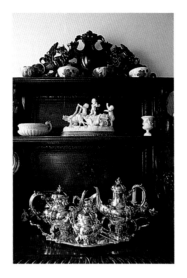

*R*ESTAURANTS

Divan
102 MacDougal Street
Greenwich Village
New York, NY
Tel: 598 9789

Kervan
360 Lawton Avenue
Cliffside Park,
NJ 07010
Tel: 945 7227

Üsküdar
1405 Second Avenue
New York
Tel: 988 2641

Anatolia
1422 Third Avenue
New York, NY 10028
Tel: 517 6262

Istanbul Cuisine
303 East 80th Street
New York, NY 10021
Tel: 744 6903

Dalyan
1663 First Avenue
New York
Tel: 348 4621

Taci's Beyti
1955 Coney Island Avenue
Brooklyn, NY 11223
Tel: 627 5750

Turkish Kitchen
3506 Park Avenue
Weehawken, NJ 07087
Tel: 863 1011

Ottoman's Restaurant
920 Courtelyou Road
Brooklyn, NY
Tel: 856 1824

Tarabya Restaurant
613 Middle Neck Road
Great Neck, NY
Tel: 482 0760

*O*THER ADDRESSES

TÜRK HARS BİRLİĞİ
Turkish Cultural Alliance
141 Neptune Avenue
Brooklyn, NY 11235

TURKISH CONSULATE GENERAL
821 United Nations Plaza
New York, NY 10017
Tel: 949 0160

TURKISH AIRLINES
821 United Nations Plaza
4th floor
New York, NY 10017
Tel : 986 5050

◆ *Avlu*: Courtyard.

◆ *Başoda*: Principal living room, the place for receiving important guests.

◆ *Çıkma*: The projected, cantilevered, or overhung part of the main, upper story; also known as *cumba* or *şahnişin*.

◆ *Çiçeklik*: A decorative niche in the blind wall of the principal living room, for the display of valuable objects or flowers (*çiçek*).

◆ *Dolap*: Cupboard, generally installed on the blind wall of living rooms or sometimes on lateral walls at the end of a sequence of windows. *Dolap* are primarily for the storage of bedding, which at night is spread over the floor of the same rooms.

◆ *Eyvan*: A platform alcove giving onto the *hayat* or the *sofa*, separated from these spaces by a step (*seki*) and sometimes by columns resting on a balustrade.

◆ *Hayat*: Veranda on the main, upper story, although sometimes found on the mezzanine. Originally open onto the courtyard but later glazed. The stairs debouch into the *hayat*, which in turn gives access to the *oda* or rooms on the floor.

◆ *Kafes*: Grilles or screens made of wood, fixed or vertically movable and installed over windows.

◆ *Kavukluk*: Niche inserted in the blind wall of a room, often between

the *dolap* and the *çiçeklik*. Originally, the *kavuk* (turbans) of visitors were placed there, but later the *kavukluk* became a place for displaying precious objects.

◆ *Keyif*: Ease and good humor. In the Orientalist literature of the West, it signifies a state of apathetic bliss unique to Orientals (*kief*).

◆ *Kilim*: Carpets without nap, thus usable on both sides, generally decorated with geometric motifs of nomad (Türkmen) origin.

◆ *Konak*: An important house belonging to a person of standing.

◆ *Köşk*: (1) Platform installed in a corner of the *hayat* facing the courtyard, furnished with carpets and cushions for summer relaxation. (2) Pleasure pavilion erected in a garden for short visits. (3) Holiday house. The origin of the word "kiosk."

◆ *Mangal*: Charcoal-fired brazier, the principal source of heat in traditional rooms.

◆ *Nargile*: Water pipe for smoking Persian-style tobacco (*tömbeki*).

◆ *Oda*: Habitable room.

◆ *Saray*: Palace.

◆ *Seccade*: Prayer rug with a niche design (*mihrab*) indicating the direction of Mecca.

◆ *Sedir*: Low banquette running completely around three sides of an *oda*.

◆ *Seki*: Step separating the entrance from the interior of an *oda*, a place where one remains seated, while also separating this from a space for circulation. The *seki* is where shoes must be removed.

◆ *Selâmlık*: Wing or room reserved for men, thus especially the place where male guests are received.

◆ *Sergen*: Overhead shelf running along three sides of the *oda* above the *sedir* and used for storing ustensils, mainly those required at meals.

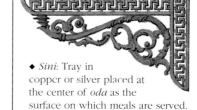

◆ *Sini*: Tray in copper or silver placed at the center of *oda* as the surface on which meals are served.

◆ *Sofa*: Antechamber on the main, upper floor, into which the stairs debouch and out of which open the other rooms (*oda*) on the floor. Otherwise, it can be completely enclosed and thus once removed from daylight, or directly illuminated by windows pierced in two opposite walls. In this case, the *sofa* can be T-shaped or cruciform; if so, the wings situated between the *oda* may contain rooms for service or be arranged as *eyvan*. The source of the English word "sofa," although this actually refers to a *sedir*.

◆ *Sofra*: Folding trestles placed under the *sini* to elevate it, as high as the *sedir* if necessary.

◆ *Taşlık*: Flagstone-paved courtyard on the ground floor. See also *avlu*.

◆ *Yalı*: Holiday house situated on the banks of the Bosphorus. From the Greek *ghialos* meaning seaside.

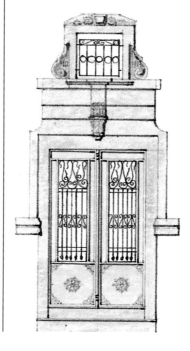

◆ Anderson, Brian and Eileen.
*Landscapes of Turkey: Around
Antalya*. London, 1989.
*Landscapes of Turkey: Around
Bodrum and Marimaris*.
London, 1991.

◆ Bean, George E. *Aegean Turkey*,
2nd ed. London, 1979.
Lycian Turkey. London, 1978.
Turkey Beyond the Maeander, 2nd
ed. London, 1980.
Turkey's Southern Shore, 2nd ed.
London, 1979

◆ Boppe, Auguste. *Les Peintres du
Bosphore au XVIIIe siècle*, rev.
Paris, 1989.

◆ Borie, Alain, and Pierre Pinon.
"La Maison ottomane: une centralité
inachevée?," *Cahiers de la recherche
architecturale*, nos. 21/21. 1987.
"Maisons ottomanes à Bursa
(Turquie)," *L'Habitat traditionnel
dans les pays musulmans autour de
la méditerranée*.
Cairo, 1990.
"La Maison turque," *Bulletin
d'informations architecturales*,
suppl. to no. l94. 1985.
and Stéphane Yerasimos. "Tokat:
essai sur l'architecture domestique
et la forme urbaine," *Anatolia
Moderna*, I. Paris, 1991.

◆ Burnaby, Frederick. *On Horseback
through Asia Minor*. 1877;
Gloucester, 1985.

◆ Charlemont, Lord. *The Travels of
Lord Charlemont in Greece and
Turkey*. 1749; London, 1985.

◆ Facaros, Dana, and Michael Pauls.
Turkey, rev. Cadogan Guides,
London, 1988.

◆ Freely, John. *Classical Turkey*.
Architectural Guides for Travellers:
London, 1990.
The Companion Guide to Turkey.
London, 1979.
Istanbul. Blue Guide: London, 1983.
and Augusto Romano Burrelli.
*Sinan: Architect of Süleyman the
Magnificent and the Ottoman*

Golden Age. London, 1992.

◆ Gilles, Pierre. *The Antiquities of
Constantinople* (written in the 15th
century). New York, 1988.

◆ Glazebrook, Philip. *Journey to
Kars*. London, 1984.

◆ Goodwin, Godfrey. *A History of
Ottoman Architecture*.
London, 1971.

◆ Haroutunian, Aroto der. *A Turkish
Cookbook*. London, 1987.

◆ Kinross, Baron John Balfour.
Atatürk: The Rebirth of a Nation.
London, 1964.

◆ Lawrence, T.E. *Crusader Castles*.
1936; London, 1992.

◆ Loti, Pierre. *Constantinople fin de
siècle*. Brussels, 1991.

◆ Macaulay, Rose. *The Towers of
Trebizond*. 1956; London, 1990.

◆ Mantran, Robert, ed. *Histoire de
l'Empire Ottoman*. Paris, 1989.
*La Vie quotidienne à Istanbul au
temps de Soliman le Magnifique*,
rev. Paris, 1990.

◆ McDonagh, Bernard. *Turkey: The
Aegean and Mediterranean Coasts*.
Blue Guide: London, 1989.

◆ Mehling, Marianne, ed. *Turkey: A
Phaidon Cultural Guide*.
Oxford, 1989.

◆ Michaud, Roland and Sabrina.
Turkey. London, 1987.

◆ Montagu, Lady Mary Wortley.
*Embassy to Constantinople: The
Travels of Lady Mary Wortley
Montagu*, intro. by Dervla Murphy.
London, 1988 (originally
published in the 18th century).

◆ Newby, Eric. *On the Shores of the
Mediterranean*. London, 1984.

◆ Nicolay, Nicolas de. *Dans l'Empire*

de Soliman le Magnifique, ed. by
Stéphane Yerasimos.
Paris, 1989.

◆ Norwich, John Julius. *Byzantium:
The Early Centuries*.
London, 1988.
Byzantium: The Apogee.
London, 1991.

◆ Orga, Irfan. *Portrait of a Turkish
Family*. 1950; London, 1990.

◆ Osmanoglou, Aïché. *Avec Mon
Père le Sultan Abdulhamid de son
palais à son prison*. Paris, 1991.

◆ Perot, J. "Un artiste lorrain à la
cour de Sélim III: Antoine Ignace
Melling," *Bulletin de la société de
l'histoire de l'art français*. 1989.

◆ Runciman, Steven. *Byzantine Style
and Civilisation*.
London, 1987.

◆ Stark, Freya. *Alexander's Path:
From Caria to Cilicia*. 1958;
London, 1991.
Ionia: A Quest. 1954; London, 1988.
The Lycian Shore. 1956;
London, 1989.

◆ Stierlin, Henri. *Soliman et
l'architecture ottomane*. Paris, 1985.

◆ Tavernier, Jean Baptiste. *Les Six
Voyages en Turquie et en Perse*, 2
vols. Ed. by Stéphane Yerasimos.
Paris, 1981.

◆ Thévenot, Jean. *Voyage du Levant*,
ed. by Stéphane Yerasimos.
Paris. 1980.

◆ Tournefort, Joseph Pitton de.
Voyage d'un botaniste, 2 vols. Ed.
by Stéphane Yerasimos. Paris, 1982.

◆ Yashar, Kemal. *The Birds Have
Also Gone*. London, 1987.
Memed, My Hawk. London, 1961.
The Sea-crossed Fisherman.
London, 1985.

◆ Yerasimos, Stéphane. *Istanbul,
visite privée*. Paris, 1991.

PHOTOGRAPHY CREDITS

ARA GÜLER : pages 4, 6/7, 12 – 18, 20, 24, 25, 30, 35, 36, 37, 40 (b,c), 44, 54 (b,c), 55, 58, 59, 60, 64, 65, 66, 68 – 75, 78 – 94, 102 – 107, 110/111, 116 – 121, 124, 127 (b), 128 – 135, 138, 140 – 151, 160, 161, 164 – 171, 172 (b) – 174, 176 – 186, 187 (b), 194 – 197.

SAMIH RIFAT : pages 8/9, 22, 27, 43, 46, 51 (a,c), 52, 53, 54 (a), 76, 77, 95 – 101, 108, 112 – 115, 122, 123, 125, 126, 127 (a), 136, 137, 139, 152 – 159, 162, 187 (a), 198 – 209.

ARTHUR THÉVENART : pages 40 (a), 41, 42, 63.

GÉRARD DEGEORGE : pages 32, 33.

MARIANNE HAAS / ELLE DÉCOR (France) : pages 10, 172 (a), 175.

HALÛK ÖZÖZLÜ : pages 50, 51 (b).

ARREDAMENTO : pages 188 – 193.

ACKNOWLEDGMENTS

Editions Didier Millet wishes to thank the following for their collaboration on this book:

Abidine, Zeynep Avci, Selma Gürbüz, Nayab Yolal, and Barbara Rosen

Printed 30 September 1992